Artists in Aprons

Folk Art by American Women

C. Kurt Dewhurst was born in Passaic, New Jersey, and received his B.A. in Social Science and an M.A. in Art Administration from Michigan State University. He has written extensively on American folk art and American decorative arts. Currently he is a curator of folk art at The Museum, Michigan State University, East Lansing, Michigan.

Betty MacDowell, art historian, was born in Detroit, Michigan, and received her B.A. and M.A. degrees in Art History from Wayne State University in Detroit, where she currently teaches. She is especially interested in religious and women's art.

Marsha MacDowell was born in Lansing, Michigan, and received her B.F.A. and M.F.A. degrees from Michigan State University. She has taught art, curated several folk art exhibitions in Michigan, and shown her prints and drawings in state and national exhibitions. Currently she is a curator of folk art at The Museum, Michigan State University.

Artists in Aprons

Folk Art by American Women

C. Kurt Dewhurst Betty MacDowell

Marsha MacDowell

E. P. Dutton in association with the

Museum of American Folk Art

New York

For information contact: E. P. Dutton, 2 Park Avenue,
New York, N.Y. 10016
Library of Congress Catalog Card Number: 78-55945

ISBN: 0-525-47503-6 (D.P.)
ISBN: 0-525-05857-5 (cloth)

Published simultaneously in Canada by Clarke, Irwin & Company
Limited, Toronto and Vancouver

Designed by Susan Mitchell

10 9 8 7 6 5 4 3 2 1

First Edition

Contents

Color insert follows page 76

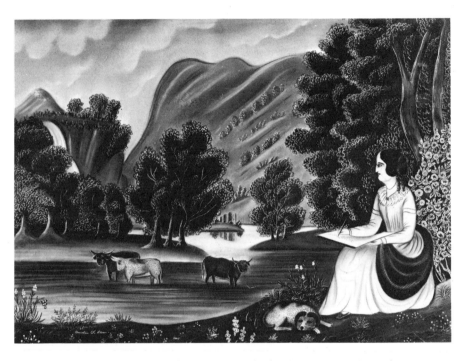

FIG. 1. Caroline Beam: *Self-Portrait*. New England. c. 1840. Charcoal on paper. 20″ × 28″. The artist has given us an interesting glimpse of a female folk artist at work in peaceful and scenic surroundings. (America Hurrah Antiques)

Introductory Note

Too often we think of heroism as something possible only for people threatened by physical danger—a soldier in battle, a policeman or fireman, stepping into the midst of a crisis. But the life of the spirit has its heroes and heroines as well. In the last three decades, in the years of McCarthyism, the civil rights movement, and Vietnam, we have come to know the kind of moral courage that political conviction demands.

Only recently, however, have we as a nation begun to appreciate another form of spiritual heroism, one unique to artists. At its core, this kind of heroism is a commitment to find, in the mundane forms, images of fresh meaning and permanent significance. The heroism of the artist is embodied in a will that refuses to be limited by the day-to-day responsibilities and practical concerns of life. In order to create, the artist must daily perform the heroic task of bringing order to a seemingly inchoate mass of sensations, of finding beauty and value in what to others is merely commonplace or, at best, serviceable. Although all artists need this kind of spiritual valor, there are some who need it more than others, and this book documents a whole class of artists for whom such heroism was the linchpin of their creative lives.

Artists in Aprons is the story of American art as it was practiced by women in their homes. The women whose needlework, fiber pieces, and paintings and drawings this book illustrates had to wrest their art from a workday that gave them no relief from life-sustaining chores, no leisure for reflection. More significantly perhaps, these women worked with little encouragement from their society. They were part of a culture whose history denied women the ability to produce art and whose system of values failed to appreciate the technical complexity and visual sophistication of their work. Yet, with all this against them, they persevered. These women had the cleverness and the insight to realize that their domestic and creative responsibilities could be combined, that it was, despite the odds, possible to make art in the home as part of one's regular routine.

This study is especially timely since most of the recent reexamination of American women painters and sculptors has been primarily focused on professional women artists, those who braved the sacrosanct boundaries of the art academies to compete in a man's world on male terms. As a result of this recent scholarly reassessment, it has been shown that the professional woman artist was capable of excellence, even genius.

The significance of this book is that it shows us the other side of the coin—

the importance placed by American women on the creation of art not for fame and fortune, but art created to bring aesthetic and spiritual sustenance to themselves, their families, and friends. This, then, is the story of domestic heroines. Their work is a marvelous legacy of formal invention, but just as wonderful is the spirit that these works embody—the indefatigable, invincible will to create that made the art of these American women possible.

JOAN MONDALE

Foreword

About three years ago Marsha MacDowell and her husband, C. Kurt Dewhurst, dropped into the office I share with my husband, Dr. Louis C. Jones. They had nearly completed the extensive legwork for a show of Michigan folk art, almost all hitherto unknown to scholars in the folk art circus tent. I hope they were as stimulated as we to find and talk with others working out where the original stuff grows wild. (The term *folk art* in the U.S.A. is applied to a great many different phenomena. The common factor is a lack of academic training and academic point of view in the artists, hence an absence of technique and, often, the presence of a willingness to try anything. The best of the work is created by those who, although lacking in scholastic technique, have a great deal to express. It defies definition because it *is* a circus-tent term, covering many diverse acts, much comedy, tragedy, and beauty.)

In the following year, 1975, they presented the results of their research in an excellent show and catalogue, *Michigan Folk Art/Its Beginnings to 1941*. The whole exhibition was shown at East Lansing and later, parts of it traveled the state of Michigan, giving the people of that state their first view of American folk art as created by their own neighbors.

This show, and a similar one in Georgia that opened in the same year, under the direction of Miss Anna Wadsworth, are the first two widely publicized collections of the work of single states, based on searching in smaller collections, and in the very countryside, as well as the larger private collections, museums, and historical societies. In other words, the search was carried beyond collectors of all sorts to the kind of people for and by whom the work was originally created. The years 1974, 1975, and 1976 were also marked by state shows in Ohio, Pennsylvania, and New York, but these depended less on combing the boondocks. Recently, the Canadians, too, have joined in the sport and are well on with an ocean-to-ocean survey.

In 1976 and 1977 C. Kurt Dewhurst and Marsha MacDowell were joined by her mother, Betty MacDowell, a member of the art history faculty at Wayne State University in Detroit, in the creation of the present show and book, *Artists in Aprons: Folk Art by American Women*. The three coauthors share each others' interests in fine art and folk art, and in folk art by women especially, as well as a desire to put these things into their social and historical contexts.

Artists in Aprons is an original approach to American folk art and should lead the way to clearer analysis of the meaning of art in the daily life of Every-

woman. The book will undoubtedly be a most useful complementary text in several fields, including Women's Studies, Folk Art, Art History, and Afro-American Studies. (Not only are there superb black women folk artists, but there were many factors in women's lives parallel to the black experience.)

For selecting the works to show, the authors set these guidelines: each piece must be known to be by a woman, and her name must be known; every piece shown must be of superior aesthetic quality. The winnowing from hundreds of examples was severe, resulting in 125 items. This book is not a catalogue, but a discussion of the background for ideas illustrated in the work itself.

Artists in Aprons includes the full range of women's known folk art: embroideries, drawings, watercolors, and oils. Among other ideas put forth here, the authors believe that in earlier times women worked less often in oil, partly because the families disliked the smell of turpentine. They account for the scarcity of sculpture by the fact that it was not an endorsed activity, an answer to that puzzle which may well be the truth. When women were finally permitted academic training in sculpture, they did very well, and at the present time women sculptors often excel.

The folk art of American women has never struck me as being different from that of the men, except as dictated by societal roles. Indeed, I hadn't ever addressed the question until it was raised by *Artists in Aprons*. In my first, admittedly superficial, approach to this, the works that came to mind as being "obviously" by women were generally in a restrained, sometimes even inhibited, rather miniature style. The subject matter may have been large but the handling was inclined to be overdetailed and was produced by more delicate colors and finer lines than you might expect to find in the equivalent men's work. These characteristics are often identified by those with a totally male point of view as "picayune," "weak," "niggling"—merely to call the work "feminine" is enough to finish it off. But perhaps these pieces deserved other adjectives, such as "sensitive," "fine," "expressive," "subtle"? Feminine characteristics, if they exist, may not be less good, just different.

Be that as it may, is it true that art can be categorized thus? I don't believe so, and many writers on academic art agree that there is no discernible difference when women achieve the training and experience that have always been in the province of male artists.

A close look at the available research reveals that so little is known of who created what that male/female generalizations cannot even be attempted; also that we know of men working in so-called feminine style, such as Henry Young and Lewis Miller, and of women creating strong, vigorous works, such as Susan Waters's life-size portraits in oil, or Clementine Hunter's multitude of genres and religious subjects.

Then there's the whole fascinating quilt phenomenon; probably very few men made quilts, for obvious reasons. In the design of pieced or appliquéd quilts women could be exceedingly bold and imaginative. Although generally using traditional patterns, by choice of colors, size of the pieces to be cut, and layout

of the colors, they succeeded in producing vibrant compositions, many of which can be hung confidently beside major modern paintings.

The piecing and the quilting were indeed fine-scaled work, for close-set stitches meant a sleeker finish and much longer wear. The very large sizes and the proportions were dictated by the beds, cots, and cribs to be covered. The fabrics were usually those found around the house, left over from other projects, or finally in the ragbag; therefore their original choice had been dictated by other processes. But somehow when the women came to put their found materials together according to the given formulas, they were often liberated to create on a wholly different scale, playing confidently with the abstract.

As a measure of the problem of how much and what folk art was created by women, consider how large a percentage of what survives comes to us with utter anonymity. In a leading recent catalogue, *The Flowering of American Folk Art, 1776–1876,* by the justly distinguished scholars Jean Lipman and Alice Winchester, there were 410 items, forming probably the largest and finest single presentation of the subject.

Of the 410 numbers in the catalogue only 132 (or one in three) are either attributed to or positively credited to a named artist, male or female; or sex not established because first names appear only as initials; and of the 132 named only 34 can be identified as women. Note also that the remaining 276 (⅔) are by as yet unidentified artists—"anonymous"; for all we know, half or more of these may be women. Why need we assume they were almost all men?

In addition, the first names of 12 others of the 132 named artists are given only as initials, and so might perfectly well represent women. Of the 276 anonymous pieces, plus the 12 signed with first initials and last name only, we have absolutely no way of knowing whether they are by a man or a woman.

Many early collectors and dealers were uninterested in knowing the historical and social setting of the art. Some, like Edith Halpert, who was one of the principal instruments in the creation of Abby Aldrich Rockefeller's superb collection, were actually opposed to recording associated information on philosophical grounds. She once told me she desired to comprehend each piece entirely through its intrinsic qualities; her interest was totally aesthetic.

If it is also very much the exception when the artist's name is known (although paradoxically a name, any name, is cherished in the market to a frightening degree), the place where it was created is even more frequently ignored, and an accurate account of anything else about the piece's history is an absolute marvel. In attempting to do research it helps little to know only the name and place. Where will you find your artist even barely mentioned, and in what unartistic context? If the artist was a woman, it is even more difficult, for the meager records of "mute, inglorious" people necessarily mention men more often than women.

In recent years training in this field has become available to men and women at such centers as Williamsburg, Virginia, Cooperstown, New York, and a growing number of colleges and universities, of which Michigan State Uni-

versity in East Lansing is an admirable example, having crowned its support of the folk art search and show by appointing Marsha MacDowell and Kurt Dewhurst jointly as their first researchers of folk art at The Museum, Michigan State University. Their responsibility is to continue locating and documenting through film folk artists and their products in the upper Great Lakes region.

In the next few years it is likely that the rapidly increasing group of serious students will begin to penetrate the many mysteries that have hobbled research. In the encouragement and facilitation of these labors, *Artists in Aprons* should be highly effective, for it sets the works of these women artists in perspective for the first time.

October 25, 1977 AGNES HALSEY JONES

Acknowledgments

Special thanks are extended to those individuals who, by sharing information, or in their willingness to lend items for the exhibition or as illustrations for the book, have helped to make this endeavor a success:

Louis and Agnes Halsey Jones, Robert Bishop, David Pottinger, Donald and Faye Walters, Phyllis Haders, Mr. and Mrs. Wallace Eversburg, Bennett Spelce, Neal Spelce, Michael and Julie Hall, Ruth Piwonka, David Davies, Elias Getz, Dr. Henry and Evelyn Raskin, Professor and Mrs. Dan Throop Smith, Mrs. Gaines R. Wilson, Patrick Leonard, Mrs. Stewart Gregory, Mrs. Barbara Johnson, Barbara Luck, Ralph Esmerian, Gertrude Rogers, Norbert and Gail Savage, Peter Tillou, Mr. and Mrs. Melbourne Sandborn, Nina Howell Starr, Nina Fletcher Little, Shirlee Studt, Mrs. Joan Friedland, Mrs. Harry Orton-Jones, Edward Stvan, Abigail Booth Gerdts, Russell Carrell, Ron and Marcia Spark, Colleen Cowles Heslip, William Wiltshire, Julia Weissman, Herbert Hemphill, Dorothy Mackerer, Mr. and Mrs. G. M. Kapelman, Mirra Bank, Janet Lauretano, Kathy Ouwell, Harlan MacDowell, and our editor, Cyril I. Nelson.

In addition, the following institutions have graciously complied with our requests for slides, photographs, information, or objects on loan. Their cooperation has been greatly appreciated and has made the tasks of the researchers much easier:

Abby Aldrich Rockefeller Folk Art Center, Williamsburg, Virginia; Addison Gallery of American Art, Andover, Massachusetts; America Hurrah Antiques, New York; Amon Carter Museum of Western Art, Fort Worth, Texas; Anglo-American Art Museum, Louisiana State University, Baton Rouge, Louisiana; The Archives of American Art, Detroit, Michigan; The Art Institute of Chicago, Chicago; Bordentown Historical Society, Bordentown, New Jersey; The Bostonian Society, Boston; Brainerd Memorial Library, Haddam, Connecticut; The Brooklyn Museum, Brooklyn, New York; Center for Southern Folklore, Memphis, Tennessee; The Columbia County Historical Society, Kinderhook, New York; The Connecticut Historical Society, Hartford, Connecticut; Essex Institute, Salem, Massachusetts; Free Library of Philadelphia, Philadelphia; Fruitlands Museum, Harvard, Massachusetts; Galerie St. Etienne, New York; Harriet Griffin Gallery, New York; Greenfield Village and Henry Ford Museum, Dearborn, Michigan; Henry Francis du Pont Winterthur Museum, Winterthur, Delaware; The High Museum of Art, Atlanta, Georgia; Idaho State Historical Society, Boise, Idaho; Indianapolis Museum of Art, Indianapolis, Indiana; Ken-

nedy Galleries, Inc., New York; Kentucky Historical Society, Frankfort, Kentucky; Los Angeles County Museum of Art, Los Angeles; The Magazine *Antiques*, New York; Massachusetts Historical Society, Boston; The Metropolitan Museum of Art, New York; The Michigan Department of State Archives, Lansing, Michigan; The Michigan State University Library, East Lansing, Michigan; Mississippi Department of Archives and History, Jackson, Mississippi; Munson-Williams-Proctor Institute, Utica, New York; The Museum, Michigan State University, East Lansing, Michigan; Museum of Art, Rhode Island School of Design, Providence, Rhode Island; Museum of the City of New York, New York; Museum of Fine Arts, Boston; Museum of International Folk Art, Santa Fe, New Mexico; The Museum of Modern Art, New York; National Collection of Fine Arts, Washington, D.C.; National Gallery of Art, Washington, D.C.; National Park Service, Washington, D.C.; Natural History Museum, Los Angeles County, Los Angeles; Nebraska State Historical Society, Lincoln, Nebraska; Newport Historical Society, Newport, Rhode Island; New York State Historical Association, Cooperstown, New York; Old Sturbridge Village, Sturbridge, Massachusetts; Pennsylvania Academy of the Fine Arts, Philadelphia; The Phillips Collection, Washington, D.C.; Pilgrim Hall Museum of the Pilgrim Society, Plymouth, Massachusetts; Rhea Goodman Quilt Gallery, New York; St. Lawrence University Art Gallery, Canton, New York; Schwenkfelder Museum, Pennsburg, Pennsylvania; Shaker Community, Inc., Hancock, Massachusetts; Shelburne Museum, Inc., Shelburne, Vermont; Smithsonian Institution, The National Museum of History and Technology, Washington, D.C.; State Historical Society of Wisconsin, Madison, Wisconsin; Union County Bicentennial Commission, Lewisburg, Pennsylvania; Virginia Museum of Fine Arts, Richmond, Virginia; Wadsworth Atheneum, Hartford, Connecticut; Walker Art Center, Minneapolis, Minnesota; and the Wenham Historical Association and Museum, Inc., Wenham, Massachusetts.

Introduction

Rarely have women folk artists been recognized for the important roles that they have played in contributing to the development of the history of American art. Because of the often confusing and conflicting attitudes of art historians toward folk art, this area of creativity has frequently been dismissed or even overlooked. In the last decade, however, scholars have begun to reevaluate the contributions of women in various fields of endeavor. One area that has recently been investigated is the art of professional women painters. Exhibitions, such as "Women Artists, 1550–1950," at the Los Angeles County Museum of Art, have brought to the attention of art historians and the general public alike the works of previously neglected artists. Judy Chicago, a contemporary professional artist, has explained this neglect by pointing out that "what has happened to all of us [women artists] over and over is that our work has been taken out of our historical context and put into some mainstream [art] context it doesn't belong in; then it is ridiculed, or incorrectly evaluated."[1] The same historical and social factors that limited the numbers of women who chose to pursue art professionally have also held sway over women folk artists. The ideas that defined and confined them to their domestic spheres not only deterred many women from seeking formal training in the fine arts, but also influenced the nature of the work they created as folk artists.

The exhibition, "Artists in Aprons," on which this book is based, was designed to focus on those women who, without formal training and professional stature, nevertheless exceeded the traditional expectations of society in producing their art. Although not in the forefront of progressive artistic movements, these women still wrought a body of work that has been generally disregarded by art historians. Working within the limitations dictated by their social role, they explored various nonacademic media with a vigor and ingenuity that often resulted in strong visual statements. Cindy Nemser, an art editor, has noted that "When women used geometric or organic designs in art work such as quilts, they were dismissed as 'mere decorators,' while men who later used similar patterns were viewed as fine artists and abstract thinkers."[2] It has been the work of women exploring areas considered to be the "decorative arts" that has actually helped stimulate the appreciation of abstraction in art outside of the professional art community. Women quiltmakers, exploiting the formal elements of color, texture, line, and shape, were pioneers in abstract design. These purely formal designs were familiar to almost every American household and thereby touched the lives of people throughout America prior to the twentieth century.

The early emphasis on training in the fundamental technical skills of sewing, necessary for successfully performing the functions of a homemaker, provided the American woman with the technical basis for the media most frequently explored: embroidery, samplers, bed rugs, quilts, and rugs. A needle was her paintbrush and a scrap bag, her palette. During the nineteenth century more educated or polished women were given additional training in seminary schools and drawing academies, which enabled them to create watercolors, mourning pictures, portraits, biblical scenes, landscapes, and genre scenes. Even though most women were discouraged from entering professional art schools, many women were able to express themselves in socially acceptable media, by working in the folk tradition. Unlike those women who were attempting to achieve recognition as professional artists, these women folk artists were not concerned with the rigors of formal art training, the inaccessibility of instruction in anatomy and life drawing, and the lack of or limited patronage for their work. Women sought and found support for their work from their families and friends. Their creative output was consistent with the social values of the day, as long as it conformed to the prescribed domestic role of women. And only because their artistic production did not attempt to transcend their domestic role, but rather served to augment their status within that role, were they able to work unplagued by many of the problems that beset professional women artists. Consequently, they did not challenge the prevailing social norms concerning women and they were able to produce an incredible wealth of art.

Since the early years in the New World, women have created art that has been recognized for its use as historical documentation of life in the home and as a reflection of emerging cultural patterns in America. Although little recognition has been accorded those women who left an important legacy to social and art historians, there is much to be gained by learning more about those women artists who synthesized their domestic and creative roles. Through an examination of the cultural context in which these women created their art, we can begin to comprehend the significance of what might be termed "extraordinary art by ordinary women." Even though much of this art was produced anonymously, we are fortunate to be able to acknowledge the contributions of a number of known American women artists through this exhibition. By tracing the evolution of the American folk art tradition through the work of women whose art exceeded the expectations of society, this book and exhibition belatedly pay tribute to these "artists in aprons," in the hope that they will now be accorded a lasting place in the history of American art.

NOTES

1. Lucy Lippard, "Judy Chicago, Talking to Lucy R. Lippard," in *From the Center* (New York: Dutton Paperbacks, 1976), p. 228.

2. Cindy Nemser, "Towards a Feminist Sensibility: Contemporary Trends in Women's Art," *The Feminist Art Journal* (Summer 1976), p. 21.

Artists in Aprons

Folk Art by American Women

"The Needle Far Excells the Rest . . ."

Of female arts in usefulness
The needle far excells the rest
In ornament there's no device
Affords adornings half so nice.

While thus we practice every art
To adorn and grace our moral part
Let us with no less care device
To improve the mind that never dies.[1]

In 1640 the young daughter of Pilgrim leader Miles Standish embroidered the words "Loara Standish is my name"[2] into a sampler, and in doing so provided the earliest evidence that, at the very dawn of the Colonial era, women in America were creating in media of their own (fig. 2). Although much of this early needlework was rendered in imitation of patterns and prints, many truly imaginative textile artists contributed original works of great merit, establishing a tradition of creative production by American women that has continued to the present day.

Although women had arrived in this country as early as 1585 as part of the "Lost Colony" on Roanoke Island, and in 1608 in the more permanent settlement in Jamestown, Virginia, women were decidedly a minority.[3] The ratio was so unequal that, in 1619, ninety women were sent as wives to America by the London Company.[4] For the next two hundred years, the population would remain male dominated, and only in the mid-nineteenth century would the male-dominated ratio be equalized.[5]

These early women settlers faced the rigors of a new frontier, so it is not surprising that an earlier dated sampler does not exist. The wise use of time and energy did not call for needlework, but rather for the more immediate activities of clearing land, building shelter, and providing food. Of necessity, skill with a needle was demanded, but only in the production of clothes for a family, not for the nonutilitarian sampler. Having survived the arduous trip from England or Holland, these women had to brave new trials and much of their energy was devoted to coping with the strange environment. Every man, woman, and child was valued for his or her contribution toward establishing a home and a settlement in this new land. In a rare social atmosphere that did not

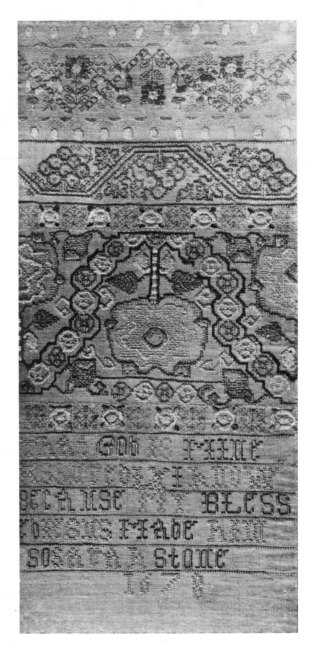

FIG. 2. Sarah Stone: Sampler. Salem, Massachusetts. 1678. Silk on linen. 16¾″ ×
7⅞″. This seventeenth-century sampler incorporates an extensive array of stitches
that are similar to the stitches in the sampler by Loara Standish. (Collection of
Theodore Kapnek)

distinguish between a pair of male or female hands, working women were considered on their own merits. Any skill was valuable, no matter which sex possessed it. Men and women all labored together to carve new homes out of the wilderness. Offering opportunities for prosperity and freedom from the persecutions of the motherlands, this country welcomed both men and women who were eager to enjoy those prospects.

Life throughout the seventeenth and eighteenth centuries, prior to the industrial revolution, revolved around the home. Even after the immediate concern of providing shelter was fulfilled, life's activity did not stray from the central core of that building. The size of the hearth and the predominance of the bed indicate the two most important centers of activity. In the first example the hearth served not only as the source of heat, but also as the center of cooking, a demanding task by any modern measure. The greater part of all food consumed by a household was prepared through its every stage by the family. Working with huge, heavy iron kettles, the woman of the house cooked these home-produced foods at her hearth. Here too, the Colonial woman gathered wood ash, which, together with lumps of lard, she used to produce soap. Candles were manufactured, medicinal syrups boiled, materials dyed, clothes washed, and numerous other tasks performed at the hearth. The building of a fire was such an undertaking that great care was taken to keep the embers burning. In front of the fire women made clothes, taught their children the alphabet, and, with their husbands, entertained guests. Indeed, while life centered around the home, the hearth was the hub of activity.

The bed, both figuratively and literally, was the other focus of Colonial life. In early household inventories one of the few pieces of furniture mentioned was the bed. According to Julia Spruill in *Women's Life and Work in the Southern Colonies*, "the most prominent article of furniture in the colonies, as in the Mother Country, was the bed, which was found in every room except possibly the kitchen. It will be remembered that at the time, kings and queens received their courtiers in their sleeping apartments. So, the 'bedd standing in ye parlour' was the most expensive and luxurious object on display in many homes."[6] In line with this prominence, the bed was covered by one of the few items of textile decoration in the whole house. Numerous early references in household inventories are made to embroidered quilts, crewel-worked bed hangings, imported block-printed coverlets and bed rugs. The last of these, made primarily in New England, were fashioned by country women in imitation of imported bedcovers. Using simple stitching techniques, women made these thick rugs to ward off the cold night air as well as to adorn the bed with a beautiful covering. Scholars believe that the technique of making bed rugs originated in New England, and the earliest rugs contained dramatic floral patterns that may have been borrowed from foreign sources, possibly from Near Eastern carpets, lining papers of document boxes, or even English crewel-worked bed hangings.[7] By the mid-eighteenth century, two patterns of rugs seemed popular: a branching floral bush, or three or more vines vertically ascending up the rug. The rug, dated 1741, attributed

to Phoebe Billings is an interesting example of the first of these patterns. With
its vinelike border around the square, delineated by an unusual double-curved
line, which in turn encloses a central foliage and sunburst, this rug suggests a
system of balance relieved by slight variations of its components (pl. 1). It is a
forthright design and its maker boldly signed her initials to it, a practice common
to the makers of bed rugs. Justifiably proud of their creativity, these women
would occasionally even sign it with their full names. To dispel all doubt, Mary
Comstock's signature, "Mary Comstock's Rug," not only proclaims her authorship
but also figures prominently in the design of her rug (1810; fig. 3).

The range of colors employed in the making of bed rugs was limited, with
indigo blue, the most available commercial dye, used most frequently. Various
shades of this blue combined with less expensive browns and natural or undyed
yarns predominated, with other colors, which were difficult to obtain, being used
more sparingly.[8] The entire process of making these rugs was of course done
at home. When added to the tasks already mentioned that the Colonial woman
had to perform, the making of a bed rug constituted a considerable project. All
materials were home raised, spun, dyed, and woven, with the foundation of the
rug usually consisting of loosely woven wool or linen that was then covered
completely with needlework.

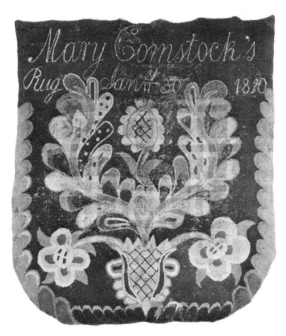

FIG. 3. Mary Comstock: Bed rug. Shelburne, Vermont. 1810. Wool foundation
with uncut pile. 87″ × 78″. Mary Comstock's name emblazoned across the upper
edge of this rug boldly and proudly proclaims her authorship. (Shelburne Museum,
Inc.)

The practice of using bed rugs began to disappear by the end of the eighteenth century. By this time more woven coverlets were being produced, and rugs had moved off the bed onto the floor. This period of transition obviously confused at least one man, a farmer named Larkin who visited the home of Lydia Huntley Sigourney around 1780. Unable to avoid stepping on the rug on the floor, he exclaimed, "I ha'nt been used to seeing kiverlids spread on the floor to walk on. We are glad to get 'em to kiver us up with at nights."[9] The farmer's surprise was understandable, as rugs in the modern sense of the term did not begin appearing in New England Colonies until after 1725 when Oriental carpets were bought by the more well-to-do families.[10] These were soon followed by carpets made on handlooms by professional weavers, first in Britain, then in the Colonies. It was popular at this time to have sand-covered floors. In her book *Floor Coverings in New England Before 1850,* Nina Fletcher Little cites two references to an artistic use of this medium by women. In the first Charles Carleton Coffin, reminiscing about the Town of Boscawen in 1800, wrote of the "floor strewn with clean white sand, gathered from the shores of Great or Long pond, and swept into curved lines, scrolls, and whorls by a broom." And Edward Jarvis, recalling the early 1800s, observed, "Now there is hardly a house without carpets on all or nearly all the rooms. Many years ago the kitchens and

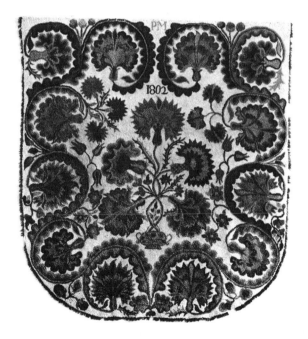

FIG. 4. Philena McCall: Bed rug. Lebanon, Connecticut. 1802. Natural wool foundation with cut pile. 101″ × 92″. Stylized foliage and naturalistic colors combine to create a design that vibrates with warmth and rhythm. (Wadsworth Atheneum)

perhaps sitting rooms were sanded over after being scoured with sand and water. The sand, when the floor was dry, was scattered all over the floor and next day was carefully swept in herringbone shape—this looking quite pretty."[11]

Before the home production of braided and hooked rugs, which reached its height of popularity in the nineteenth century, a type of floor covering quite commonly used, although unfamiliar to us now, was the painted floorcloth. Lyman Beecher, in volume 1 of *The Autobiography of Lyman Beecher,* recalls that in 1800–1801

> We had no carpets; there was not a carpet from end to end of the town . . . Your mother introduced the first carpet. Uncle Lot gave me some money, and I had an itch to spend it. Went to a vendre, and bought a bale of cotton. She spun it, and had it woven; then she laid it down, sized it, and painted it in oils, with a border all around it, and bunches of roses and other flowers over the centre. The carpet was nailed down to the garret floor, and she used to go up there and paint.[12]

Occasionally the floor itself was painted in imitation of mosaic tile, marble, and carpets, sometimes even complete with tasseled, fringed ends. Artist Ruth Henshaw Bascom, of Fitzwilliam, New Hampshire, wrote these notes in her unpublished *Journals,* in reference to this practice:

> 29 June Tuesday—fair . . . I began to paint my parlor floor in imitation of a striped carpet. 30 June Wednesday . . . I painted ¼ of my striped floor. 3 July Saturday . . . I finished painting my floor, at 6 P.M. Striped with red, green, blue, yellow and purple—carpet like.[13]

Unlike the fancy needlework done later by schoolgirls or the samplers done as learning pieces for both reading and sewing skill, bed rugs were the handwork of older women, sometimes created as long as twenty-five years after their marriage.[14] Therefore, they were not an evidence of accomplishment in the nineteenth-century terms of true womanhood, but rather a unique evidence of a creative spirit manifested in a free skilled expression of design using materials at hand. That these women found time to construct such works of art is surprising; that the rugs are so visually alive is a pleasant revelation.

In addition to creating rugs for the adornment of their beds, some Colonial women produced crewel-embroidered bedcoverings and hangings. These curtains and valances, which were hung around the bed, served three main functions: to ward off drafts, to provide some privacy, and to furnish visible and decorative evidence of a family's social and economic status. American crewelwork embroidery differed from its European counterpart in its use of lighter and fewer types of stitches and freer, more natural designs utilizing wool, silk, or cotton threads on various backgrounds. So prized were these magnificent examples of needlework that few complete sets of bed hangings have been preserved intact,

since the precious components were distributed among the descendants of the makers. A rare exception is the handsome ensemble made by Mary Bulman around 1745 in York, Maine (pl. 2).

The bed served as another focus of Colonial activity as women were constantly giving birth. Because of the uneven ratio of men to women and the urgent need for more helping hands, it was important that large families be produced. A

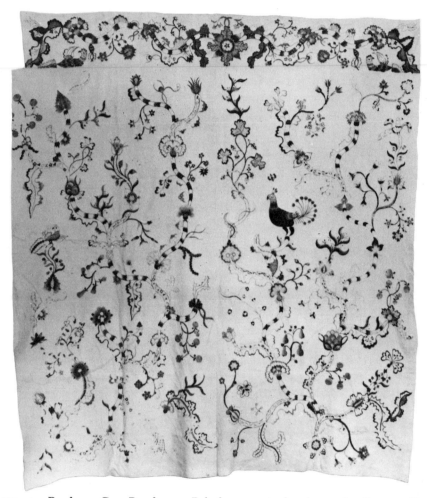

FIG. 5. Prudence Geer Punderson: Polychrome crewelwork coverlet. Preston, Connecticut. Late eighteenth century. 81″ × 55″. The maker of this wonderful piece of crewelwork was related to two other artists represented in this book: Prudence Punderson Rossiter was her daughter and Hannah Punderson, her daughter-in-law. (Connecticut Historical Society)

popular toast of the time, which was used at entertainments, summed up this New World attitude: "Our land free, Our men honest, and Our women fruitful."[15] This declaration was literally borne out, as women were in an almost perpetual state of pregnancy all their childbearing years. The shortage of women encouraged their marriage at an early age, and almost everyone married. The demand for more laborers exerted an economic pressure that drove the birthrate higher.[16] The larger the population, the faster the land would be settled and the rewards reaped. It was not uncommon for families to number from ten to fifteen children. The strain of this childbearing burden largely contributed to the short life-spans of women, but so important was it to produce children that innumerable widowers married two, three, and four times. Correspondingly, there existed a high child-mortality rate, and, although a woman might give birth to fifteen children, generally only a few youngsters lived to maturity. In a land that posed numerous hardships for adults, life was particularly hard on infants and young children. Crude methods of deliveries, religious practices such as baptizing a newborn child outdoors regardless of weather, and the proliferation of diseases exacted their tolls from the numbers born. Reverend Cotton Mather, the famous spiritual leader of the Colonial period, had fifteen children, although only two lived to survive him.[17]

As an eagerly awaited economic asset, these children were quickly initiated into the domestic household industries. In attaining economic self-sufficiency, it was crucial for the production of textiles to be conducted in the home. Even though women were confined to the chores of the hearth and burdened by never-ending pregnancies, the production of textiles was an enterprise that, however difficult, could be accomplished within the physical boundaries of

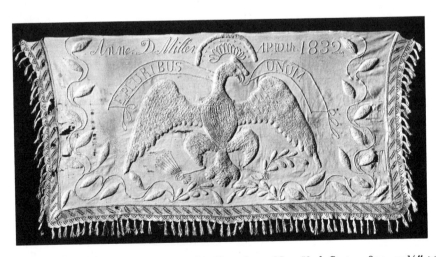

FIG. 5a. Anne D. Miller: Candlewick pillow sham. New York State. 1832. 29½″ × 61½″. Tufts of material form the design interest by the use of this popular textile technique of candlewicking. (Private collection)

the home. Here, a mother could tend to her homemaking chores and still supervise the carding, spinning, and weaving processes. Much of the work in domestic wool spinning and weaving was done by young girls, thereby providing their economic contribution to the family unit and freeing up the already overburdened work load of the mother. Compelled by both religious dictates ("idle hands are the Devil's tools") and civil law magistrates, who ordered that children tending sheep or cattle in the field should be "set to some other employment withal, such as spinning upon the rock, knitting, weaving tape, etc.,"[18] both boys and girls helped with producing linen and wool. The reliance on the economic contribution of children fostered a healthy atmosphere of interdependence within the family unit, and they were regarded with both appreciation and affection.

The making of textiles occasioned some of the sanctioned social events of a young girl's life. Flax scrutching, spinning, carding, and quilting bees all provided time for shared work and companionship. In 1734, following a favorite custom, houses were built on commons, and equipped with spinning wheels and flax for the employment of the poor.[19] In 1765 England passed the Stamp Act, which resulted in an increased determination on the part of the Colonists to spin and weave their own wool and linen.[20] Prior to the American Revolution, when high duties were being levied on imported textiles, it became politically fashionable to hold spinning matches. The earliest notice of any gathering of the "Daughters of Liberty," a Colonial patriotic organization, was at Providence in 1766 when seventeen young ladies met at the house of Deacon Ephram Bowen and spun all day long for the public benefit.[21] Committed to the growing cause for freedom, women continued to band together, holding spinning matches, and vowing to wear only garments of homespun manufacture. As a result of this patriotic interest, both the graduating classes of Harvard in 1768 and Rhode Island College in 1769 were clothed in homespun suits at their commencements.[22]

Still, home manufacture was inadequate to keep up with the demands of clothing the ever-growing population, and as early as 1643 twenty families from Yorkshire, a woolen district in England, emigrated to Massachusetts and began to manufacture cloth. Professional weavers were welcomed into the country and were numerous among the listed occupations of indentured servants. Although most indentured servants who bound themselves over to a family for weaving were men, occasionally there appeared an indentured woman "such as Anna Blickley [who] came to Germantown for fifteen years to knot and spin."[23] When the American Revolution commenced, the fledgling textile industry was under increased pressure to produce. The stories of the ill-clad soldiers at Valley Forge are well known; it was because of a lack of domestic wool that Continental troops were clothed largely in linen.

Women played a significant role in the development of the silk industry in America. After successfully developing an indigo business in South Carolina,

Eliza Pinckney began to cultivate silkworms with the same degree of success in the 1730s.[24] In Virginia, South Carolina, and Georgia several other women were involved in the silk business. Silk raised in 1770 by Susannah Wright, a Quaker of Lancaster County, Pennsylvania, was made into a dress for the Queen of England.[25] This was clear evidence of the skill and success of the Colonial woman's involvement in the textile industry.

"Knowinge of the Law of God" Sufficient to "Withstonde the Perilles of the Sowle"[26]

~~~

In the early Colonial years education was deemed a necessity for both the church and the state to prosper. Reading was required for the study of the Bible and religious tracts, while both reading and ciphering were fundamental skills needed for the transaction of trade. As early as 1636 Massachusetts passed a law that gave over one-half the annual income of the entire Colony to establish the school, which two years later became Harvard College.[27] Rhode Island was the only New England Colony that did not compel by charter or legislation the building of schools and the education of children. The first school was started in 1633 in New Amsterdam, and by 1670 or 1680 these common schools were taught frequently by women, particularly in the summer farming months when men were in the fields. A 1647 Massachusetts law required towns of fifty families to support an elementary or common schoolmaster to teach all children "as shall resort to him to read and write."[28] Even though this law and similar provisions in other Colonies seemingly provided equal education for both sexes, girls mainly attended these women's or dame schools. For a woman's formal education, only two requisites had to be met: reading ability enough to use the Bible and arithmetic sufficient to keep the household accounts. Even in New England, where more instruction in general was available for women, few dame schools enlarged their curriculum beyond the rudimentary skills. Prevailing opinion dictated this confined sphere of education, and if a woman were to venture too far into the realm of learning, it became a matter of serious concern. An account by William Bradford told of a governor of Connecticut in Colonial times whose wife was

> . . . fallen into a sad infirmity, the loss of her understanding and reason, which has been growing upon her diverse years, by occasion of her giving herself wholly to reading and writing, and had written many books. Her husband, being very loving and tender to her, was loath to grieve her; but he saw his error, when it was too late. For if she had attended her household affairs, and such things as belong to women, and not gone out of her way and calling to meddle in such things as are proper for men, whose minds are stronger, etc., she had kept her wits, and might have improved them usefully and honorably in the place God had set her. He brought her to

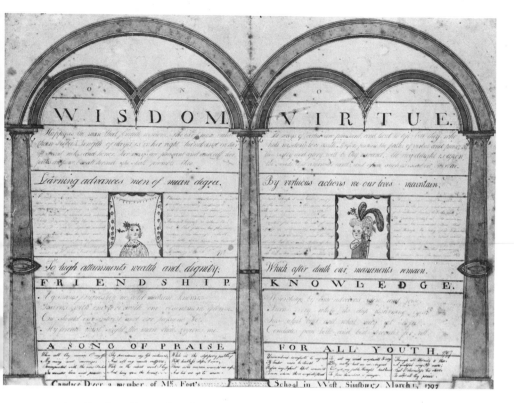

**FIG. 6.** Candace Dyer: *Wisdom-Virtue*. West Simsbury, Connecticut. 1797. Pen and ink on paper. 16¾″ × 22″. Appropriately proclaiming the maxims of learning, this work by a student of Mr. Foot's school in West Simsbury, Connecticut, is a charming expression of a young lady's accomplishment. (Collection of Mrs. Stewart E. Gregory)

Boston, and left her with her brother, one Mr. Yale, a merchant, to try what means might be had here for her. But no help could be had.[29]

Clearly, it was believed that women of the upper social class had no use for education beyond fundamentals.

In the New England Colonies, schools proliferated. Besides the court-designated schools, many men and women advertised the opening of schools in their own homes. Newspapers of the period carried countless notices of these schools, such as the one in the *Boston Gazette* of September 7, 1742, when James Hovey, A.B., ran the following:

This is to acquaint the Publick that there is a private school opened in Boston, near the Orange Tree; wherein is taught the Latin and Greek (both to young Gentlemen and Ladies), arithmetick, and divers sort of writing,

> Viz. English, German and Church texts, the Court, Roman, and Italian hands. . . . Children Sent to said School for their education, shall have the Utmost Care and Diligence used therefor, by the Master thereof, James Hovey, A.B.[30]

More common were much simpler notices offering fewer subjects, with extra costs tacked onto tuition if a student wanted to learn more than reading and ciphering.

In nearly all cases, young girls received an education that became progressively and distinctively different from that received by young boys. William Smith wrote in 1756 that the schools in New York were of the "lowest order and that women, especially, were ill educated."[31] Often girls had to be content with irregular or inconvenient school hours; if a shortage of teachers existed in a community, they had to contend with receiving no education at all.

Compounding the view of women's education at the time were contemporary writings and lectures. For example, in 1787 Dr. Benjamin Rush gave an address titled "Thoughts Upon Female Education, Accommodated to the Present State of Society, Manners and Government of the United States of America." In his lecture he suggested that teaching girls serious subjects was only utilitarian, since they would later pass on their knowledge to their sons.[32] His view was simply a reflection of the popular educational philosophy of the day, notions that were amply documented in available literature. Most seventeenth-century ladies' libraries consisted of handbooks on domestic economy, furnishing a woman with all the necessary particulars pertaining to her position as housewife. The manual most often advertised in the Colonies was E. Smith's *The Compleat Housewife*,[33] which was as popular a reference in those days as *Joy of Cooking* and *Emily Post's Book of Etiquette* are in our century. To find a model for morality and decorum, Colonial women could refer to *The Ladies Calling*,[34] the prevailing publication devoted primarily to the proper conduct of women. The few works of fiction available were themselves actually thinly disguised guides to conduct. Inevitably, the hero's or heroine's successes or failures were but models for the actions of the gentle reader. Therefore, the exceptional woman who did read well and had access to books was bound to discover that the written word available to her not only dealt primarily with the domestic sphere but also disparaged any further pursuit of education.

Those women who were daughters of the clergy or learned men were fortunate to receive additional advanced training at home. As a young man, Cotton Mather resolved to persuade his sister to spend a required amount of time daily for writing and learning about religious matters.[35] In his book *Ornaments* he gave more attention to women's religious instruction than to their intellectual training. However, in the chapter titled "Industry" he wrote of the Virtuous Maid, "that she learned housewifery and needlework . . ."[36] Despite the conflicting notions regarding women in the seventeenth and eighteenth centuries, one fact remained consistent: all writers and educators were in agreement that

no matter what other skills or knowledge a woman strove to attain, skill in needle-work was of first priority.

## "Fair Education Paints a Pleasing Thought"
~~~

The basic needle skills were learned at home and samplers were undoubtedly the first results of those lessons. Samplers comprise a fascinating body of work in themselves. They are not an indigenous art form, neither are they generally exploitative of the design possibilities of the medium, but as a body of work they provide a rewarding glimpse into the creative lives of seventeenth-, eighteenth-, and nineteenth-century American women. Essentially a piece of cloth containing examples of embroidered letters, design motifs, verses, pictures, and the maker's name, the sampler was an almost universal creative medium, occasionally the

FIG. 7. Mary Williams: *The Queen of Sheba Admiring the Wisdom of Solomon.* New England. 1744. Polychrome petit-point needlework. 22″ × 18″. In this multi-tiered depiction of a meeting of Solomon and Sheba, the characters are represented in Colonial dress and setting. (National Museum of History and Technology)

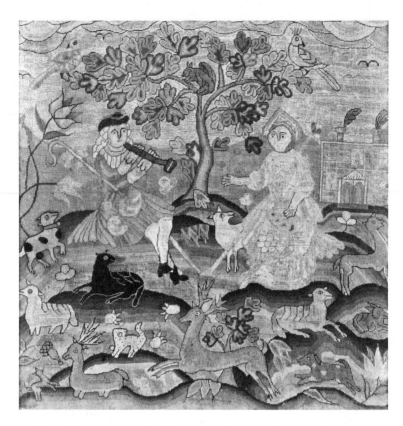

FIG. 8. Mary Fleet (attributed): Embroidered picture. Boston, Massachusetts. 1745. 23⅝″ × 22⁷⁄₁₆″. With rolling hills and prancing animals, this courtship scene suggests the rhythm of rustic life. The inspiration for this image may have come from an English engraving. (Museum of Fine Arts, Boston; Gift of Mrs. Samuel Cabot)

only form of visual expression that seventeenth- and eighteenth-century women enjoyed. The earliest samplers were made for reference use, a record of stitches to which a woman could always resort. Such a sampler can be seen in Sarah Stone's work (fig. 2) in which she set forth a display of neatly arranged stitches. By the end of the seventeenth century samplers had acquired a greater significance, serving as visible evidence of a young lady's accomplishment. The completed sampler declared the young girl's mastery of needlework and her readiness for marriage. Toni Flores Fratto, in a well-constructed essay on samplers, suggests that it was for this very reason that samplers were not fully explored as an art form by the makers. She believes that because samplers were such an integral part of the socialization process and because they were judged on their conformity, restraint, and sentimentality, the "creativity of sampler makers and the development of a powerful sampler-style were inhibited."[37] Happily, in spite of these restrictions, there were exceptional pieces executed with both consummate skill and well-thought-out designs. Mary Fleet's needle-

work is probably the least American in appearance with its suggestion of an English park setting. A shepherd and shepherdess share the canvas with sheep, stags, rabbits, birds, squirrel, tree, and double-chimneyed building. The needle-point is hardly a sampler, but it is a lively capturing of a fanciful scene (fig. 8). Patty Coggeshall's more typically American sampler of 1795 has a marvelous border of exotic flowers encircling a two-tiered scene full of courting couples, birds, and trees. In addition to her alphabet letters, she has included the ever-present religious sentiment in the verse (fig. 9):

If I Am Right, Oh Teach My Heart
Still in The Right to Stay
If I Am Wrong Thy Grace Impart
To Find The Better Way.

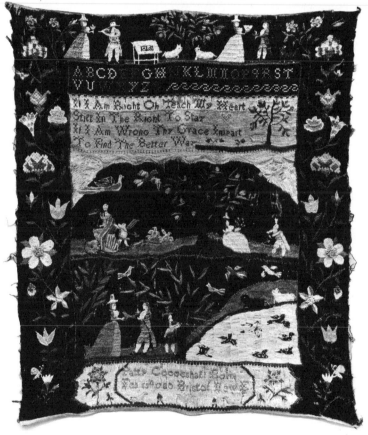

FIG. 9. Patty Coggeshall: Sampler. Bristol, Rhode Island. 1790–1795. Silk thread on linen. 19½″ × 16⅝″. In this two-tiered scene depicting the romantic moments in a courtship, the artist has given us a lush picture, full of flowers and doves, and a pastoral landscape. (The Metropolitan Museum of Art)

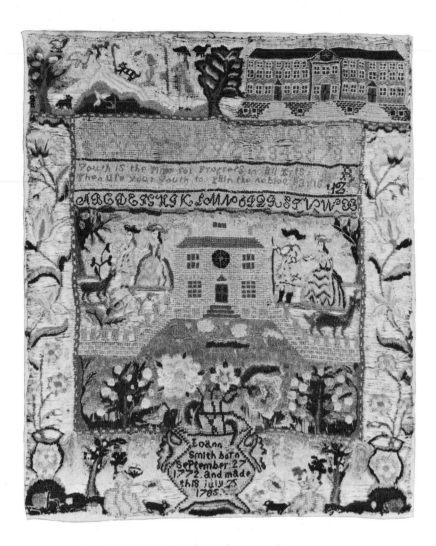

FIG. 10. LoAnn Smith: Sampler. Providence, Rhode Island. 1785. Satin stitch and cross-stitch on linen. 14½″ × 11¾″. Bordered on two sides by vines and flowers, the two architectural views are carefully and artfully incorporated into the overall design. (Museum of Art, Rhode Island School of Design; Gift of Mrs. Gustave Radeke)

LoAnn Smith's sampler contains architectural views of the University Hall at Brown University and the old State House of Providence[38] (fig. 10). Nabby Martin displays a variation on these views in her sampler of 1786, done at Miss Polly Balch's school in Providence (pl. 3). Miss Balch's students prided themselves on their embroidery abilities and the delicately embroidered samplers

of LoAnn Smith, Nabby Martin, and Sally Munro (fig. 11) are glowing proof of their talents. One can only speculate what these women could have achieved had they had adequate professional training. Nonetheless, the quantity and quality of the samplers produced testify to the abilities of women to attempt and successfully resolve design problems. These small squared or rectangular pieces of material were tiny formats for ingenious arrangements of patterns. Emblazoned with a requisite religious sentiment, these miniature works of art successfully blended figures, words, and colors into a harmonious whole.

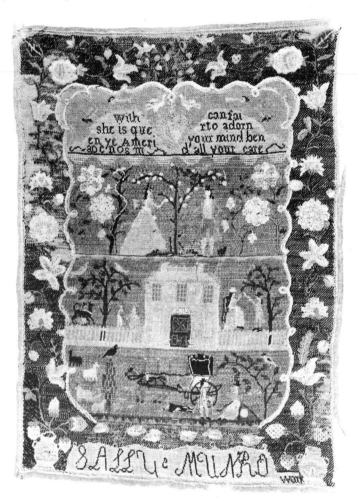

FIG. 11. Sally Munro: Sampler. Providence, Rhode Island. 1790. Queen stitch, satin stitch, and cross-stitch on linen. 17″ × 12″. From Miss Polly Balch's School comes this simplistic yet charming example of needlework incorporating architectural detail. (Newport Historical Society)

Although numerous verses gained popularity for inclusion in samplers, here are three that seem to sum up the social conditions under which samplers were created:

> Plain as this canvas was, as plain we find,
> Unlettered, unadorned the female mind,
> No fine ideas fill the vacant soul,
> No graceful coloring animates the whole.

> With the close attention carefully inwrought,
> Fair education paints a pleasing thought,
> Inserts the curious line on proper ground,
> Completes the whole, and scatters flowers around.

> My heart exults, while to the attentive eyes,
> The curious needle spreads the enamell'd dyes,
> While varying shades the pleasing tasks beguile,
> My friends approve me, and my parents smile.[39]

And in the following verses:

> Behold when I try,
> My needle can vie
> With my pen and pencil to prove.
> My very fond wish,
> Is centered in this;
> To gain my dear parents your love.[40]

> Whence did the wonderous mystic art arise
> Of painting speech and speaking to the eyes
> That we by tracing magic lines are taught
> How both to colour and embody thought.[41]

A few samplers contained rather morbid appeals for remembering the sampler artist after she was gone. Much like the albums that were kept later and the birthday and autograph books of our century, these samplers provided a slate for touching verses. A typical sentiment follows:

> This work in hand my friends may have
> When I am dead and in my grave.

> And which whene'er you chance to see
> May kind remembrance picture me
> While on this glowing laurels stands
> The laborer of my youthful hands.[42]

To receive the necessary training for the complex forms of needlework stitches, young girls were enrolled in special classes. While numerous schools were springing up for the continued education of young boys, special lessons in needlework were offered for girls. *Arts and Crafts in New England* contains many advertisements reprinted from Colonial newspapers, such as these two:

> Young ladies may be taught plain Work, Dresden, Pint (or Lace) work for Child Bed Linnen, Cross-stitch, Tentstitch, and all other kinds of Needle Work.
>
> by Bridget Suckling
> *Boston Gazette*, July 2, 1751[43]

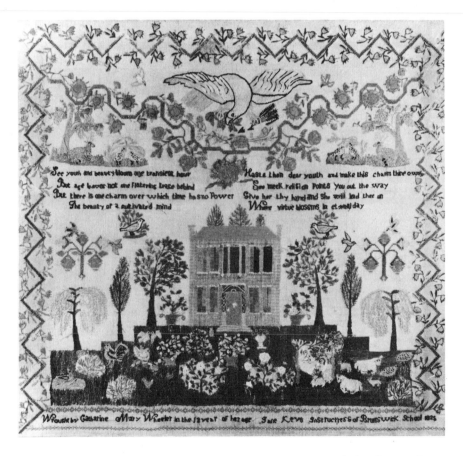

FIG. 12. Catherine Wheeler: Sampler. New England. 1825. Embroidery on linen. 22½" × 26". A large eagle keeps watch over a pastoral potpourri of lambs, children, deer, hens, and flowers, all arranged on a tiered landscape. (Abby Aldrich Rockefeller Folk Art Center)

Taught by Eleanor M. Gevaine, opposite Governor's, Dresden painting on Glass, Shell Work, Tent Stitch, and other works proper for young Ladies.

Boston Evening Post, March 27, 1758[44]

Even Peter Pelham, a well-known engraver and artist of the day (stepfather to John Singleton Copley and husband of Mary, a tobacco shop operator),[45] taught painting on glass and needlework.[46]

The making of samplers was a universally accepted activity for young girls, whether they served merely as examples of newly mastered stitches or as badges of readiness for womanhood. The activity was not confined to one social class, as a portrait of Mrs. Ruth Stanley Mix proves (fig. 13). Here a woman of evidently enough means to have her portrait painted chose to be depicted with her needlework in hand. It is well known that Martha Washington was a skilled seamstress (fig. 14), and a sampler by Abigail Adams is still in existence today. With all the training available and the public and private endorsement of this activity, it is unfortunate that most women executed only one sampler and did not pursue more actively the creative potential in this medium. The skills attained were not lost, however, for in the next centuries women with their well-founded

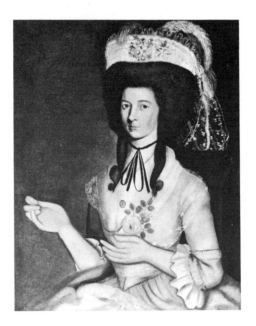

FIG. 13. Unidentified artist: *Mrs. Ruth Stanley Mix.* New England. 1788. Oil on canvas. 32″ × 25½″. This portrait captures a fashionable image of the Colonial woman, with needle appropriately in hand. Women who could afford to have their portraits painted were proud of their needlework accomplishments. (Abby Aldrich Rockefeller Folk Art Center)

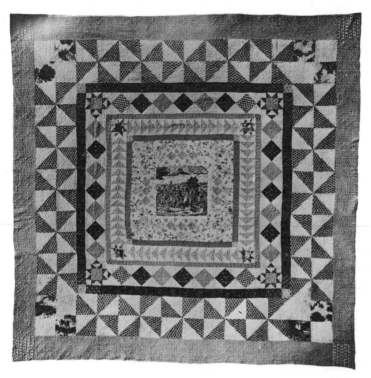

FIG. 14. Martha Washington: Pinwheel patchwork quilt. Mount Vernon, Virginia. 1785. Linen and toiles. 100¾" × 100". Martha Washington, Abigail Adams, and other famous Colonial women shared in the eighteenth-century woman's involvement with needlework. (Mount Vernon Ladies' Association of the Union)

needlework heritage progressed to participation in all areas of textile manufacture and design.

Although needlework was overwhelmingly the creative medium of the Colonial woman, there are exceptions well worth mentioning, especially that of Sarah Perkins, one of the earliest painters among women in America. Her portraits, all of which are of her family and close friends, were executed in the 1790s. A short account of her life provides a fascinating glimpse into the life of a woman artist of that period and helps explain why so few women were able to create in other than the needlework medium. In 1795, when Sarah Perkins was twenty-four, her mother died of consumption, leaving seven children younger than Sarah. Four years later her father died, leaving her the sole support of that large family. In 1801 she added more responsibilities when she married General Lemuel Grosvenor, a widower with five children. Together they proceeded to

have four more children of their own. Without a doubt, Sarah's youthful art days were severely curtailed by the burdens of such a large family.

From the degree of competence displayed, it is thought that Sarah may have had some instruction, but she also imprinted the portraits with her own unmistakable touch and they have a genuine folk quality to them—formal but with an inner vitality (figs. 15 and 16). Sarah's father was a proprietor of the nearby Plainfield Academy in Connecticut, and very likely Sarah attended that school. In her portrait of Mrs. Caleb Perkins, there is meticulous detail in the lace edging of her cap. Obviously, Sarah Perkins maintained an attention to needlework that was entirely in keeping for an eighteenth-century woman.[47] Another exception to the traditional textile medium is Sibyl Huntington May's painting on wood used for either a fireboard or an overmantel (pl. 4), painted in Haddam, Connecticut, where she lived with her husband, the Reverend May, and their

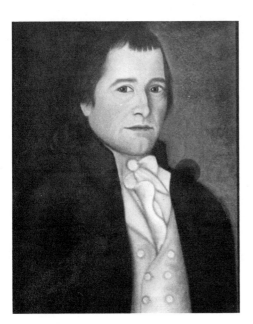 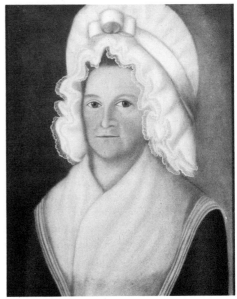

FIG. 15. (*Above, left*) Sarah Perkins: *Dr. Caleb Perkins.* Plainfield, Connecticut. 1790–1799. Pastel on paper mounted on canvas. 19¾" × 15¼". In this portrait of her uncle, Sarah Perkins demonstrated talent and skill in depicting the three-dimensional form of the sitter. It has been suggested that the young artist might have received some art training from Joseph Seward who worked in nearby Hampton. (Connecticut Historical Society)

FIG. 16. (*Above, right*) Sarah Perkins: *Mrs. Caleb Perkins.* Plainfield, Connecticut. 1790–1799. Pastel on paper mounted on canvas. 19¾" × 15¼". When she captured this likeness of her aunt, Sarah Trumbull Perkins, the close attention the artist gave to the lace edging of the cap was entirely in keeping with an eighteenth-century woman's interests. (Connecticut Historical Society)

ten children. Reverend May, a Yale graduate, courted Sibyl after he was said to have "seen her paintings and vowed he would marry the artist."[48] Family tradition indicates that Sibyl probably taught the rudiments of painting to the young artist John Trumbull. Since they were from neighboring towns, this suggested relationship might warrant further research. It is interesting to note that Sibyl painted an object that decorated the hearth, the woman's clear domain in the house.

It is not surprising that, other than extraordinary needleworkers, few women folk artists of this period are known. At this point in history the American Colonies still looked to Europe, and in particular to England, for their cultural goods. Contemporary male artists of the period, in order to pursue both adequate instruction and patronage, traveled to England. Witness both Benjamin West, who went to England in 1763, and John Singleton Copley, who followed in 1774. This was a voyage that few male artists and almost certainly no women could afford. The predominantly middle-class structure of American society could rarely support a professional artist, and most fine artists were tradesmen or craftsmen as well. Even successful artists augmented their income by commercial work: Peter Pelham was an engraver and a teacher, Paul Revere was both silversmith and engraver, and Benjamin West was a carriage painter at one point in his career. In rural areas, it was common practice for artists to supplement their income by painting signs and carriages or by offering instruction in painting.

The few trained professional women artists during the Colonial years were generally born into wealthier families or into supportive artists' families. Ellen and Rolinda Sharples were members of an active English painting family that came to America.[49] Ellen, wife of the artist James Sharples, was an accomplished miniaturist in her own right. Her daugher Rolinda, encouraged by her parents, sought better fortunes back in England and later won honorary membership there in the Society of British Artists.[50] Other examples of professional women artists have been mentioned in newspapers, including a Mary Roberts who advertised in 1734 that "she had several paintings to dispose of and offered to do face painting."[51] In 1772 another woman announced that, as the niece of Her Majesty's Portrait Painter, she would follow "the Act of Painting Portraits in Crayons" in Charleston, South Carolina.[52]

Henrietta Johnston was America's first professional artist. Seldom signing her name, this artist of pastel portraits worked almost exclusively in the Charleston, South Carolina, area. Married to the minister Gideon Johnston, she undertook portraiture to alleviate their financial problems. Later, when her husband died by drowning in 1716, she was able to support herself through the sale of her work.[53] She died in 1728 or 1729, according to a notice of her funeral in old Saint Philip's Church Register.[54]

Probably one of the most unusual professional women artists was Patience Lovell Wright, a Quaker from Bordentown, New Jersey. Along with her sister, Rachel Lovell Wells, and her own daughter, Elizabeth, she pioneered portrait sculptures in America through the use of wax modeling. The period of her

greatest productivity was during the years 1750 to 1780.[55] Although she began to experiment in wax modeling in her early married years, it was not until her husband died and she moved to New York City that she began to pursue her talent seriously. In New York she established a waxworks and successfully earned both her living and a reputation for a distinctive talent in capturing likenesses. After a disastrous fire on June 10, 1771, Patience Wright left for England where she was equally successful.[56] She must have been a remarkable woman, for during the Revolution she served Benjamin Franklin as a spy in London.[57] Her position as a self-supporting female artist in the late eighteenth century was certainly an exception, and apparently her success was regarded with tolerance and amusement.

Undoubtedly, even these exceptional women artists were well versed in the needle arts. The women who advertised drawing instruction invariably also offered instruction in needlework forms. In the *Boston Evening Post* of April 18, 1748, there appeared the following ad, which demonstrates the versatility of Colonial women: "Drawing, japanning, and Painting on Glass, taught by Mrs. Sarah Morehead, at the Head of the Rope-Walks, near Fort Hill."[58] In 1739 the *South Carolina Gazette* carried a notice that Jane Voyer offered to teach "any young Ladies that have a mind to learn Embroidery, Lace-Work, Tapistry, or any other Needlework, Drawing and French."[59]

"Remember Me Is All I Ask"

~ ~ ~

The women of the early Colonial years enjoyed an atmosphere of surprising legal freedom. Women were granted property allotments, won legal cases in their own names, and even won inheritance rights.[60] When the initial burst of colonization subsided, more laws were put into effect, or old laws were reinterpreted that disclaimed women's rights in legal matters. By the time of the writing of the Declaration of Independence, it was necessary for Abigail Adams to admonish her husband John, "and by the way, in the new Code of Laws which I suppose it will be necessary for you to make, I desire that you would Remember the Ladies, and be more generous and favourable to them than your ancestors."[61] By the nineteenth century the advent of the "cult of true womanhood" had firmly established the ideal of the accomplished lady confined to her domestic sphere. The very conditions that had nurtured the spirit of freedom and prosperity for all had ironically constricted women's domain of accomplishment.

The Colonial period fostered an aura of equality in professions as any skilled person, male or female, was eagerly welcomed. Business opportunities were so numerous that women could engage in commercial ventures without any prejudice or restriction. As evidence of their participation, in the list of Salem merchants who protested against the Stamp Act were the names of five women.[62] At this time the most prevalent business occupations for women were as midwives, schoolteachers, and tavern keepers. A common sight in Elizabethan

England, taverns or "ordinaries" were set up in America nearly as quickly as it was settled. Running a tavern was a respectable manner of earning a living and also a convenient one, especially if it meant simply turning over part of the home to this purpose. For many widowed women with children, the keeping of a tavern meant economic independence. The earliest known account of a woman in this occupation exists in the Records of the Quarterly Courts of Essex County, Massachusetts, for 1647, where a petition was filed by a Salem widow, Mrs. Clark, to keep an ordinary "with liberty to draw wine, for which privileges she was to pay a fee of ten pounds annually."[63] For the next hundred years, it was common for a woman to keep a tavern or inn.

The practice of midwifery was almost totally woman's domain for the first century of this country's history. In fact, women were avocational doctors, druggists, and nurses until late in the eighteenth century. Around 1750 men began to attend births, and in 1756 Dr. William Shippen, Jr., opened a maternity ward and lectured on midwifery in Philadelphia.[64] Women began to advertise that they had been approved by a doctor or had taken a midwifery course. As the study of obstetrics advanced and as women were excluded from medical schools, men gradually took over the role under the wing of the medical profession. Before being displaced, women midwives had presided at thousands of births, and records tell of several who had officiated at two or three thousand births each.[65] It was not until 1848 that a woman would officially enter the medical profession with the admittance of Elizabeth Blackwell to the Geneva Medical School in New York.

Even though there were few professions that included many women, still women were represented in almost all the occupations entered by men. Women practiced nearly all the crafts and trades in the eighteenth century and, although it was unusual for women to initiate a new business, it was a common practice for widows to assume their husband's businesses.

A number of women worked alone or in their husband's shops as printers. As early as 1696 Dinah Nuthead received a license to set up her press.[66] In 1735 a sister-in-law of Benjamin Franklin took over her husband's printing business upon his death.[67] In 1761 the wife of John Haugan advertised that "she stamps linen china blue or deep blue or any other colour that gentlemen and Ladies fancied."[68] Since it was thought to be a risk for a woman without any prior experience to carry on a business after her husband's death, we can assume that these women had already shared to some extent in the family craft or trade. Baking, tailoring, silk dyeing, fabric printing, and the craft of printing itself were businesses that were often taken over by widows. In Colonial Women of Affairs Elisabeth Anthony Dexter mentions a few more irregular occupations held by women: "Hannah Breintnall, who kept shop at 'the Sign of the Spectacles' in Second Street, near Black-Horse Alley."[69] A Mrs. Jackson, of Boston, "who makes and sells Tea-Kettles and Coffee-Pots, Brass and Copper Sauce Pans, Stew-Pans, Baking-Pans, Kettle-Pots, and Fish-Kettles."[70] Mary Salmon, also of Boston, "who continues to carry on the business of horse-shoeing, as heretofore, where

all gentlemen may have their Horses shoed in the best Manner, as also all sorts of Blacksmith's Work done with Fidelity and Dispatch."[71] And Robert Trent, in his book *Hearts and Crowns,* shatters the image of the masculine carpenter when he cites an Anna Crittenden Parmele who "bequeathed all my Tools for Chairmaking" to her son in 1790.[72]

As was mentioned previously, a working woman of the 1700s was considered on her own merits. After 1800 however, the woman in business began to be regarded more critically because of three factors: the rising middle-class attitude toward the ideals of genteel femininity; the equalizing of the male-to-female ratio in the population in general, which made competition for business stiffer; and the advent of the industrialized age, which moved home industries into factories. The role of women in professions changed dramatically; no longer was the home a self-sufficient economic unit. As mills and factories were established that offered greater rewards for the laborer and cheaper goods for the consumer, it no longer was necessary to produce some items at home. As the new incentives for income and spending progressed, woman and her hearth began to be regarded as the ideal vehicles for the display of wealth. It became fashionable to have a factory-produced carpet rather than a sand-strewn or painted floor, manu-factured textiles rather than homespun and woven ones, and so on. Both house and woman were adorned with the accouterments of position and prosperity attained by socially rising merchants, farmers, and craftsmen. The American dream of affluence for all, so fervently hoped for by the early settlers, was on its way to becoming a reality.

Women continued to be involved in business and "women merchants and craftsmen were as prevalent as ever, but they were more apt to confine themselves to the making and selling of dry goods and clothing, lines in which they dealt chiefly with women."[73] Another area in which women maintained a hold was in the production of textiles. Professional male weavers had begun early to travel around the country, weaving the wool already spun by women, thereby taking one of the production steps away from women. When the intricate jacquard loom was developed, only one woman is known to have mastered it, Sarah Latourette of Indiana, who worked in her father's shop[74] (fig. 17). When the great textile mills opened, countless women and young girls entered the fac-tories. Already familiar with the materials and the basic techniques, they made a natural progression from hearth to mill. "So-called art industries, where rapid mass production by machine called for cheap skilled hand-labor designers, pat-tern-makers, china-painters, rug and textile designers and 'hand finishers,' " made women's artistic skills in demand.[75] Unfortunately for women, their principal occupation in the textile factories was as laborers while men dominated the supervisory and ownership positions. To this day, women have largely filled the various lower occupations in textile businesses.

In the few instances in which the craft was not taken out of the home or

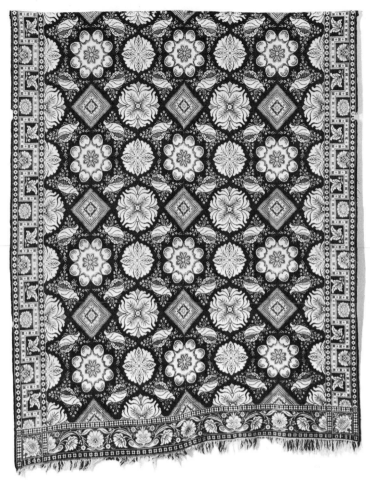

FIG. 17. Sarah Latourette: Jacquard coverlet. Rush County, Indiana. 1846. Woven cotton and wool. 78″ × 79″. This handsome example of jacquard weaving was made by the only woman known to be skilled in that intricate weaving technique. (Indianapolis Museum of Art)

nearby shop, women continued to participate. Particularly in family businesses such as the production of pottery or tinware, women played an artisan role. In her book *American Country Tinware, 1700–1900* Margaret Coffin cites several direct references to women decorating tinware, notably the Butler sisters, Minerva, Ann, and Marilla, in addition to Mercy North and Sarah Upson. Minerva's album, containing drawings of tinware designs, is owned by the New York State Historical Association in Cooperstown. In it she wrote, "Remember me is all I ask, And if that be a task, Forget me." Mrs. Coffin ventures to suggest that there "were probably women painters in every tin family."[76] In a letter (fig. 18) from Oliver Filley written to Harvey Filley in April 1824, several

FIG. 18. Letter from Oliver Filley to Harvey Filley, April 22, 1824. In this letter concerning decorators, from tinsmith Oliver Filley to Harvey Filley, several women are mentioned. One of them is expected to "learn to paint handy and would like to paint the greatest part of the time." Photograph courtesy Connecticut Historical Society.

references are made to women decorators. He mentions, "I then came across a Mrs. Bennett who it is said is a good painter and has been to Baltimore two or three seasons." He also states in reference to another woman that she "cannot get any Boy for you, she, I expect, would learn to paint handy and would want to paint the greatest part of the time. There has been a great call for painters in these quarters and they are very scarce."[77]

Similarly, in the production of stoneware pottery, it is thought that women were instrumental as slipware decorators. In *Decorated Stoneware Pottery of North America* Donald Blake Webster suggests that "there is reason to believe that a good percentage of productive decorators were artistically inclined women —working perhaps on a part-time and piecework basis."[78] Although he warns against premature generalization, he has traced down individual decorators at five different New York State potteries and found them all to be women. At least one woman was known to have run her own pottery. Anna Margretta Dipple of Lewistown, Pennsylvania, took charge of the family pottery upon

FIG. 19. Anna Margretta Dipple: Stoneware crock. Lewistown, Pennsylvania. 1885–1897. 16¾″ × 14″. This signed stoneware crock provides us with visual proof that an enterprising, capable woman could successfully run a pottery business. Photograph courtesy Union County, Pennsylvania, Bicentennial Commission.

the death of her husband, was taxed as "a potter," and signed stoneware with her own mark[79] (fig. 19).

In summarizing the role of women in the artistic production of the seventeenth and eighteenth centuries in America, it becomes evident that women by and large contributed to a wealth of needlework production, sometimes achieving masterworks of creativity. Given the restrictions of little or no training and using only materials at hand, women were still able to express themselves artistically. The sampler remains as the dominating mode of that expression, yet within that single medium countless variations were executed and originality persisted. However, one piece of needlework does rise above the rest and seems not only single-handedly to exemplify the richness of the medium, but also to capture the integral nature of creative sewing in the life of Colonial women. In Preston, Connecticut,

FIG. 20. Prudence Punderson Rossiter: *St. James the Disciple*. Preston, Connecticut. c. 1776. Needlework, silk thread on satin. 8″ × 7″. This unusual embroidered picture is from a set of the twelve disciples stitched by this remarkable artist. (Connecticut Historical Society)

FIG. 21. Prudence Punderson Rossiter: "First, Second and Last Scene of Mortality." Preston, Connecticut. 1783. Crimped silk floss with ink on satin. 12⅝″ × 16¹¹⁄₁₆″. A timeless masterpiece of needlework, this embroidered scene provides a perfect picture of the eighteenth-century woman: at home, flanked by symbols of her mortality and her tools for embroidery. (Connecticut Historical Society)

Prudence Punderson Rossiter wrought her "First, Second and Last Scene of Mortality" sometime before 1783, the year she married Dr. Timothy Wells Rossiter. Here is the complete and perfect picture of the eighteenth-century woman. On the right a servant woman is rocking a cradle—the first tentative scene of mortality. At center stage a young woman with an apron covering her gown is appropriately working on her embroidery. On the left is a drop-leaf table supporting a coffin with the initials *PP* on top—the inevitable final scene in Prudence's life. Worked in silk embroidery on satin, this masterful work is a shining tribute to the creativity of Colonial women (fig. 21).

NOTES

1. Ethel Stanwood Bolton and Eva Johnston Coe, *American Samplers* (New York: Dover Publications, 1973), p. 273.

2. *Ibid.*, pp. iv, 5.

3. Roger Thompson, *Women in Stuart England and America* (London and Boston: Routledge and Kegan Paul, 1974), pp. 29–31.

4. Alice Morse Earle, *Colonial Dames and Good Wives* (Boston and New York: Houghton Mifflin and Company, 1895), pp. 2–3.

5. *Ibid.*

6. Julia Cherry Spruill, *Women's Life and Work in the Southern Colonies* (Chapel Hill, N.C.: The University of North Carolina Press, 1938), pp. 23–24.

7. William Lamson Warren, *Bed Ruggs: 1722–1833*, exhibition catalogue (Hartford, Conn.: Wadsworth Atheneum, 1972), pp. 16–19.

8. *Ibid.*

9. *Ibid.*, p. 12.

10. Nina Fletcher Little, *Floor Coverings in New England Before 1850* (Sturbridge, Mass.: Old Sturbridge Village, 1967), p. 3.

11. *Ibid.*, p. 5.

12. Barbara M. Cross, ed., *The Autobiography of Lyman Beecher*, vol. 1 (Cambridge, Mass.: Harvard University Press, 1961).

13. Mrs. Ruth Henshaw Bascom, unpublished *Journals* in the collection of the American Antiquarian Society, cited in Nina Fletcher Little, *Floor Coverings in New England*, p. 28.

14. Homer Eaton Keyes, "A Note on Certain Early Coverlets," The Magazine *Antiques*, 12, no. 5 (November 1927), p. 390.

15. Spruill, *Women in Southern Colonies*, p. 45.

16. Carl Holliday, *Woman's Life in Colonial Days* (Boston: The Cornhill Publishing Company, 1922), p. 114.

17. Alice Morse Earle, *Child Life in Colonial Days* (New York: The Macmillan Company, 1943), p. 12.

18. *Ibid.*, p. 305.

19. Frances Little, *Early American Textiles* (New York and London: The Century Company, 1931), p. 76.

20. *Ibid.*, p. 75.

21. Earle, *Colonial Dames and Good Wives*, p. 241.

22. *Ibid.*

23. Little, *Early American Textiles*, p. 69.

24. Spruill, *Women in Southern Colonies*, p. 310.

25. Little, *Early American Textiles*, p. 148.

26. Spruill, *Women in Southern Colonies*, p. 208.

27. Earle, *Child Life in Colonial Days*, p. 64.

28. Elisabeth Anthony Dexter, *Colonial Women of Affairs* (Boston and New York: Houghton Mifflin Company, 1924), p. 68.

29. James Kendall Hosmer, ed., *Winthrop's Journal: "History of New England,"* 1630–1649, New York, 1908, II, 225, quoted in Aileen S. Kraditor, *Up From the Pedestal* (Chicago: Quadrangle Books, 1968), p. 30.

30. George Francis Dow, *The Arts and Crafts in New England, 1704–1775* (New York: Da Capo Press, 1967), p. 279.

31. Earle, *Child Life in Colonial Days*, p. 94.

32. Linda Grant DePauw and Conover Hunt, *"Remember the Ladies": Women in America, 1750–1815*, exhibition catalogue (New York: The Viking Press, 1976), p. 97.

33. Spruill, *Women in Southern Colonies*, p. 213.

34. *Ibid.*

35. Mary Sumner Benson, *Women in Eighteenth Century America* (New York: Columbia University Press, 1935), p. 111.

36. *Ibid.*

37. Toni Flores Fratto, "Samplers: One of the Lesser American Arts," *The Feminist Art Journal*, 5, no. 4 (Winter 1973), p. 12.

38. Bolton, *American Samplers*, p. 75.

39. *Ibid.*, p. 269.

40. *Ibid.*, p. 273.

41. *Ibid.*, p. 274.

42. *Ibid.*, p. 272.

43. Dow, *Arts and Crafts*, p. 274.

44. *Ibid.*, p. 275.

45. Dexter, *Colonial Women*, p. 20.

46. Dow, *Arts and Crafts*, p. xviii.

47. William Lamson Warren, "Connecticut Pastels, 1775–1820," *Connecticut Historical Society Bulletin*, 24, no. 4 (Hartford, Conn.: The Connecticut Historical Society), pp. 101–107.

48. Inventory of American Painting, National Collection of Fine Arts, Washington, D.C.

Everett E. Lewis, *Historical Sketch of the First Congregational Church of Haddam, Connecticut* (Haddam, Conn.: The First Congregational Church, 1879).

Two Hundredth Anniversary of the First Congregational Church of Haddam, Connecticut (Haddam, Conn.: The First Congregational Church, 1902).

49. Karen Petersen and J. J. Wilson, *Women Artists: Recognition and Reappraisal* (New York: Harper Colophon Books, 1976), p. 65.

50. *Ibid.*, p. 66.

51. Spruill, *Women in Southern Colonies*, p. 259.

52. *Ibid.*, p. 66.

53. William H. Gerdts, *Women Artists of America, 1707–1964*, exhibition catalogue (Newark, N.J.: The Newark Museum, 1965), p. 8.

54. Peterson and Wilson, *Women Artists*, p. 65.

55. Marion Nicholl Rawson, *Candleday Art* (New York: E. P. Dutton & Co., Inc., 1938), p. 75.

56. Dow, *Arts and Crafts*, pp. 289–290.

57. Gerdts, *Women Artists of America*, p. 8.

58. Dow, *Arts and Crafts*, p. 267.

59. Spruill, *Women in Southern Colonies*, p. 197.

60. Thompson, *Women in Stuart England*, pp. 167–169.

61. Letter, Abigail Adams to John Adams, March 31, 1776. Massachusetts Historical Society, Boston.

62. Dexter, *Colonial Women*, p. 37.

63. *Ibid.*, p. 3.

64. *Ibid.*, p. 167.

65. Little, *Early American Textiles*, p. 190.

66. Dexter, *Colonial Women*, p. 66.

67. *Ibid.*, p. 61.

68. Elisabeth Anthony Dexter, *Career Women of America, 1776–1840* (Boston: Houghton Mifflin Company, 1950), p. 40.

69. Dexter, *Colonial Women*, p. 28.

70. *Ibid.*, p. 54.

71. *Ibid.*, p. 53.

72. Robert F. Trent, *Hearts and Crowns* (New Haven, Conn.: New Haven Colony Historical Society, 1977), p. 59.

73. Dexter, *Career Women*, p. 225.

74. Peggy S. Gilfoy, *Indiana Coverlets*, exhibition catalogue (Indianapolis, Ind.: Indianapolis Museum of Art, 1976), p. 23.

75. Albert Ten Eyck Gardner, "A Century of Women," *Metropolitan Museum of Art Bulletin*, 7, no. 4 (December 1948), p. 111.

76. Margaret Coffin, *American Country Tinware, 1700–1900* (Camden, N.J.: Thomas Nelson and Sons, 1968), p. 81.

77. Letter, Oliver Filley to Harvey Filley, April 22, 1824. Connecticut Historical Society, Filley Correspondence.

78. Donald Blake Webster, *Decorated Stoneware Pottery of North America* (Rutland, Vt.: Charles E. Tuttle, 1970), p. 53.

79. Jeanette Lasansky, *Made of Mud: Stoneware Potteries in Central Pennsylvania, 1834–1929* (Lewisburg, Pa.: Union County Bicentennial Commission, 1977), pp. 15–16.

Beyond Expectations

Not her hand can build the city;
Not her voice should rule the State;
She must reign by love and pity—
Through her goodness make men great![1]

The character of the art created by American women during the nineteenth century was largely determined by the prevailing attitudes *about* women. These attitudes were shaped by ideas defining the nature and place of women in society, which stemmed from seventeenth- and eighteenth-century writings, many of which originated in England. The development of an American leisure class during the eighteenth century had resulted in greater attention being given to women in order to discover their innate differences from men and to determine their proper roles in life. By the end of the century spreading industrialization was removing economic activity from the home to factory and office, leaving upper- and middle-class women with even greater leisure. Ideas regarding woman's place were naturally of more concern to the emerging polite society than to those still engaged in pushing back the frontiers of the wilderness, where everyone's help, regardless of sex, was required. At the outposts of civilization, women continued to play a critical part in the struggle for survival, just as they had done in the early years of colonization. Their vital contribution to the maintenance of life made consideration of their "role" seem irrelevant. Eventually, however, through the expansion of American printing and progress in transportation, both imported and domestic ideas about women reached to some extent into every social level and every remote settlement. This widespread dissemination of views concerning women's character and conduct played a major part in curbing or deflecting the creative impulses of American women during the nineteenth century.

Through newspaper articles, cartoons, pamphlets, sermons, etiquette books, moral guides, domestic manuals, novels, and ladies' magazines, women were continually advised, usually although not always by men, of their physical, mental, and emotional limitations in addition to being assured of their moral and cultural assets. More than in the eighteenth century writers of the nineteenth century prescribed the "domestic sphere" as the proper place for women. Much of the rhetoric was a reaction against the feminist writings of such women as Mary Wollstonecraft, whose *Vindication of the Rights of Women* had appeared

in England in 1792. As other voices were raised to protest the legal and social barriers facing women in both England and America, the defense of such restrictions became increasingly insistent and inflexible. Writers and orators devoted long passages to describing the ideal woman, defining her natural realm and denouncing the few women who rebelled. The essential qualities of the ideal woman required by the "cult of true womanhood" have been identified by Barbara Welter as piety, purity, submissiveness, and domesticity.[2] Women were pronounced to be more naturally pious than men. The secularization of society in eighteenth-century America had turned men's minds away from the claims of the church and more toward the affairs of the world. Woman's supposed natural propensity toward religion was viewed as a special gift from God, bestowed on her that she might reclaim the wayward world through her shining spirituality and happily relieve most men from such grave responsibility. Her pious nature would also aid woman in coping with any discontentment in her ordained lot in life. Moreover, she could engage in religious activities (although not church leadership) without neglecting her domestic duties. Women without religious inclinations were viewed as monstrous, with one male writer declaring that "female irreligion is the most revolting feature in human character."[3]

Just as women were by nature more pious than men, so also they were more pure, raised "above those sordid and sensual considerations which hold such sway over men."[4] The penalties for slipping from a state of purity were public shame, madness, and death, according to the self-appointed mentors of maidenhood. In spite of their alleged superiority in dealing with the sensual self, young women were constantly warned against those compromising situations that might ultimately lead to a sordid end.

The positive moral attributes of piety and purity ascribed to women were meant to compensate somewhat for their inferior physical and mental capacities. A popular early guide for women had declared that "Men, who were to be the Lawgivers, had the larger share of Reason bestow'd upon them . . . Your Sex wanteth our Reason for your Conduct, and our Strength for your Protection; Ours wanteth your Gentleness to soften, and to entertain us."[5] Male physicians usually agreed that "the intellectual powers of the female are, as a general rule, less than those of the male,"[6] since it was obvious that the space within her cranium "destined to be filled with the brain is smaller."[7] In his lecture to a graduating class of medical students, one physician generously observed that "woman has a head almost too small for intellect but just big enough for love."[8]

Woman's acceptance of her physical and mental deficiencies prepared her for her submissive role and domestic realm. Time and again the American woman was reminded of her subordinate status and proper place—the home. "That *Home* is her appropriate and appointed sphere of action there cannot be a shadow of doubt; for the dictates of nature are plain and imperative on this subject, and the injunctions given in Scripture no less explicit . . . Whenever she . . . goes out of this sphere to mingle in any of the great public movements of the day, she is deserting the station which God and nature have assigned

to her," asserted one writer in dealing with the question of woman's place in society.[9] Another pointed out that man, with his greater physical strength, courage, and boldness, might venture "into the turmoil and bustle of an active, selfish world" but "her inferior strength and sedentary habits confine her within the domestic circle; she is kept aloof from the bustle and storm of active life . . . Timidity and modesty are her attributes."[10]

Within her restricted realm woman was to reign as queen, although always ready to defer to her husband's will. In his early nineteenth-century domestic guidebook, Samuel Jennings devotes a chapter to the "Proper Conduct of the Wife Toward Her Husband," wherein he offers the following advice:

> It is your interest to adapt yourself to your husband, whatever may be his peculiarities. Again, nature has made man the stronger, the consent of mankind has given him superiority over his wife, his inclination is, to claim his natural and acquired rights. He of course expects from you a degree of condescension, and he feels himself the more confident of the propriety of his claim, when he is informed, that St. Paul adds his authority to its support. "Wives, submit yourselves unto your own husbands, as unto the Lord, for the husband is the head of his wife." In obedience then to this precept of the gospel, to the laws of custom and of nature, you ought to cultivate a cheerful and happy submission.[11]

Not all such mentors were male. In her mid-century analysis of the American woman's proper role in life Maria McIntosh pursued a similar theme:

> The unqualified assertion of equality between the sexes would be contradicted alike by sacred and profane history. There is a political inequality, ordained in Paradise, when God said to the woman, "He shall rule over thee," and which has ever existed, in every tribe, and nation, and people of earth's countless multitudes. Let those who would destroy this inequality pause ere they attempt to abrogate a law which emanated from the all-perfect Mind. And let not woman murmur at the seeming lowliness of her lot. There is a dignity which wears no outward badge, an elevation recognized by no earthly homage. This wise, and for her most happy inequality, secludes woman from the arena of political contention, with its strifes and rivalries, its mean jealousies and meaner pretensions, in the quiet home where truth may show herself unveiled, and peace may dwell unmolested . . . All the influences of that lot to which God assigned her, are calculated to nurture in her that meek and lowly spirit with which He delights to dwell . . .[12]

Already thus backed by nature and Scripture, ideas of male dominance and female subordination were likewise supported by English common law under which woman lost her identity in marriage just as "when a small brooke . . .

incorporateth with . . . the Thames, the poor rivulet looseth its name . . . To a married woman, her new self is her superior, her companion, her master."[13] In marriage, women forfeited their rights to property, to sign contracts, to their own earnings, even to their children in the event of a legal separation. But such sacrifices were seen as slight when compared to the security and respect to be gained by woman in her role as wife and mother. Safe in her domestic sanctuary, the American woman, with the aid of her daughters and servants, was expected to provide a welcome refuge from the turmoil and tension of the marketplace and political arena, a haven of calm and contentment to which her husband and sons would gladly return from their worldly affairs, "there to refresh their wearied spirits, and renew their strength for the toils and conflicts of life."[14]

Much precious time and energy were given to convincing the American woman that, even though she remained cloistered within the walls of her home, she might still exert a far-reaching influence upon the world. One divine postulated that

> . . . it is the province of woman to make home, whatever it is. If she makes that delightful and salutary—the abode of order and purity, though she may

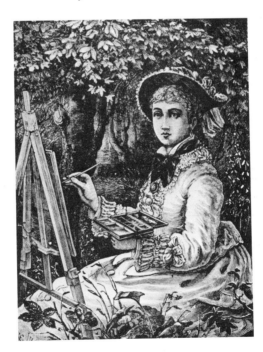

FIG. 22. Illustration from *What Can a Woman Do?* by Mrs. M. L. Rayne. Detroit, Michigan. 1885. The youthful "lady artist," fashionably attired, poses at her easel in this representation of the creative role of women, which was rarely acknowledged in nineteenth-century America. (Courtesy Betty MacDowell)

never herself step beyond the threshold, she may yet send forthe from her humble dwelling, a power that will be felt round the globe.[15]

Godey's Lady's Book, that popular social arbiter which reached 150,000 subscribers by 1860, concurred in verse:

> *Not her hand can build the city;*
> *Not her voice should rule the State;*
> *She must reign by love and pity—*
> *Through her goodness make men great.*[16]

Godey's editor for forty years, Sarah Josepha Hale, often reinforced popular sentiment regarding woman's proper role in statements such as this: "The station of woman as the companion of free, independent, civilized and Christian man is the most important she can sustain—the most honorable, useful and happy."[17]

The cult of true womanhood had its devoted followers throughout the nineteenth century, as indeed it has even today. In recalling his own life in the nineteenth century, one businessman could still state unequivocally in 1910:

> Nature made woman weaker, physically and mentally, than man, and also better and more refined. Man, compared with her, is coarse, strong and aggressive. By confining themselves to the duties for which nature has prepared them, respectively, the better they will harmonize. Let her stay in; let him go out.[18]

Unhappily for those contented with the status quo, not all women "stayed in." Indeed, murmurs of discontent had surfaced early in the history of the new nation. "Constantia," unconvinced of her alleged mental shortcomings, dared in 1790 to question the narrow limits of the domestic sphere:

> Should it still be vociferated, "Your domestic employments are sufficient"— I would calmly ask, is it reasonable, that a candidate for immortality, for the joys of heaven, an intelligent being, who is to spend an eternity in contemplating the works of Deity, should at present be so degraded, as to be allowed no other ideas, than those which are suggested by the mechanics of a pudding, or the sewing of the seams of a garment?[19]

At the turn of the century, notwithstanding the dictum that only domesticity bred felicity in woman, the letters of young Eliza Southgate could also express a divergent viewpoint:

> I do not esteem marriage absolutely essential to happiness, and that it does not always bring happiness we must every day witness in our acquaintance.

A single life is considered too generally as a reproach; but let me ask you, which is the most despicable—she who marries a man she scarcely thinks well of—to avoid the reputation of an old maid—or she, who with more delicacy, than marry one she could not highly esteem, preferred to live single all her life. The inequality of privileges between the sexes is very sensibly felt by us females, and in no instance is it greater than in the liberty of choosing a partner in marriage.[20]

The ideal woman—weak, pious, pure, sheltered—was a model established for the majority of middle- and upper-class women, who would become wives and mothers. When held up to women who remained single or to women of the lower economic and social levels, the model became a goal impossible to attain. Perhaps no more eloquent protest against the notion of delicate womanhood has been uttered than that spoken in 1851 by the freed slave and abolitionist leader Sojourner Truth:

That man over there says women need to be helped into carriages and lifted over ditches, and to have the best place everywhere. Nobody ever helps me into carriages or over puddles, or gives me the best place—and ain't I a woman? Look at my arm! I have ploughed and planted and gathered into barns, and no man could head me—and ain't I a woman? I have born thirteen children, and seen most of 'em sold into slavery, and when I cried out with my mother's grief, none but Jesus heard me—and ain't I a woman?[21]

To still the swelling volume of voices raised in protest that threatened to destroy the sanctity of the domestic realm, dismal prophecies poured forth from pulpits and from pages of ladies' magazines predicting the disasters that would surely befall those women who dared doubt the ideal or venture beyond the limits established for them by society. The same clergyman who attributed to woman an earthshaking power within her domestic setting felt compelled to warn against the unleashing of this mighty force in other areas of life:

I am confident no virtuous and delicate female, who rightly appreciates the design of her being, and desires to sustain her own influence and that of her sex, and fulfill the high destiny for which she is formed, would desire to abate one jot or tittle from the seeming [biblical] restrictions imposed upon her conduct . . . Let her lay aside delicacy, and her influence over our sex is gone . . . For this would she sacrifice the almost magic power, which, in her own proper sphere, she now wields over the destinies of the world? Surely such privileges, obtained at such cost, are unworthy of a wise and virtuous woman's ambition . . . And be assured, ladies, if the hedges and borders of the social garden be broken up, the lovely vine, which now twines itself so gracefully upon the trellis, and bears such rich clusters, will be the first to fall and be trodden under foot . . .[22]

Perhaps the most persuasive deterrent to women tempted to overstep the established bounds was the fear of ridicule and loss of respect. "When she assumes the place and tone of man as a public reformer, . . . her character becomes unnatural," warned the Congregationalist ministers of Massachusetts in chastising women abolitionists.[23] Another writer conceded that "there are women, to be sure, who inherit much of male faculty, and some of these prefer to follow male avocations; but in so doing they for the most part unsex themselves; they fail to perform satisfactorily their maternal functions."[24] To become unnatural and unsexed were but two of the perils that awaited the rebellious spirit. The further she might venture beyond her appointed sphere, the harsher the judgments, the more vicious the jibes directed at her.

"Painting Had Seemed as Inaccessible as the Moon . . ."

~ ~ ~

The field of fine art, like those of medicine, law, politics, and religious ministry, was considered unbecoming to the "true woman." In her mid-century musings on woman's proper role, a popular woman novelist cautioned women against embarking upon a career as an artist:

> Art [is] the most difficult—perhaps, in its highest form, almost impossible to women. There are many reasons for this; in the course of education necessary for a painter, in the not unnatural repugnance that is felt to women's drawing from "the life," attending anatomical dissections, and so on—all which studies are indispensable to one who would plumb the depths and scale the heights of the most arduous of the liberal arts . . . To the amateur who . . . paints prettily, her work is mere recreation; and though it may be less improving for the mind to do small things on your account, than to be satisfied with appreciating the greater doings of other people, still, it is harmless enough, if it stops there. But all who leave domestic criticism to plunge into the open arena of art . . . must abide by art's severest canons. One of these is, that every person who paints a commonplace picture . . . contributes temporarily . . . to lower the standard of public taste, fills unworthily some better competitor's place, and without achieving any private good, does a positive wrong to the community at large . . . Therefore, let men do as they will . . . but I would advise every woman to examine herself and judge herself, morally and intellectually, by the sharpest tests of criticism before she attempts art, . . . either for abstract fame or as a means of livelihood. Let her take to heart, humbly, the telling truth, that "fools rush in where angels fear to tread," and be satisfied that the smallest achievement is nobler than the grandest failure.[25]

The above quotations are included here in an attempt to depict the social setting within which the American woman lived during the nineteenth century.

Urged on all sides to conform to the ideal of the "true woman" as defined by the moral preceptors of her day, she was in most cases hesitant to respond to those occasional other voices urging her to recognize and develop her own potential as an individual. Thus, if she felt any longing to devote herself exclusively to artistic pursuits, she either stifled her ambitions as being "unseemly" for her sex, or found creative outlets that were socially acceptable and compatible with her domestic role. Of course there were exceptions to this general trend—women who chose to wear artists' smocks instead of aprons—but in many cases these were relatives of male artists from whom they had received technical training and encouragement: the Peale women, for example. In other cases, talented women were sponsored by their well-to-do families or friends to go abroad for study of the old masters and contact with contemporary masters: Harriet Hosmer and Edmonia Lewis to Rome, Mary Cassatt to Paris. It is telling that many of these women dedicated to the professional pursuit of art chose never to marry. Hosmer's own words testify to the sacrifice expected of the serious woman artist:

> Even if so inclined, an artist has no business to marry. For a man, it may be well enough, but for a woman, on whom matrimonial duties and cares weigh more heavily, it is a moral wrong, I think, for she must neglect her profession or her family, becoming neither a good wife and mother nor a good artist. My ambition is to become the latter, so I wage eternal feud with the consolidating knot.[26]

For the most part, women had willingly accepted or unknowingly absorbed the ideal set before them, so that when confronted with creative impulses, they contented themselves with those artistic pastimes deemed "proper" or else completely quenched the fires of artistic creativity, as did Jane Swisshelm during the second quarter of the century:

> During all my girlhood I saw no pictures, no art gallery, no studio, but had learned to feel great contempt for my own efforts at picture-making. A traveling artist stopped in Wilkinsburg [Pennsylvania] and painted some portraits; we visited his studio, and a new world opened to me. Up to that time painting had seemed as inaccessible as the moon—a sublimity I no more thought of reaching than a star; but when I saw a portrait on the easel, a palette of paints and some brushes, I was at home in a new world . . .
> Bard, the wagon-maker, made me a stretcher, and with a yard of unbleached muslin, some tacks and white lead, I made a canvas. In the shop were white lead, lampblack, king's yellow and red lead, with oil and turpentine. I watched Bard mix paints, and concluded I wanted brown. Years before, I heard of brown umber, so I got umber and some brushes and began my husband's portrait. I hid it when he was there or I heard any

one coming, and once blistered it badly trying to dry it before the fire, so that it was a very rough work; but it was a portrait, a daub, a likeness, and the hand was his hand and no other. The figure was correct, and the position in the chair, and, from the moment I began it, I felt I had found my vocation . . . I forgot God, and did not know it; forgot philosophy, and did not care to remember it; but alas! I forgot to get Bard's dinner, and, although I forgot to be hungry, I had no reason to suppose he did. He would willingly have gone hungry, rather than give any one trouble; but I had neglected a duty. Not only once did I do this; but again and again, the fire went out or the bread ran over in the pans, while I painted and dreamed.

My conscience began to trouble me. Housekeeping was "woman's sphere," although I had never then heard the words, for no woman had gotten out of it to be hounded back; but I knew my place and scorned to leave it. I tried to think I could paint without neglect of duty. It did not occur to me that painting was a duty for a married woman! Had the passion seized me before marriage, no other love could have come between me and art; but I felt that it was too late, as my life was already devoted to another subject—housekeeping.

It was a hard struggle. I tried to compromise, but experience soon deprived me of that hope, for to paint was to be oblivious of all other things. In my doubt, I met one of those newspaper paragraphs with which men are wont to pelt women into subjection: "A man does not marry an artist, but a housekeeper." This fitted my case, and my doom was sealed.

I put away my brushes; resolutely crucified my divine gift, and while it hung writhing on the cross, spent my best years and powers cooking cabbage . . .

Friends have tried to comfort me by the assurance that my life-work has been better done by the pen than it could have been with the pencil, but this cannot be. I have never cared for literary fame . . . and never could be so occupied with it as to forget a domestic duty . . .

Where are the pictures I should have given to the world? . . . Is that Christianity which has so long said to one-half of the race, "Thou shalt not use any gift of the Creator, if it be not approved by thy brother; and unto man, not God, thou shalt ever turn and ask, 'What wilt thou have me to do?' "[27]

Jane Swisshelm, unable to reconcile the conflicting demands of brush and broom, abandoned art altogether. Other women, who tried to arrange their home-bound lives so that there would be snatches of time for artistic activity, wisely chose to work in media that, like needlework, were already associated with the domestic sphere, or that, like watercolor and pastel, were readily available, relatively inexpensive, quickly executed, and easily put away. Hampered by their lack of serious artistic training and by the demands of family responsibilities, these "artists in aprons" managed nevertheless to employ their natural gifts for

FIG. 23. Unidentified artist: *Woman with Sewing Box*. New England. 1850–1860.
Oil on canvas. 51⅝″ × 42½″. This painting of a woman and her sewing box records
the important role played by needlework in the lives of American women in the nine-
teenth century. (Abby Aldrich Rockefeller Folk Art Center)

line, color, and form in the production of beautifully designed quilts, rugs,
embroidered pictures, and paintings.

"All My Joys and Sorrows Are Stitched into Those Pieces"

~~~

The needle arts, especially, were the most socially acceptable and therefore the
most popular. The sewing box was an ever-present attribute of accomplished
womanhood (fig. 23). "Needlework, in all its forms of use, elegance, and
ornament, has ever been the appropriate occupation of women," counseled
Mrs. Sigourney in her *Letters to Young Ladies*.[28] Substituting needle and thread
or yarn for brush and paint and pieces of cloth for canvas, women used the

FIG. 24. Sarah Furman Warner: Appliqué bedcover. Greenfield Hill, Connecticut. c. 1800. 105″ × 84″. One wonders if the artist herself is depicted among the figures in the townscape in the center of this quilt. A masterpiece of needle workmanship, this appliquéd and embroidered coverlet was unfortunately destroyed in a fire. Photograph courtesy Greenfield Village and Henry Ford Museum.

FIG. 25. E. W. Perry: "The Patchwork Quilt." *Harper's Weekly*. December 21, 1872. Working alone at the quilting frames, to which the finished patchwork top was fastened, a nineteenth-century woman carefully stitched together the three layers of her quilt. Photograph courtesy The Brooklyn Museum.

traditional tools and techniques of "women's work" to fashion what might be termed "mistresspieces" of art, admired today for their superb sense of color and design. Unlike bed rugs, which were thick and heavy bed coverings usually worked in wool yarn on woolen backgrounds, the earliest quilts were generally produced as blankets for extra warmth and were contrived of lighter weight fabrics such as cotton. Pieced quilts were assembled from scraps of fabric left over from the sewing of family clothing. These bits of cloth, each often a reminder of someone dear, were carefully cut into various geometric shapes that were then sewn together into intricate and ingenious geometric designs. Other quilts, called appliqué, were made by cutting fabric into the design elements and attaching the shaped pieces onto a fabric background. Ernestine Eberhardt Zaumzeil's quilt was constructed by this method (back cover). Both the pieced and appliqué techniques are combined in the quilt by Elizabeth Mitchell (fig. 87).

Whichever type of quilt was made, the finished patchwork top then had to be joined to a backing with an intermediate filling between. This was done by "quilting" the three layers together with innumerable tiny stitches worked

in linear patterns that became an integral part of the original design. Sometimes the quiltmaker worked unaided from start to finish, creating the top and then quilting it onto the other two layers (fig. 25). But often she was assisted in the quilting process by other women who gathered for the "quilting bee," a uniquely American institution (fig. 26). Ostensibly, the bee served to assist each woman in the completion of her quilt, but its greater value lay in the opportunity it afforded women for getting together to exchange news, recipes, home remedies, fabric scraps and patterns, to discuss political issues and personal problems, to learn new skills from one another, and to teach the basic skills to their daughters, all in a mutually supportive way. By allowing women to come together and discover their common concerns, such occasions were the forerunners of today's encounter groups or consciousness-raising sessions. A detail from a quilt, unfortunately now lost, made by Eunice M. Cook of Vermont, has been labeled *The Gossips* (fig. 27). The exchange between these two may have been sparked by the consideration of social issues raised at the quilting bee, where such subjects of great significance to women were often discussed. It was at a quilting bee that Susan B. Anthony made her first speech advocating the vote for women.

The support system it provided extended beyond the bee itself, since women

FIG. 26.  Henry Bacon: *The Quilting Bee*. Paris, France. 1872. Oil on wood. 7¼″ × 11½″. The handsome young man threading a needle seems to be more of a distraction than a help. (Shelburne Museum, Inc.)

FIG. 27. Eunice W. Cook: *The Gossips* (detail from patchwork quilt). Vermont. Nineteenth century. 10¾″ × 11⅞″. This detail from a quilt may depict a confidential exchange of opinion concerning the controversial struggle for women's suffrage. (Index of American Design, National Gallery of Art)

were their own admiring audience and astute critics. Women involved in the production of quilts recognized their validity as art. Quiltmakers frequently signed and dated their work, with understandable pride. It is interesting to note that during the years when American and European painting consisted only of representational styles, quilt artists were already exploring the purely formal elements of color, line, texture, and shape. The widespread use of traditional quilt designs did not devalue the artistry to be found in many quilts. Even when working with such well-known patterns as the Log Cabin or Star of Bethlehem (fig. 28), the quilt artist exploited the design possibilities through her color relationships, value contrasts, and inventive variations of the original pattern. In the hands of an imaginative quiltmaker many quilts based upon conventional designs achieved true artistic stature. In addition, there were those women, like

Harriet Powers and Hannah Riddle, who created entirely original designs that endure as unique works of art. That quilts provided women with a means of expressing their innate artistic ability is apparent in one quiltmaker's poignant remark that "quilts kind of filled in for the disappointment of not going to school to learn to be an artist."[29] Within each community of quiltmakers, a few, like Hannah Riddle (pl. 5), were acknowledged by their peers to be the finest, because of their superb designs, which they executed with impeccable skill. At church and at city and county fairs women with a practiced eye for the inherent aesthetic qualities of quilts served as jurors and awarded the coveted ribbons. Benjamin Harrison's painting of a fair in New York City notes the abundant array of quilts displayed overhead (fig. 29). The most magnificent

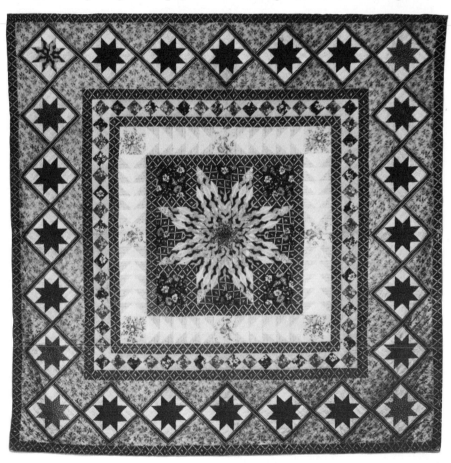

FIG. 28. Sophonisba Peale: Star of Bethlehem quilt. Philadelphia, Pennsylvania. c. 1850. Printed calicoes. 115¼" × 113". Even women who enjoyed a reputation as professional artists did not necessarily forsake a feminine interest in needlework. (Philadelphia Museum of Art)

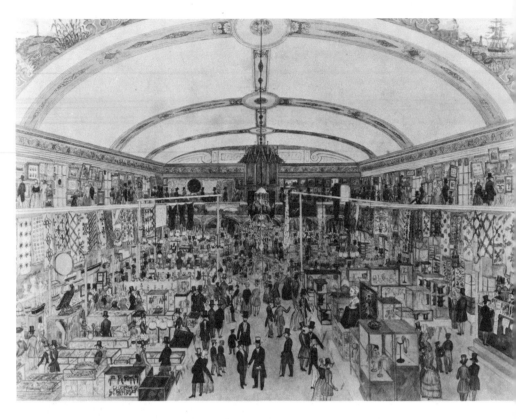

FIG. 29. Benjamin J. Harrison: *Annual Fair of the American Institute at Niblo's Garden.* New York City. c. 1845. Watercolor on paper. 27½″ × 20¼″. Quilts share equal billing with paintings at this fair attended by fashionable patrons. (Museum of the City of New York)

quilts were prized possessions, treated as tenderly as any fine paintings in a museum. They were carefully stored, sparingly used, and lovingly bequeathed as precious heirlooms to the makers' descendants. Because these women were not working in the traditional artistic media, their exquisite creations were not accorded serious consideration by the world of fine art until only recently. It is difficult now to understand how those who organized the exhibits of women's art and handicraft at either the 1876 Centennial Exposition or the World's Columbian Exposition of 1893 could have overlooked quilts, the most prevalent and perhaps the first truly American art form, one that belonged almost exclusively to women.

Girls were taught the art of quilting at a very early age. As soon as they were old enough to cut cloth into squares and sew them together, they began to make quilts, simple at first, but successively more complex. Tradition says that every

young girl aspired to have thirteen quilts stored in her dower chest by the time she married so that she might "set out" in style. These she pieced and quilted herself, with the exception of the final and most elaborate "Bride's Quilt" which her friends joined in finishing. On one quilt has been found this embroidered bit of advice:

> At your quilting, maids don't dally,
> A maid who is quiltless at twenty-one,
> Never shall greet her bridal sun.[30]

Before the guests arrived for a quilting bee, the finished top was pinned evenly to the sides of the quilting frames, which had been set up on the floor or suspended from the ceiling. The women might work in shifts around the frames, one group quilting while the rest did fancy work. When a portion of the quilting was completed, another group took its turn. When only the last row of quilting remained, the married women stepped aside, leaving the girls to vie for the

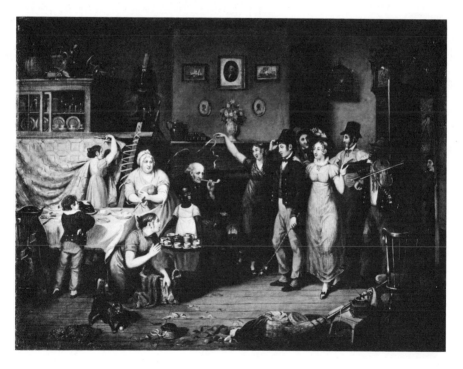

FIG. 30. John Lewis Krimmel: *The Quilting Frolic*. Philadelphia, Pennsylvania. 1813. Oil on canvas. 16⅞″ × 22⅜″. As soon as the quilting is finished, the menfolk and musicians arrive for a festive evening of games and dancing. Courtesy The Henry Francis du Pont Winterthur Museum.

distinction of setting the last stitch, for the winner would be the next to marry. At such special occasions the men were invited to join in the merrymaking that followed the completion of the quilt. That the quilting bee was a popular social event in nineteenth-century America is confirmed by countless references to it in diaries, paintings, verses, and song (figs. 30, 31). Stephen Foster musically recorded the socializing aspect of the bee in the lines "And 'twas from Aunt Dinah's quilting party, I was seeing Nellie home."[31] Another more personal reference appears in the diary of a young girl who lived in New York State during the Civil War:

> March 26, 1862. I have been up at Laura Chapin's from 10 o'clock in the morning until 10 at night, finishing Jennie Howell's bed quilt, as she is to be married very soon. Almost all of the girls were there. We finished it at 8 P.M. and when we took it off the frames we gave three cheers. Some of the youth of the village came up to inspect our handiwork and see us home. Before we went Julia Phelps sang and played on the guitar and Captain Barry also sang and we all sang together, "O, Columbia, the gem of the ocean, three cheers for the red, white and blue."[32]

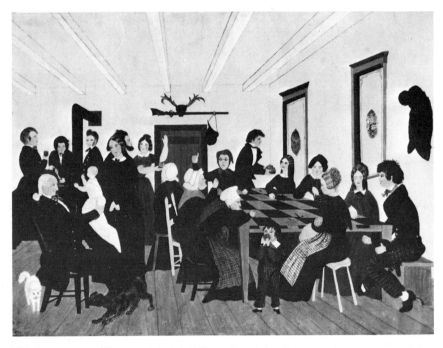

FIG. 31. Unidentified artist: *The Quilting Party*. Western Virginia. c. 1854. Oil on wood. 13¼″ × 25¼″. The discreet handholding under the quilting frames has not escaped the granny's sharp eye in this lively scene. (Abby Aldrich Rockefeller Folk Art Center)

Quiltmaking, along with other needle arts, was often an outlet not only for creative energy but also for the release of a woman's pent-up frustrations. One writer observed that "a woman made utility quilts as fast as she could so her family wouldn't freeze, and she made them as beautiful as she could so her heart wouldn't break."[33] Women's thoughts, feelings, their very lives were inextricably bound into the designs just as surely as the cloth layers were bound with thread, as the bittersweet recollections of one quiltmaker reveal:

It took me more than twenty years, nearly twenty-five, I reckon, in the evening after supper when the children were all put to bed. My whole life is in that quilt. It scares me sometimes when I look at it. All my joys and all my sorrows are stitched into those little pieces. When I was proud of the boys and when I was down-right provoked and angry with them. When the girls annoyed me or when they gave me a warm feeling around my heart. And John too. He was stitched into that quilt and all the thirty years we were married. Sometimes I loved him and sometimes I sat there hating him as I pieced the patches together. So they are all in that quilt, my hopes, and fears, my joys and sorrows, my loves and hates. I tremble sometimes when I remember what that quilt knows about me.[34]

Of all the visual art forms practiced by women in nineteenth-century America, the making of quilts, like the eighteenth-century production of sam-

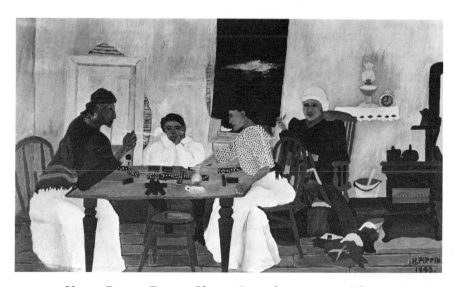

FIG. 32. Horace Pippin: *Domino Players*. Pennsylvania. 1943. Oil on composition panel. 12¾″ × 22″. In this depiction of life in the black community, the quiltmaker in the background pieces together her patchwork quilt while other family members enjoy their evening game. (The Phillips Collection)

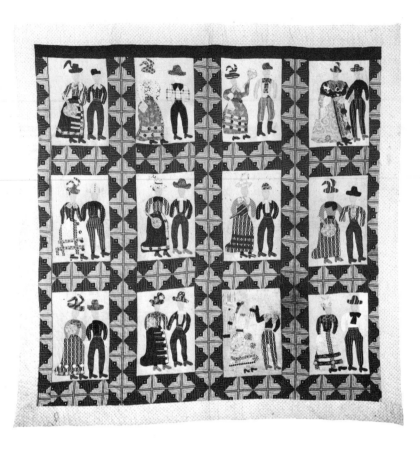

FIG. 33. Mary Jane Batson: Couples Quilt. Richmond, Virginia. Mid-nineteenth century. Pieced and appliquéd cottons. 74″ × 80″. From scraps of cloth left over from her mistress's elegant ball gowns, slave woman Mary Jane Batson created this lively representation of many of her friends. (Collection of Ron and Marcia Spark)

plers, was the most universal, engaged in by women from all walks of life. Many Indian women, in becoming quiltmakers, introduced their traditional rug motifs into quilt designs. Indian influence upon quiltmaking is evident in some of the design names, such as Indian Hatchet and Indian Trails.[35] Some of the most unusual quilts were made by slave women, snatching precious bits of time from their heavy schedule of domestic chores. Horace Pippin's painting of the *Domino Players* visually records the presence of quiltmaking within the black community (fig. 32). Mary Jane Batson, a slave on a plantation in Virginia, created her Couples Quilt out of scraps left over from her mistress's ball gowns (fig. 33). Harriet Powers, born into slavery, fashioned her appliquéd quilts after the Civil War, when she lived with her husband and their three children on a small farm near Athens, Georgia (pl. 6). In the Georgia census of 1870 she listed her occupation as "keeping house." Because of financial hardship, she was forced

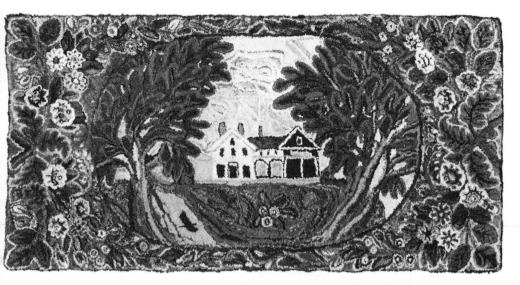

FIG. 34. Lucy Barnard: Hooked rug. Dixfield Common, Massachusetts. c. 1860. Burlap, yarn, cloth. 30″ × 60″ (approx.). In this hooked rug, Lucy Barnard has created a lively design using an array of colors and shapes. (The Metropolitan Museum of Art)

to part with one quilt in 1891 for five dollars, and the buyer's account of the sale testifies to the far-reaching influence of the cult of true womanhood:

> She offered it for ten dollars, but I told her I only had five to give. After going out and consulting with her husband, she returned and said, "Owin' to de hardness of de times, my ole man lows I'd better teck hit." Not being a new woman she obeyed.[36]

Rugmaking served the same need of women to satisfy their creative urge, to beautify their sometimes prosaic lives, and to express the pleasures and pains of the female experience. Unlike the quiltmakers who often enjoyed a sense of community at quilting bees, rug artists worked individually in the privacy of their own homes to produce floor coverings that transcended their merely utilitarian function through the beauty and strength of their designs. The greatest rugs are true monuments of American folk art, enduring testimonials to the native artistry and ingenuity of their makers. The most famous rug in America, the Caswell carpet, was created around 1835 by young Zeruah Higley Guernsey, using yarn from wool which she herself had sheared, spun, and dyed (pl. 7). With her homemade materials she embroidered her original design onto wool background squares that she then joined into a magnificent rug measuring over twelve feet square. In one block she depicted a romantic pair representing the couple that she predicted would someday "keep house on her carpet." In 1846

she fulfilled her own prophecy by marrying Mr. Caswell, the name by which
her masterpiece is known. A second rug deserves special mention not only
because of its great beauty but also because of its maker's age. Jane Gove was a
girl of only eleven when she set out to make an appliquéd rug out of her dead
mother's clothing, according to a family legend. If so, her memories of her
mother must have been happy ones, for the rug she produced is filled with
youthful exuberance and delight (fig. 36).

## Homemakers as Picturemakers
~ ~ ~

Just as some homebound women sought artistic expression through plying their
needles, other women enriched their domestic lives by using their brushes and

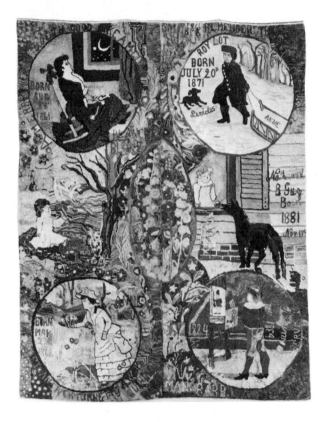

FIG. 35.   Eleanor Blackstone: Hooked rug. Macon, Illinois. c. 1885. Burlap, yarn,
cloth. 94″ × 117″. The maker of this rug included portraits of her six children, to-
gether with their names, birthdates, pastimes, and pets, in her design. Strands of the
children's hair are worked into their individual portraits. (Greenfield Village and
Henry Ford Museum)

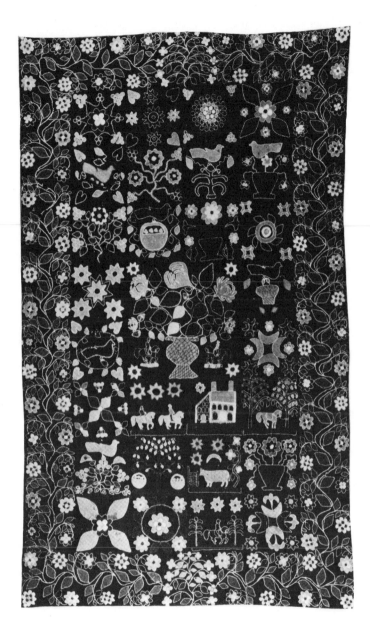

FIG. 36. Jane Gove: Appliquéd and embroidered rug. Wiscasset, Maine. 1845. Wool on wool. 43″ × 75″. When she was eleven years old, Jane is said to have fashioned this rug from fragments of her dead mother's clothing, but its effect is lively rather than somber. Birds with nests of eggs, trees, flowers, horses, a cow, and her own house were the pictorial ingredients of the young artist's design. (Natural History Museum of Los Angeles County)

FIG. 37. (*Above, left*) Eunice Pinney: Watercolor Sketch of a Fashionable Lady. Connecticut. c. 1810. 6″ × 4″. A stylish young woman complete with bonnet is depicted here in this fairly typical example of Pinney's work. (Collection of Mr. and Mrs. G. M. Kapelman)

FIG. 38. (*Above, right*) Eunice Pinney: *Lolotte et Werther.* Connecticut. 1810. Watercolor on paper. 15⅛″ × 11⅝″. The artist has here provided an intimate glimpse of an early nineteenth-century interior. (National Gallery of Art; Gift of Edgar William and Bernice Chrysler Garbisch)

paints to produce pictures for their own pleasure or to present to friends. Among these self-taught artists, who also happened to be wives and mothers, perhaps the most notable was Eunice Pinney. In addition to managing her household and rearing her five children, Pinney was a prolific painter of vigorous watercolors (figs. 37, 38, 39; pl. 8). Pinney's wide range of subject matter included landscapes, mourning pictures, literary, religious, allegorical, historical, and genre scenes, the last of which were uncommon for her time. Some of her literary and allegorical paintings were inspired by eighteenth-century engravings but they are in no way mere copies of the originals. Instead, they are loose translations, infused with a robust strength and solidity. Her forthright style is in marked contrast to the more delicate and often timid approach used by the younger

schoolgirl artist. When she began to paint in the opening years of the nineteenth century, Pinney was already a mature woman, twice married, with five children. Her maturity and her basically eighteenth-century outlook gave an unusual vitality and air of self-assurance to her work. Another woman who combined her creative life with a domestic role was Ruth Henshaw Bascom (fig. 40). Although childless, she performed the many duties of a clergyman's wife as she followed her husband from pastorate to pastorate, yet she always found time for "taking profiles" of her friends with pastel crayons. Like Pinney, Bascom was a mature woman when she began her artistic activity, but her subject matter was limited to profile portraits and her style was more gentle, due, perhaps, to the nature of her medium.

An important part of the mythology undergirding the ideal of "true womanhood" was the notion that women, being more compassionate and pious than men, were therefore better suited to care for the sick and mourn for the dead. The decline of the death rate in the late eighteenth century resulted in a less matter-of-fact attitude toward death, with increasingly elaborate and sentimentalized mourning practices. To some extent this change was a reflection of

FIG. 39. Eunice Pinney: *Children Playing*. Connecticut. 1813. Watercolor, ink, and pinpricks on paper. 5⅜" × 8". A huge butterfly, some unusually proportioned figures, and a number of hats all add interest to this playful scene. (Collection of Peter Tillou)

FIG. 40.  Ruth Henshaw Bascom: Cutout Profile of a Young Lady. Massachusetts or New Hampshire. 1835–1840. Pastel, pencil, and metal foil on paper. 18⅜″ × 13″. An assemblage of materials was often employed by Ruth Bascom to create her profile portraits. She is believed never to have accepted money for her work. (Collection of Peter Tillou)

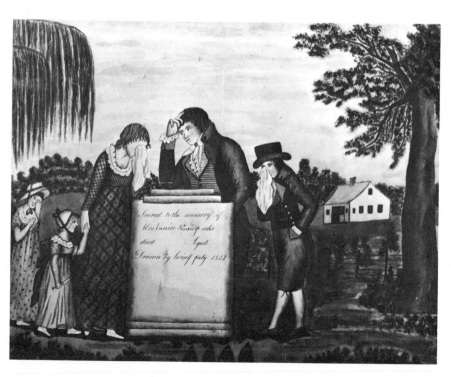

FIG. 41.  Eunice Pinney: *Memorial for Herself*. Connecticut. 1813. Watercolor on paper. 13⅛″ × 16″. Anticipating her own death, Eunice Pinney portrayed her mourners and her tombstone, carefully leaving blank the space for her death date. (New York State Historical Association)

the romantic movement in all the arts, an approach to life that stressed the expression of feelings. In the rituals of death women played the leading roles. Thus it is not surprising that the embroidered or painted "mourning picture," created as a memorial for a departed hero or loved one, should become a favorite subject for women artists, one that remained almost exclusively their own. Eunice Pinney, for example, painted several "family mortuary pieces," including one for herself (fig. 41), leaving the date of her death to be filled in later (it never was).

The penchant for mourning pictures first appeared in eighteenth-century America in embroidered form. They became especially popular after the death in 1799 of George Washington, the first hero of the new nation. Many pictures dedicated to his memory were produced as part of the national outpouring of grief. The mourning picture had added significance in that it reflected liberalized attitudes toward the classical past by infusing ancient Greek and Roman symbols with Christian meanings. Based upon classical concepts and models, the mourn-

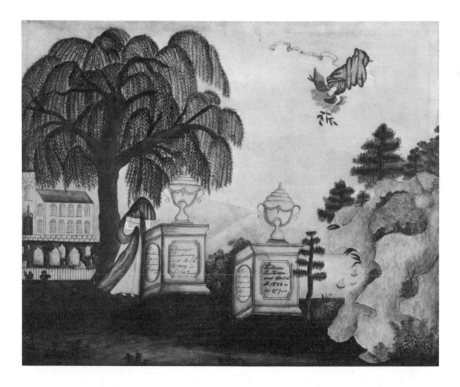

FIG. 42.  Hannah Punderson: *Mourning Picture for Prudence and Ebenezer Punderson.* Connecticut. c. 1809. Watercolor on paper. 21¾″ × 25¾″, framed size. The creator of this mourning picture was a sister-in-law of the artist Prudence Punderson Rossiter. Inclusion of the upside-down angel is unique to the American mourning picture. (Connecticut Historical Society)

ing picture also gave evidence of the new nation's erudition, elegance, and good taste.[37] Mourning pictures were composed of standard motifs, each imbued with its own special meaning. Whether painted or stitched, they shared certain features in common: imaginary landscape settings, classical urns mounted on inscribed tombstones, weeping willow trees, and mourning figures, generally female, bowed in the classical posture of grief (fig. 42). Similar scenes had been executed in paint, thread, or stone since the days of classical Greece, but, in the hands of American women and schoolgirls of the early nineteenth century, the memorial picture took on a freshness and individuality that gave it a distinctively American character. The addition of new motifs (the church, pine trees, villages, ships, angels, birds, and flowers) to selective combinations of conventional motifs and the use of an almost two-dimensional style accounted for the typically American appearance of their mourning pictures.

## "To Form the Maiden for th'Accomplished Wife"
~~~

Most of the mourning pictures produced during the first half of the nineteenth century were the work of schoolgirl artists learning the skills deemed necessary

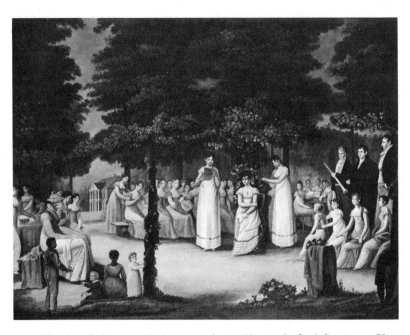

FIG. 43. Unidentified artist: *A Ceremonial at a Young Ladies' Seminary*. Virginia. c. 1810. Oil on canvas. 30″ × 39″. The genteel atmosphere encouraged by young ladies' seminaries is reflected in this depiction of a springtime graduation ceremony. (Collection of Edgar William and Bernice Chrysler Garbisch)

FIG. 44. *Art of Writing* by John Jenkins. 1813. Frontispiece. The young lady pictured has elegantly inscribed this sober thought with practiced hand: "Love God, Obey your parents, and improve your Time for Eternity." (Michigan State University Library)

for their entrance into polite society. Up until almost the end of the eighteenth century education for girls was severely limited when compared with that for boys. Although they might learn to read and write in dame schools or under private tutelage, girls were not generally admitted to the higher schools provided for boys. Around the time of the American Revolution private academies or seminaries that attempted to provide for girls from prosperous families the same sort of genteel education offered to their counterparts in England had begun to appear. According to a "GENTLEMAN who attended the Commencement" at the Young Ladies' Academy of Philadelphia in 1789, their goal was "To form the maiden for th'accomplished wife,/And fix the basis of a happy life!"[38] The aura of graceful gentility in the painting of a seminary ceremonial (fig. 43) suggests that these institutions often achieved their aim.

The emulation of English training placed a heavy emphasis upon the ladylike accomplishments of fine penmanship (fig. 44), drawing, watercolor

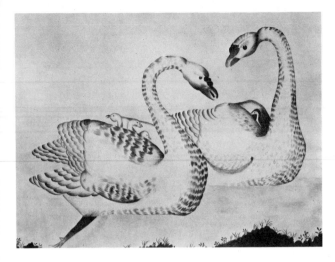

FIG. 45. Louisa Jane Pratt: *Two Swans with Babies*. Eastern United States. c. 1830. Watercolor and ink on paper. 20½″ × 24½″. Pastoral scenes such as this one were among the favorite subjects of young women in the early nineteenth century. (Private collection)

FIG. 46. Susan Whitcomb: *The Residence of General Washington*. Brandon, Vermont. 1842. Watercolor on paper. 19⅞″ × 24″. Based on a print by Alexander Robertson (who operated the Columbian Academy) and engraved by Francis Jukes, this stylized version of Mount Vernon was executed by a young student at the Vermont Literary and Scientific Institution, where instruction in painting and drawing "with the use of patterns" could be had for $1.00 per quarter. (Abby Aldrich Rockefeller Folk Art Center)

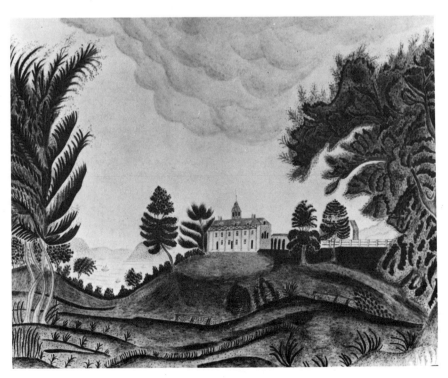

painting, fancy needlework, and music, in addition to providing various combinations of such basic subjects as reading, writing, arithmetic, geography, French, and perhaps the classics. For these "finger skills" parents paid extra fees. At the Vermont Literary and Scientific Institution in Brandon, attended by Susan Whitcomb (fig. 46), instruction in painting and drawing could be had for an additional charge of one dollar per quarter "with the use of patterns."[39] It was in these fashionable seminaries that schoolgirl artists produced vast quantities

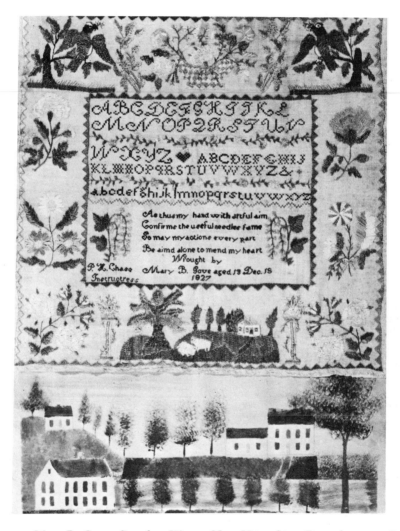

FIG. 47. Mary B. Gove: Sampler. Weare, New Hampshire. December 15, 1827. Watercolor on paper and silk embroidery on linen. 16″ × 17″. This unusual combination, embroidered sampler above and a watercolor below, was made by thirteen-year-old Mary under the instruction of P. H. Chase. (Private collection)

of pencil-and-ink sketches, watercolors, and embroidered pictures. One such school was that operated by Mrs. Susanna Rowson, also distinguished as an actress, playwright, and author of such popular novels as *Charlotte Temple* (fig. 48). Beginning in 1805 she held annual exhibitions of her young students' work which received much acclaim. From Mrs. Rowson's academy in Medford, Massachusetts, young Eliza Southgate wrote to her father in 1800 that "I learn Embroidery and Geography at present and wish your permission to learn Musick."[40] Later in a letter to her sister Octavia, who was attending Mrs. Frazier's school, she advised, "About your work . . . a mourning piece with a figure in it, and two other pictures, mates—figures of females. I think handsomer than Landscapes."[41]

The mourning picture, with its somewhat overdrawn sentimentality, became a favorite subject for the romantic schoolgirl artist, who was frequently reminded of her own mortality. Often, when a classmate died, her name was listed on black-bordered pages of the seminary catalogue, with the ominous warning, "Be ye then also ready."[42] Every year on her birthday the schoolgirl was apt to observe soberly in her diary that it might well be her last. This preoccupation

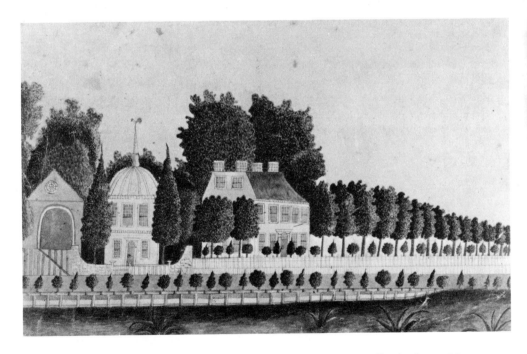

FIG. 48. Unidentified artist: *Mrs. Rowson's and Mrs. Haswell's Academy.* Massachusetts. Early nineteenth century. Watercolor on paper. 6⅛″ × 9½″. This view of an academy gives us an idea of the setting in which some young ladies became accomplished. Photograph courtesy Old Sturbridge Village. Photograph by Henry E. Peach. (The Bostonian Society)

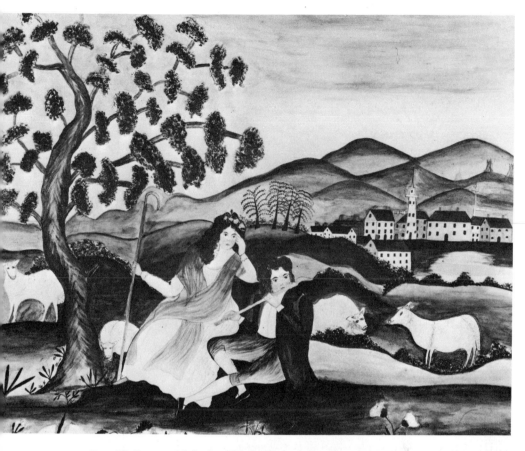

FIG. 49. Sara H. Dana: *Adelaide, Shepherdess of the Alps*. New England, 1825–1830. Watercolor on paper. 16″ × 20″. Prints made to illustrate popular novels, such as *Adelaide, Shepherdess of the Alps*, inspired the paintings of many schoolgirl artists. Photograph courtesy Old Sturbridge Village. Photograph by Henry E. Peach. (Old Sturbridge Village)

with death encouraged the creation of countless mourning pieces commemorating heroic figures or lamenting deceased relatives (many of whom the young artist had never known). Schoolgirl artists often relied on engraved prints of painted works as their guides to composition. Each academy owned books of engravings to which the young artist could refer. Prints of paintings by the eighteenth-century Swiss-born Angelica Kauffmann were especially popular as source material, not only for mourning pictures but for other subjects as well. Helpful instructions for copying these prints were to be found in *The Artist's Assistant*, published first in London and later in America. Stencils were also employed as patterns for the trees, monuments, and figures.[43] In spite of the frequent use of identical print sources or stencils, which gave a similar character to the

products of each school, every young artist worked out her own personal interpretation of the mourning picture formula, so that no two works are exactly the same and each has its own special appeal.

The earliest schoolgirl pictures were embroidered, using silk floss on silk or satin grounds. Each girl was expected to return home from her stay at the boarding academy with a needlework picture suitable for framing and displaying in the front parlor. The admiration bestowed on this work by her proud family was determined in part by the cost of the materials that went into its making. "She has been four quarters with Miss Julia, and has worked Friendship and Innocence with cost, upwards of a hundred dollars," confides the proud mother in Eliza Leslie's "Pencil Sketches" of 1835.[44] When watercolor paints became available in solid form, they were readily adopted for their convenience of use and gradually began to replace needlework as the favored medium for fashion-

FIG. 50. Sophia Burpee: *The Shepherd*. New England. October 1, 1806. Watercolor on paper. 12¾″ × 10⅟₁₆″. The subject, style, and medium suggest schoolgirl training in "fashionable" accomplishments. Courtesy New York State Historical Association.

able young ladies. For a time in the early years of the nineteenth century the two techniques were combined, most of the scene being embroidered with the sky and faces painted, as in the mourning picture made by Abigail Mason Payne (fig. 52). Eventually paint replaced thread altogether, but young watercolor artists such as Prudence Perkins (fig. 53) continued to simulate the look of embroidery with their short, stitchlike strokes of the brush, sometimes heightening the effect of fabric by pin-pricking holes into the paper. Besides mourning pictures, schoolgirls were fond of creating "fancy pieces" that illustrated popular novels, classical literature, Shakespearean plays, historical scenes, and biblical stories, such as Mary Parke's *Rebecca at the Well* (fig. 56) and Betsy Lathrop's *Japhthah's Return* (fig. 57).

Another way in which schoolgirl artists employed their drawing and painting skills was by decorating wooden boxes and tables with pictorial motifs,

FIG. 51. Ruth Downer: *New England Goddess*. Massachusetts. Early nineteenth century. Watercolor on silk. 22″ × 26″. A young goddess rides through the clouds, pulled in a chariot by doves and watched over by guardian angels. A similar example is owned by the Abby Aldrich Rockefeller Folk Art Center. (Museum of Art, Rhode Island School of Design)

FIG. 52. Abigail Mason Payne: *Memorial to Mrs. Judith Mason and Josiah Mason*. Granby, Massachusetts. 1802–1808. Embroidery and watercolor on paper. 19¼″ × 17½″. Attributed to the Abby Wright School at South Hadley, Massachusetts, this graceful mourning picture reflects the early nineteenth-century preoccupation with death. (Old Sturbridge Village)

FIG. 53. Prudence Perkins: *River and Townscape with Figures*. Rhode Island. 1810. Watercolor and ink on paper. 18½″ × 22¾″. Here the artist has combined techniques that result in the simulation of embroidery. (Collection of Peter Tillou)

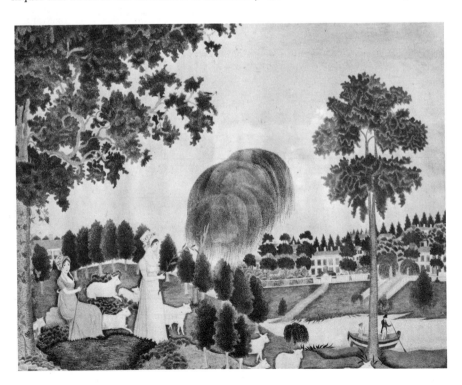

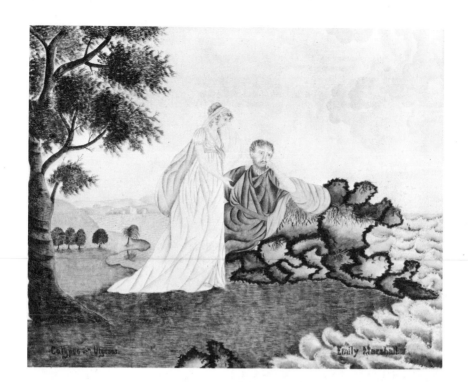

FIG. 54. Emily Marshall: *Calypso and Ulysses*. New England. 1840. Watercolor on paper. 19″ × 23¾″. Ulysses, hero of *The Odyssey,* is shown with the sea nymph Calypso on the island of Ogygia, where he stayed for seven years. Like many other schoolgirl paintings, this one suggests needlework in its brushwork. (Abby Aldrich Rockefeller Folk Art Center)

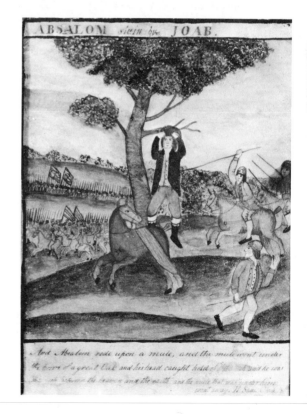

FIG. 55. Caroline Joy: *Absalom Slain by Joab*. New England. 1830. Watercolor on paper with pinpricks. 9⅞″ × 7¾″. The biblical story of King David's ill-fated son is the source for this schoolgirl painting, which simulates embroidery in both the application of paint to resemble stitched thread and the pricking of the paper to resemble fabric. (Abby Aldrich Rockefeller Folk Art Center)

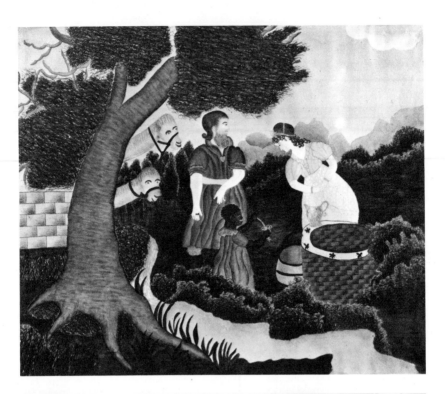

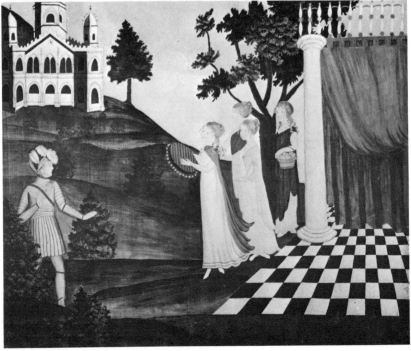

FIG. 56. (*Opposite page, top*) Mary Parke: *Rebecca at the Well*. New England. 1805. Watercolor and gilt painting on paper. 18⅛″ × 20″. In this schoolgirl version of a biblical story, typical in its use of watercolor to simulate embroidered stitches, the camels' ability to conceal their bodies behind the tree is rather remarkable. Courtesy New York State Historical Association.

FIG. 57. (*Opposite page, bottom*) Betsy B. Lathrop: *Japhthah's Return*. New England. 1812. Watercolor on silk. 22″ × 25¾″. The schoolgirl artist who illustrated this tragic biblical tale clothed her central character in knightly attire and placed the event in an English Gothic setting. The picture records the return of the victorious warrior, who had vowed to his Lord that he would offer as sacrifice whatever he first saw emerging from the door of his house. Unfortunately, his daughter was the first to welcome him home. (Abby Aldrich Rockefeller Folk Art Center)

using watercolor paints and India ink.[45] Although painting on velvet or paper was more prevalent, there were some seminaries that also offered instruction in painting on wood. The scenes depicted were similar to those executed on paper: landscapes, baskets of fruit and flowers, mythological, biblical, and literary scenes, derived from the same books of prints that provided inspiration for other types of painting. The young artist seldom depicted her American surroundings. However, the wooden sewing box decorated by Jane Otis Prior in 1822 includes a representation of Front Street in Thomaston, Maine, as well as a view of the Boston State House (fig. 58). Jane may have been a student at Miss Tinkham's school in Wiscasset, Maine, where painting on wood was part of the curriculum.

FIG. 58. Jane Otis Prior: Sewing box. Wiscasset, Maine. March 1822. Mahogany with maple veneer, shells, and enamel painting. W. 12″. With townscapes adorning its sides, this box carries the following inscription: "Miss Sarah McCobb's, painted by Miss Jane Otis Prior, March, 1822. Remember your friend Jane when far distant from each other—when you look at this. J.O.P." (Private collection)

The worktable decorated by Sarah Eaton Balch at Mrs. Rowson's Academy is painted to resemble bird's-eye maple, festooned with rose garlands, and topped with a rustic landscape scene (fig. 59). The schoolgirl's ability to decorate furniture gave added proof of her accomplishment and further reason for family pride.

Many girls unable to attend boarding school might learn to draw by taking private lessons from professional artists who advertised their services in local newspapers. They might also attend private drawing schools such as the Columbian Academy operated by Alexander and Archibald Robertson in the city of New York from 1792 to 1821. Such drawing academies sprang up after the American Revolution as European professional artists arrived in America. In these drawing schools young ladies received only such instruction as was necessary for the genteel accomplishment of a refined education, while young gentlemen learned to draw in preparation for engineering and architectural careers. In place of drawing from nature or from life, the method of instruction in both seminary

FIG. 59. Sarah Eaton Balch: Worktable. Boston area. Early nineteenth century. Maple and pine. W. 17″. Small boxes and sewing tables were convenient supports for the display of a young seminary student's newly developed artistic skills. (Private collection)

and drawing academy stressed copying from examples, usually the engravings found in the books owned by these schools. This type of formal training is represented in the watercolor rendering of a girl's drawing class (fig. 60). The young girl intent upon teaching herself to draw would probably turn to such manuals as *The Artist's Assistant* (1806) or *Valuable Secrets Concerning Arts and Trades* (London, 1775; Norwich, Conn., 1795; Boston, 1798; New York, 1809). She would have been encouraged in her efforts by such advisors as Mrs. Sarah Ellis, author of *The Family Monitor and Domestic Guide,* which praised the art of drawing for its quiet, unobtrusive quality, adding, "It is, of all other [genteel] occupations, the one most calculated to keep the mind from brooding upon self, and to maintain that general cheerfulness which is a part of social and domestic duty . . . It can also be laid down and resumed, as circumstance or inclination may direct, and that without any serious loss."[46]

By the second decade of the century the shallowness of most female seminary training was under attack by those who refused to believe that "chemistry enough to keep the pot boiling, and geography enough to know the location of the different rooms in her house, is learning sufficient for a woman."[47] Determined women educators such as Emma Willard sought to establish schools of higher

FIG. 60. Unidentified artist: *The Watercolor Class.* New York. 1815–1820. Watercolor. 14⅝″ × 23⅝″. This painting depicts the type of instruction obtainable in the female seminaries and private drawing academies that catered to young ladies' needs. Learning to draw and to paint moderately well were necessary parts of a fashionable education during the early part of the nineteenth century. Courtesy The Art Institute of Chicago. (Emily Crane Chadbourne Collection)

learning for young women where they could pursue a more rigorous course of study that included algebra, geometry, trigonometry, and even physiology, the last of which had until then been considered far too improper a subject for delicate female sensibilities. Mrs. Willard's Troy (New York) Female Seminary opened in 1821, the first publicly financed educational institution of higher learning for young women. It was such an improvement over the type of training previously available that we can forgive its founder for her too conservative goal: to produce educated women who might "be expected to acquire juster and more enlarged views of their duty" as supportive, submissive wives and "enlightened" mothers of a "great and good race of men."[48]

Even Oberlin College in Ohio, founded in 1833 and justly lauded as the first institution of higher learning to open its doors to all, women as well as men, continued to perpetuate the idea that "women's high calling was to be the mothers of the race . . . Washing the men's clothes, caring for their rooms, serving them at table, listening to their orations, but themselves remaining respectfully silent in public assemblages, the Oberlin 'coeds' were being prepared for intelligent motherhood and a properly subservient wifehood."[49]

By 1840, the increase in town-supported schools modeled after Mrs. Willard's seminary, with a greater emphasis upon serious study, led to a decline in output of showy schoolgirl accomplishments. The stitched or painted mourning pictures, which had served the useful purpose of recording family statistics, were replaced for a brief period of time by mass-produced lithographs to which the proper names and dates could be added. Finally, as the romantic movement itself came to a close by mid-century, the mourning picture, a reflection of that impassioned mood, disappeared altogether.

The barriers encountered by a young woman in securing an ample education in the various branches of learning were even more formidable when she attempted to obtain adequate training in the fine arts so that she might become a professional artist. According to the code of true womanhood, it was a breach of decorum for her to view the nude human body, whether male or female. Only married women could discuss, with the greatest delicacy, of course, certain subjects of a highly personal nature or look upon certain works of art deemed inappropriate for maiden eyes. Consider then the impropriety of the aspiring young artist in studying human anatomy from either statuary or the living model. To protect her purity, she was denied access to anatomy classes in the medical schools and systematically excluded from life-drawing classes in the fine arts academies. The Pennsylvania Academy of the Fine Arts in Philadelphia was the first institution of its type to give attention and opportunity to women art students, but even there progress was slow, and it was not until the 1880s that women enjoyed equal educational advantages with the men students. In 1844 the Board of Directors, noting that female students would suffer embarrassment if they were to study nude statuary in the company of male students, agreed

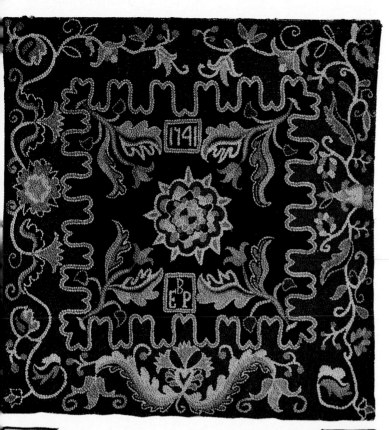

PL. 1. Phoebe Billings (attributed): Bed rug. New England. 1741. Wool foundation with uncut pile. 96″ x 96″. With the lively tan and gold vine set against a deep blue and black background, this bed rug, made for or by Phoebe Billings, provides a wonderful visual testament to the creativity of Colonial women. (Addison Gallery of American Art; Bequest of Henry P. Moseley)

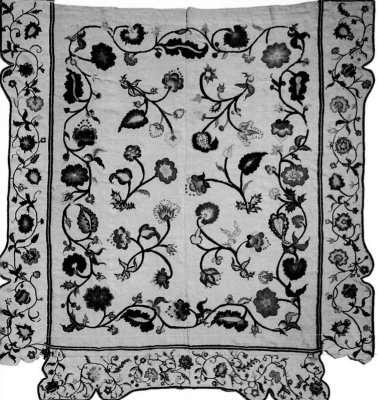

PL. 2. Mary Bulman: Bed covering. York, Maine. c. 1745. Crewelwork on linen. 79″ x 73½″. This coverlet is part of the finest complete set of early crewel bed furniture known. Mary Bulman is thought to have designed and embroidered this beautiful set while her husband was serving as surgeon under Sir William Pepperell. (Old Gaol Museum)

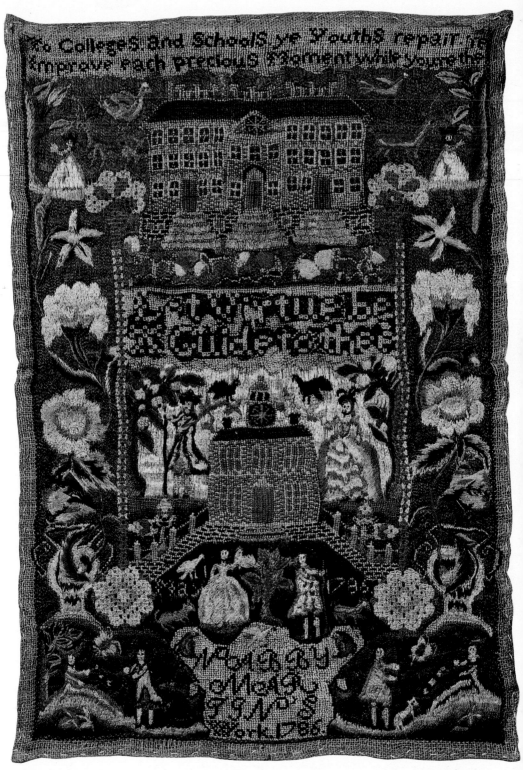

PL. 3. Nabby Martin: Sampler. Providence, Rhode Island. 1786. Silk on canvas. 15″ x 10¼″. Rich colors, a well-balanced design, and interesting architectural views mark this sampler stitched at Mary Balch's school. (Museum of Art, Rhode Island School of Design)

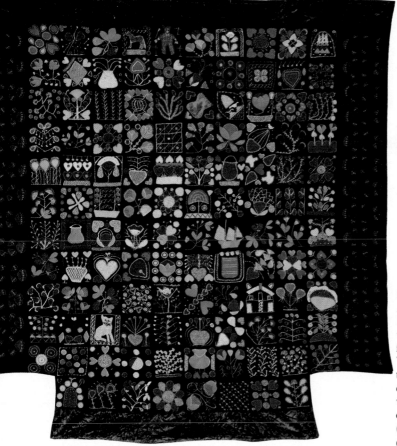

PL. 4. Sibyl Huntington May: *Hunting Scene,* fireboard or overmantel. Haddam, Connecticut. 1756. Oil on board. 24″ x 32″ (approx.). In this rare example of a known, eighteenth-century woman artist's work, we find depicted a scene from early Haddam history. Also pictured here is the Congregational church where the artist's husband, the Reverend Eleazor May, had his pastorate. Photograph courtesy Mr. and Mrs. Harry Orton-Jones. (Brainerd Memorial Library)

PL. 5. Hannah Riddle: Appliqué quilt. Woolwich, Maine. 1870. Felt and velvet. 77½″ x 76″. A first-prize winner at the Woolwich Fair of 1870, this quilt continues to elicit admiration for its vivid arrangement of colors and shapes. (Collection of Harriet Griffin)

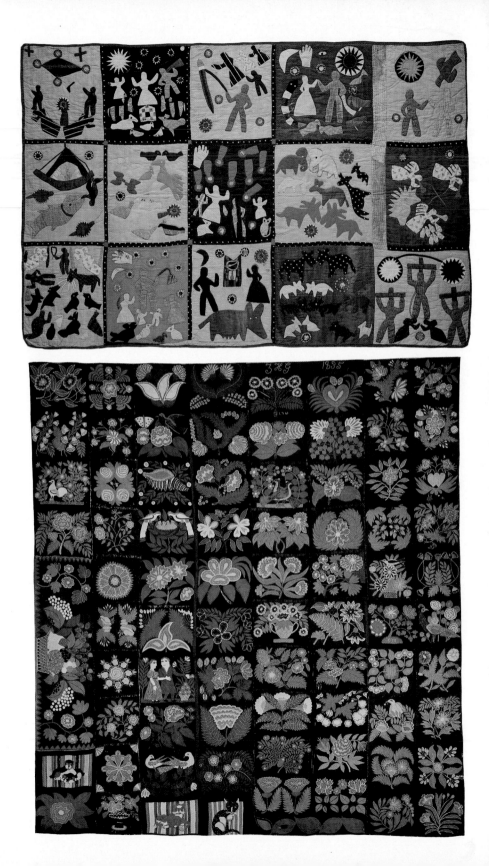

CHARLOTTES VISIT to the VICAR.

The good old man was sitting upon his bench at the sight of
Charlotte he forgot his old age and his oaken stick and
ventured to walk towards her. She ran to him and made him
sit down again. Eunice Pinney's Painting. 1810

PL. 6. (Opposite page, top) Harriet Powers: Appliqué quilt. Athens, Georgia. c. 1895. 105″ x 69″. A narrative quilt depicting stories from the Bible, this work exemplifies a technique traceable to West Africa. Only two quilts are known to have been produced by Harriet Powers, but they both rank among the masterpieces of American textile production. (Museum of Fine Arts, Boston; Bequest of Maxim Karolik)

PL. 7. (Opposite page, bottom) Zeruah Higley Guernsey Caswell: Carpet. Castleton, Vermont. 1832–1835. Wool embroidered on wool. 159″ x 147″. This remarkable rug consists of seventy-six embroidered squares and a removable rectangular section that covered the hearth in the summer months. Its maker sheared, spun, and dyed the wool used to create her designs, one of which depicts the romantic pair who would someday "keep house" on her carpet. (The Metropolitan Museum of Art; Gift of Katharine Keyes, 1938, in Memory of her father, Homer Eaton Keyes)

PL. 8. Eunice Pinney: *Charlotte's Visit to the Vicar.* Connecticut. 1810. Watercolor and ink on paper. 13½″ x 9¾″. Many of Pinney's watercolors are based on contemporary engravings and illustrations in children's books. Through a careful use of color and pattern, she has embued the copied images with her own unmistakable style. (Collection of Edgar William and Bernice Chrysler Garbisch)

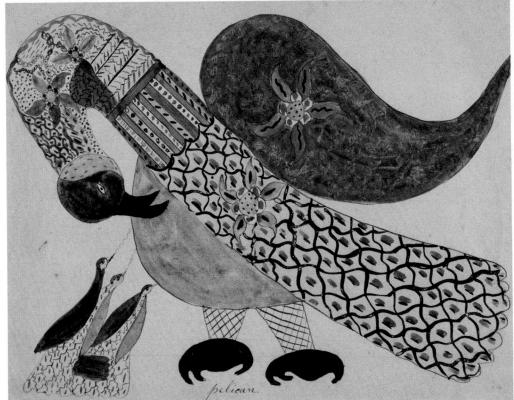

pelican

PL. 9. (Opposite page, top) Susanna Heebner: *A Song of Summer*. Montgomery County, Pennsylvania. 1807. Ink and watercolor on paper. 8⅛″ x 13 3/16″. A member of the Schwenkfelder group of Pennsylvania Germans, this Fraktur artist was among its finest calligraphers. Her text is taken from a song by Paulus Gerhardt and begins: "Go out, my heart, and seek joy/during this beautiful summertime/in the gifts of your Lord." (Free Library of Philadelphia)

PL. 10. (Opposite page, bottom) Mary Ann Willson: *Pelican*. Greenville, New York. c. 1820. Watercolor and ink on paper. 12⅞″ x 6″. The pelican, with its flat patterns, highly stylized forms, and vibrant colors, is characteristic of Willson's style. (Museum of Art, Rhode Island School of Design)

PL. 11. Deborah Goldsmith (signed and dated): *The Talcott Family*. Hamilton, New York. 1832. Watercolor on paper. 18″ x 21 7/16″. This family portrait not only preserves the likeness of each member but also provides a pictorial record of dress and furnishings in early nineteenth-century America. (Abby Aldrich Rockefeller Folk Art Center)

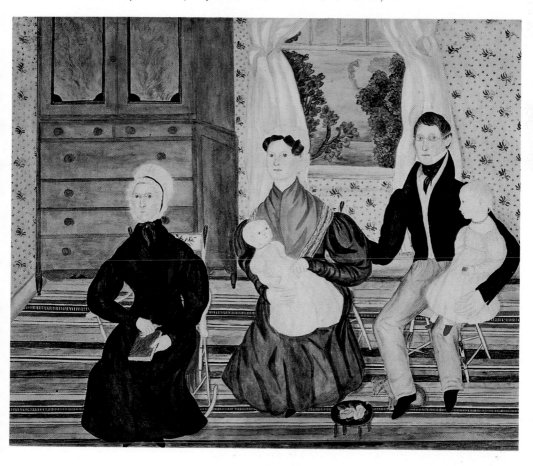

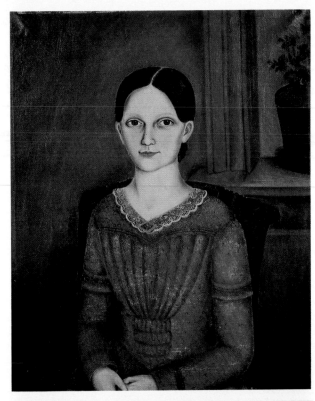

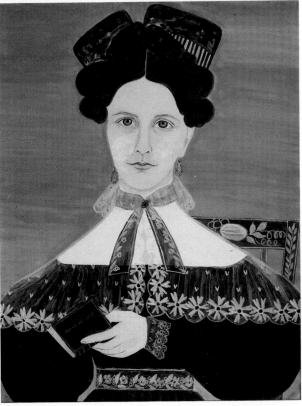

PL. 12. (Left, top) Susan C. Waters: *Helen Kingman*. New York. 1845. Oil on canvas. 30″ x 25″ (approx.). The stiff frontal pose, the flattening of forms, and the emphasis on line are characteristics of the folk-style portrait. (Collection of Russell Carrell)

PL. 13. (Left, bottom) R. W. and S. A. Shute (signed and dated): *Dolly Hackett*. Hooksett, New Hampshire. 1832. Watercolor on paper. 23¾″ x 19″. Atypically large for a watercolor portrait of this period, this full-front pose displays both an exuberant brush technique and a strong color usage. (Fruitlands Museums)

PL. 14. (Opposite page, top) Ruby Devol Finch: *Prodigal Son*. Westport, Massachusetts. c. 1830. Watercolor on paper. 12¼″ x 13¾″. Nine scenes from the Parable of the Prodigal Son, presented in comic-strip style, show the characters in contemporary nineteenth-century settings and dress. Another version of this parable by the same artist is owned by the Abby Aldrich Rockefeller Folk Art Center. (Private collection)

PL. 15. (Opposite page, bottom) Eliza Ann Taylor: *A Present from Mother Lucy to Eliza Ann Taylor*. New Lebanon, New York. 1849. Ink and watercolor on paper. 14″ x 16⅜″. Among the many inspirational messages inscribed within this decorative spirit drawing is this generous thought: "As my Mother has taught me So will I do, and divide my blessings with this lovely few." (Hancock Shaker Village, Shaker Community, Inc.)

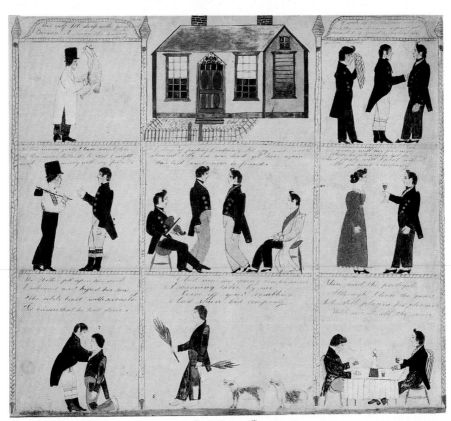

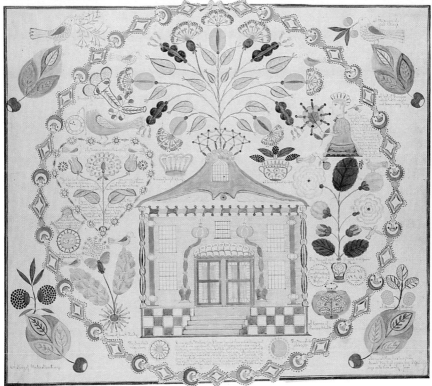

PL. 16. Sallie Cover: *Homestead of Ellsworth L. Ball.* Garfield County, Nebraska. 1880–1890. Oil on canvas. 19½″ x 23″. The pioneer woman artist recorded the isolation and ruggedness of prairie life in this view of her neighbor's sod dwelling as seen from her own window. (Nebraska State Historical Society)

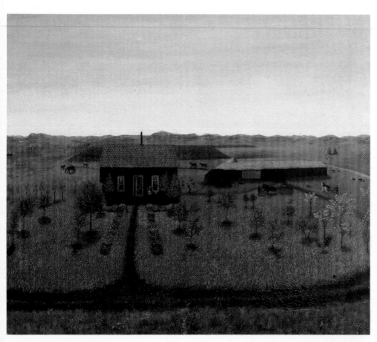

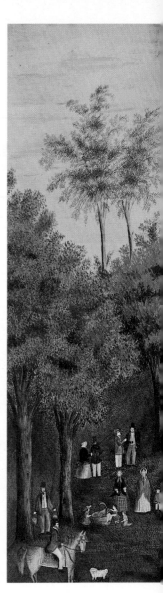

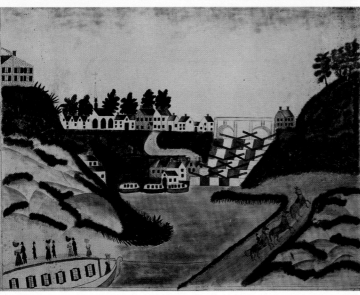

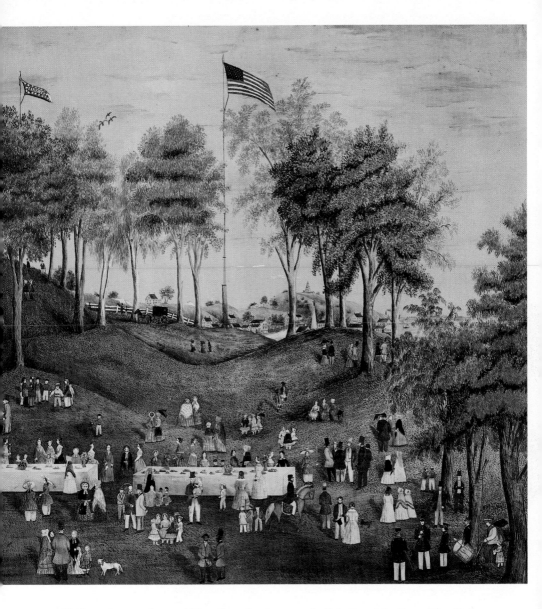

PL. 17. (Opposite page, bottom) Mary Keys: *Lockport on the Erie Canal.* Lockport, New York. 1832. Watercolor on paper. 14⅜″ x 19⅜″. Ignoring true perspective and proportion, the artist produced a pleasing pattern by reducing natural and architectural elements to their geometric essentials. (Munson-Williams-Proctor Institute)

PL. 18. Susan Merritt: *Fourth of July Picnic at Weymouth Landing.* Weymouth Landing, Massachusetts. 1845. Watercolor and cut paper. 26″ x 36¼″. Unhampered by academic restraints, the self-taught artist was free to employ unconventional techniques. Here, the minute forms of picnicking celebrants were first painted on paper, then carefully cut out and affixed to the painted landscape setting. (The Art Institute of Chicago)

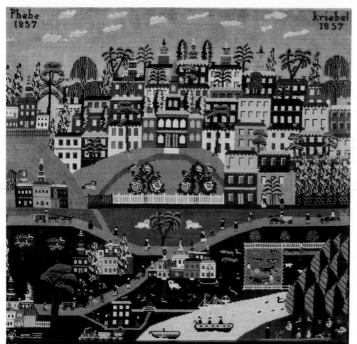

PL. 19. Phebe Kriebel:
Townscape. Towamencin
Township, Pennsylvania. 1857.
Wool embroidery on canvas. 27″
x 27″. Hills, town, river, and
trees have all been simplified,
flattened, and integrated into a
lively design with rich, inventive
coloring. (Schwenkfelder
Museum)

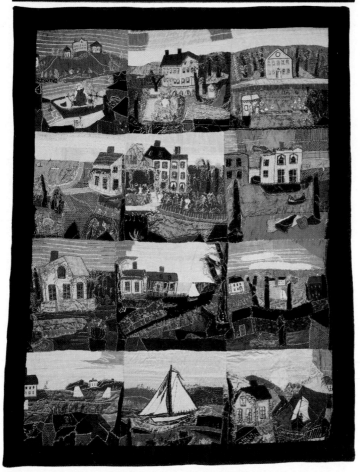

PL. 20. Celestine Bacheller:
Embroidered crazy quilt.
Wyoma, Massachusetts. c. 1900.
73½″ x 57″. This unique
pictorial quilt is believed to depict
homes and scenes around
Wyoma. (Museum of Fine Arts;
Gift of Mr. and Mrs. Edward J.
Healy in memory of Mrs. Charles
O'Malley)

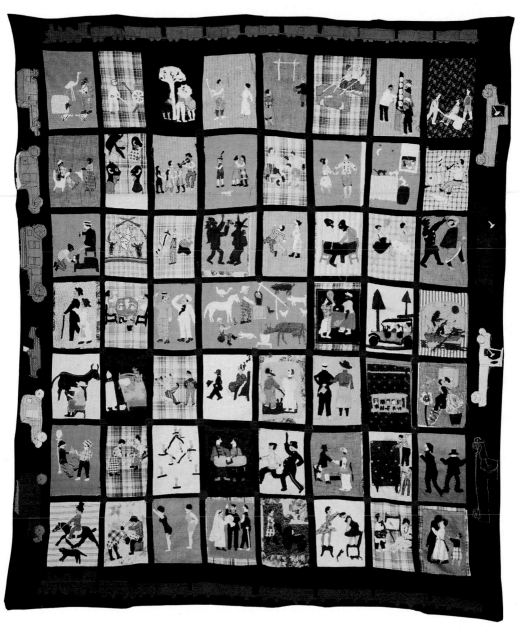

PL. 21. Mrs. Cecil White: *Scenes from Life,* Appliqué quilt. Hartford, Connecticut. c. 1930. 66″ x 77″. This remarkable quilt captures one woman's impressions of life all around her. Photograph courtesy Rhea Goodman: Quilt Gallery, Inc.

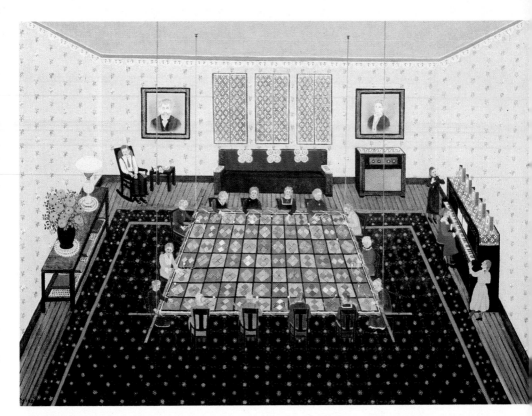

PL. 22. Fannie Lou Spelce. *Quilting Bee.* Austin, Texas. 1968. Oil on canvas. 28″ x 38″. In this painting the artist recaptures a scene from memories of her living room where her relatives gathered to quilt, sing, and socialize. This work offers a vivid personal account of women working together in the characteristic setting in which most quilts were produced. (from the Spelce Family collection)

PL. 24. Minnie Evans: *Green Animal.* Wilmington, North Carolina. Twentieth century. Crayon on paper, with white oil paint. 8¾″ x 11½″. This artist is known primarily for her brilliant colored drawings containing eyes, symmetrical images, and foliage. Here an imaginary, lone green animal looms in a barren landscape. (Lent by Nina Howell Starr)

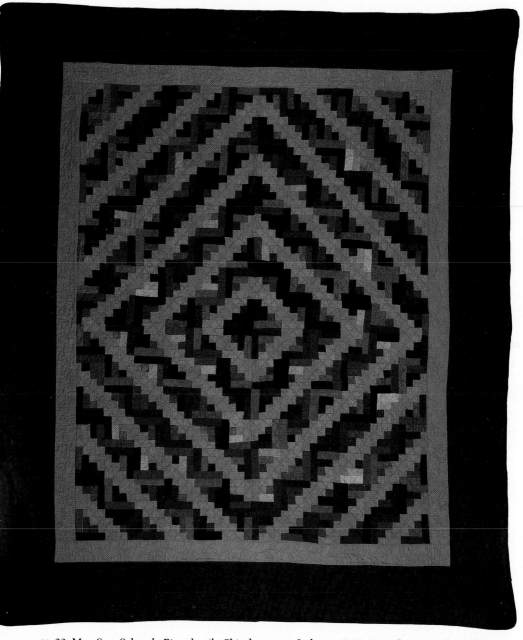

PL. 23. Mrs. Sam Schrock: Pieced quilt. Shipshewanna, Indiana. 1925–1930. Cotton. 82″ x 72″.
An intuitive sense of color, a keen eye for composition, and a talent with the needle were
combined in this beautiful example of Amish quilting. (Collection of David Pottinger)

PL. 25. Sadie Kurtz: *Two Women*. Bayonne,
New Jersey. c. 1965. Poster paint
on paper. 16¼″ x 13¼″. Working mainly
with bright colors, Sadie Kurtz
creates active, resonant imagery in her
decorative paintings.
(Collection of Elias Getz)

PL. 26. Malcah Zeldis: *Brighton Beach*.
New York City. 1970.
Oil on canvas. 23½″ x 32″. Malcah Zeldis
focuses primarily on scenes she knows well;
here she recaptures a bustling beach scene
and, as usual, she includes a self-portrait.
(Collection of David L. Davies)

that the women might have exclusive use of the statuary gallery for study between the hours of ten to eleven on Mondays, Wednesdays, and Fridays. In 1856 the Board decreed that "a close-fitting but inconspicuous fig-leaf be attached" to the statues in need of it.[50] This innovation allowed women students to study in the gallery at the same time as men without undue discomfiture. In 1859 a Miss Franklin became the first woman student permitted to copy a painting, an approved method of learning depicted in John Sloan's etching, *Copyist at the Museum* (1908; fig. 61). It was 1860 before women students at the academy were allowed to attend anatomy lectures that included dissections. Throughout these years women were denied entry into life-drawing classes where they might study from living models. Alice Barber Stephens's 1879 painting the *Female Life Class* records the significant advance made in 1868 with the inauguration of the "Ladies' Life Class" where women students had access to the living female model

FIG. 61. John Sloan: *Copyist at the Museum*. New York. 1908. Etching. 7½″ × 9″. The aspiring woman artist, following the approved custom of learning by copying, has elicited some expressions of disapproval by her bold behavior. (National Collection of Fine Arts)

for the first time (fig. 62). Male models were not permitted to women students until the late 1870s, and even then many persons voiced their disapproval of a situation "where every feeling of maidenly delicacy is violated."[51] The well-known painter Thomas Eakins was forced to resign as professor at the academy because he had dared to remove the loincloth from a male model while lecturing to his female students (1886).

It was much less difficult for women to secure training in schools of design where they could learn the skills needed in various industries. As early as the 1840s, the "Franklin Institute for the promotion of the Machanic Arts," established by Mrs. Peters at Philadelphia, offered instruction to women in wood engraving, fabric design, and in "designing, coloring or staining, painting, enameling, burnishing or carving household goods and utensils of every description, mouldings and carvings, and nearly every article of use or ornament."[52]

FIG. 62. Alice Barber Stephens: *Female Life Class*. Philadelphia. 1879. Oil on cardboard. 12″ × 14″. This painting commemorates the progressive step taken when the Pennsylvania Academy instituted a "Ladies' Life Class" for its women students in 1868. (Pennsylvania Academy of the Fine Arts)

FIG. 63. *The Ladies' Home Journal:* Masthead. Philadelphia. December 1886. The "true woman's" sphere in nineteenth-century America included traditional domestic duties but allowed room for creative expression, as this illustration reveals. (Michigan State University Library)

FIG. 64. *The Ladies' Home Journal:* "Brush Studies." Philadelphia. February 1887. Guided by the instructions found under this heading, the domestic artist produced works of unexpected merit. (Michigan State University Library)

FIG. 65. *The Ladies' Home Journal:* "Artistic Needlework." Philadelphia. May 1887. Columns such as this instructed the needlework artist in techniques and design problems. (Michigan State University Library)

Other similar schools of design included the Cooper Union Free Art School for Women, begun in New York in the 1850s, and the Cincinnati School of Design. This type of training in the decorative arts, which were closely related to women's traditional domestic skills, was considered much more appropriate for women with artistic talent than the "indelicate" sort of instruction required for the fine arts.

". . . Rare and Unique Works of Art . . ."

~ ~ ~

Faced with such barriers to serious training in the fine arts and conditioned to accept the tenets of "true womanhood," most young women with artistic yearnings chose instead the domestic life and looked upon their art as a pleasant pastime. If they needed guidance, in drawing or fancy work, they turned to the drawing manuals or to instructions found in the pages of the ladies' magazines. *Godey's Lady's Book* featured regular columns such as "The Family Drawing Master" (it was always "Papa") and the "Alphabet of Fancy Letters" while *The Ladies' Home Journal* offered "Brush Studies" (fig. 64) and "Artistic Needlework" (fig. 65).[53] Stencils were also available to those who had need of them. Like the copying of prints, the use of stencils as a learning device and

drawing aid was perfectly acceptable in the nineteenth century. Stencils, known as theorems, were cutout patterns that could be duplicated in paint on paper or velvet grounds. Schoolgirl artists produced many theorem paintings on white velvet with the aid of stencils. Older women also found stencil work helpful and satisfying. Paintings done with stencil are recognizable because of their crisply outlined shapes. Favorite subjects for this technique were fruit and flower pieces, such as Emma Cady's *Fruit in Glass Compote* (1890; fig. 66).

It is tempting today to dismiss paintings done through such mechanical means as mere copy work demanding neither ability nor imagination; in fact it required considerable skill to use theorems well and no small amount of ingenuity to combine the shapes and colors into pleasing designs. Despite its obvious use of stencils, Anny Mohler's "presentation piece" (fig. 67) has an appealing air of spontaneity. Linda Nochlin has suggested that perhaps theorem painting represented the democratization of artmaking in America, extending to all the means by which they might quickly and easily create aesthetically

FIG. 66. Emma Jane Cady: *Fruit in Glass Compote*. East Chatham, New York. 1890. Watercolor on paper. 16" × 19½". This watercolor has recently surfaced and gives us more information about the artist, who was previously known for a nearly identical watercolor owned by the Abby Aldrich Rockefeller Folk Art Center. Photograph courtesy Columbia County Historical Society. (Private collection)

satisfying "works of art," just as Seurat's systematized technique of *divisionism* was intended to do in late nineteenth-century France. As Nochlin points out, "Mechanization and standardization were seen as instruments of democracy, ways of making more and more available to more and more people, not as instruments of alienation or dehumanization."[54] However that may be, it is undeniable that women, working in this manner, often produced works of great beauty that transcended the merely mechanical means and standardized formula.

Still another way in which women learned the skills required for their artistry was through the handing down of traditional forms and techniques brought to America by those who came, willingly or unwillingly, from other parts of the world. Harriet Powers's quilts, for example, resemble in method and motif the appliquéd tapestries produced by the Fon people of Dahomey in West Africa (pl. 6). In both are found the use of animal forms as the proverbial characters of oral traditions; both also employ a similar means of securing the

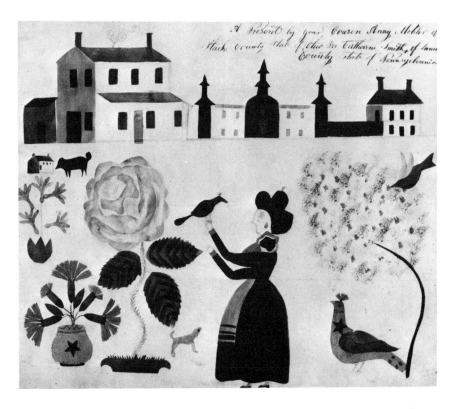

FIG. 67. Anny Mohler: *Anny's Gift*. Stark County, Ohio. 1830. Watercolor on paper. 19½" × 16⅜". Using stencils and sponge, this Ohio artist created a "presentation piece" as a gift for her cousin in Pennsylvania. (Abby Aldrich Rockefeller Folk Art Center)

appliqué figures to the backing by using a chain stitch applied in such a way as to keep the figures smooth.[55] Such similarities suggest that artists among the black community continued to perpetuate the visual arts of their ancestors just as singers and storytellers preserved their rich heritage in songs and legends.

Yet another native art form brought to America by its early settlers was the illuminated manuscript tradition as it had evolved in Germany. German immigrants came as early as 1683, settling mainly in Pennsylvania where they continued to practice the arts of their ancestors, including that of *Fraktur-schriften,* the making of decorated, handwritten documents, which had been required by law in the mother country.[56] These certificates were used to record births, baptisms, marriages, and deaths within the German-speaking communities of Pennsylvania and elsewhere. Some Fraktur pieces were created by school-masters as examples of penmanship or as rewards of merit for their students. Other paintings served as "house blessings," "presentation pieces" to be given as gifts, or as purveyors of religious and moral truths. Although most practitioners of Fraktur-writing were clergymen and schoolmasters, a number of women are known to have worked in this traditional art form. Among those whose names have been recorded is Susanna Heebner, whose Fraktur piece titled *A Song of Summer* (1807) is presented here (pl. 9). Using the motifs and methods handed down through generations, women Fraktur artists such as Heebner blended pictorial elements with text to produce designs that delight the eye. The hand production of Fraktur pieces dwindled for the same economic reason that caused the decline of mourning pictures: competition from commercial lithographed forms. Most Fraktur work was done between 1780 and 1850, with the greatest number occurring between 1800 and 1835.[57] During the 1830s, Fraktur pieces of all kinds were mechanically produced by lithography. Since these were cheaper and neater than those made by hand, they soon replaced the latter in popularity, and by mid-century, there was no longer a market for the products of the Fraktur artist.

Whether Susanna Heebner and other women Fraktur artists worked for pay or purely for pleasure is not certain. However, some women folk artists of early nineteenth-century America were professionals in the sense that they sold their work to support themselves and their households. Perhaps the earliest and surely the most unusual of these was young Martha Ann Honeywell, who had the misfortune to be born without arms and with only one foot. Incredibly, she somehow managed to teach herself how to cut profile portraits (figs. 68, 69) and watch papers (fig. 70) by holding the scissors in her mouth. Using her bizarre technique, she held public exhibitions where she demonstrated her remarkable ability "to the Benevolent and Curious," by cutting silhouettes of members of her audience. Her handbills advertised that "Admittance including a Profile Likeness (cut in a few seconds without hands by Miss Honeywell)" was "25 cents, children half-price."[58]

That Honeywell's talent was exploited by her "poor but respectable" parents is undeniable. Her performances were in the nature of a circus freak show.

FIG. 68. (*Above, left*) Martha Ann Honeywell: Silhouette of a Woman. Massachusetts. Early nineteenth century. Cut paper on paper background. 4″ × 3″. "Cut without hands" is inscribed on this typical silhouette created by a very unusual, handicapped artist. (Private collection)

FIG. 69. (*Above, right*) Martha Ann Honeywell: Silhouette of a Young Man. Massachusetts. Early nineteenth century. Cut paper on paper background. 4″ × 3″. By fashioning these silhouettes, M. A. Honeywell was able to support herself, an unusual accomplishment for a woman born without both arms and one foot. (Private collection)

Yet it was her unfortunate physical deformity that permitted her to practice art professionally, by placing her beyond the limits established for normally endowed young women. One is reminded of the heroine of *Olive,* a popular novel written in mid-century by Dinah Craik, the same woman who dispensed such discouraging advice to aspiring women artists. Young Olive, like young Martha Ann, is similarly afflicted with a physical defect, in her case an abnormally shaped back. Barred, so it seems, from the usual goals of wifehood and motherhood, she pleads for the chance to become an artist. "I, too, am one of these outcasts; give me then this inner life that atones for all!," she begs her male artist friend, although he had taught her "that no woman can be an artist—that is, a great artist." With his reluctant help, she attains her goal for "that sense of personal imperfection which she thought excluded her from a woman's natural destiny, gave her freedom in her own."[59] In the end, love comes even to Olive and, having achieved artistic success, she relinquishes all for her Mr. Gwynne, whose "influence was robbing their Scottish Academy of no one knows how many

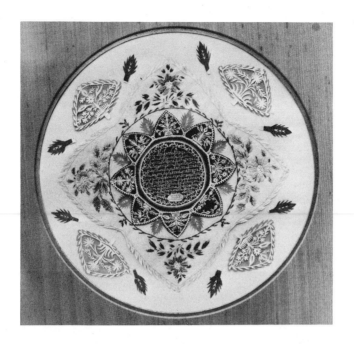

FIG. 70. Martha Ann Honeywell: *The Lord's Prayer*. Massachusetts. Early nineteenth century. Cutout paper. Diam. 8⅞″. Written in the oval below the Lord's Prayer in this cutout are the words: "Cut with the mouth by Martha A. Honeywell." (Edward and Elizabeth Stvan)

grand pictures." Mrs. Craik concludes approvingly that "it was a natural and womanly thing that in her husband's fame Olive should almost forget her own."[60] According to the available evidence, Martha Ann Honeywell's career probably did not end in such noble self-sacrifice.

The case of Mary Ann Willson, although not so spectacular as that of Honeywell, is still somewhat out of the ordinary. Defying convention, she lived openly with her "romantic attachment," a Miss Brundage, who farmed their few acres while Willson created "rare and unique works of art" that she sold to augment their income.[61] In many ways, her domestic life resembled those of other women artists who combined homemaking with picturemaking. Using paints concocted from berries, brick dust, and vegetable dyes, sometimes supplemented with "store paints," Willson produced lively and colorful paintings of varied subjects. Although some of her scenes were based upon engraved sources, her spirited use of bold color, decorative patterns, and flattened forms transformed her paintings into highly original works with a strong sense of abstract design (figs. 71, 72; pl. 10).

Deborah Goldsmith undertook her professional career as a traveling "limner," or portrait painter, in order to support her needy and aged parents. With

FIG. 71. Mary Ann Willson: *Marimaid* [*sic*]. Greenville, New York. 1800–1825. Ink and watercolor on paper. 13" × 16". A fantastic creature is made even more improbable, but more decorative, with the addition of patterned scales in bold colors. (New York State Historical Association)

FIG. 72. Mary Ann Willson: *The Prodigal Son Wasted His Substance*. Greenville, New York. 1815. Ink and watercolor on paper. 12⅝" × 10". Taking license herself with form and color, the artist successfully captured the well-known scene of another's licentious behavior. (National Gallery of Art; Gift of Edgar William and Bernice Chrysler Garbisch)

such a laudable motive, she could scarcely be faulted for overstepping the bounds of decorum by traveling alone from town to town. In any event, her career was cut short by her marriage to the son of a patron, and her life was cut short by her untimely death at the age of twenty-seven. Although Ann Hall's *Self-Portrait with the Ward Family* (1834; fig. 73) is academic rather than primitive in style, it shows us the way in which the portrait artist painted family groups within their homes. In this same manner, Deborah Goldsmith stayed with the Throop family, painting its members, including son George, whom she later married. Some of Goldsmith's paintings include domestic settings, documenting the styles of dress and furnishings of early nineteenth-

FIG. 73. Ann Hall: *Self-Portrait with the Ward Family.* 1834. Oil on canvas. 37½″ × 46½″. Picturing herself at the easel, Ann Hall has documented the way in which early nineteenth-century traveling limners worked in the homes of their clients, recording the likenesses of middle-class American families. (Kennedy Galleries, Inc.)

century America, as well as its people (figs. 74, 75; pl. 11). Goldsmith's two albums, which have been preserved by her descendants, are filled with drawings, watercolors, her own poetry, and the rhymed sentiments entered by her family and friends. In 1829, at the age of twenty-one, she wrote in one of her albums: "Innocently to amuse the imagination in this dream of life is wisdom."[62] Through her innocently imaginative approach to art, Deborah Goldsmith has left us a legacy of enduring value.

FIG. 74. Deborah Goldsmith: *Mr. and Mrs. Lyman Day and Daughter Cornelia.* Upstate New York. 1823. Watercolor on paper. 9⅜" × 8⅞". Busy patterns on the wall and the floor contrast effectively with the simple, flat shapes of the family trio. Photograph by Taylor and Dull, Inc. (Collection of Mrs. Stewart Gregory)

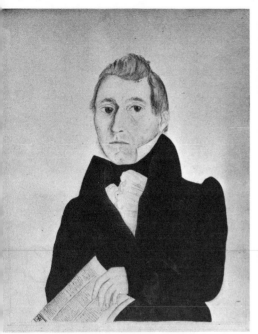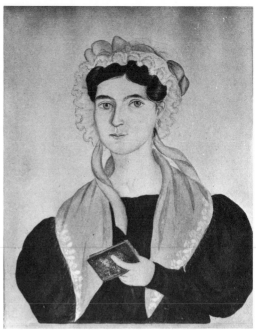

FIG. 75. Deborah Goldsmith: *Husband and Wife.* Upstate New York. 1830. Watercolor on paper. 6″ × 4¾″. Unconcerned with proportion and modeling, the folk artist of portraits concentrated instead upon catching a likeness and creating a pleasing design. (New York State Historical Association)

Other women who worked as itinerant portrait painters were Susan Waters (pl. 12) and one or both of the pair known as the Shutes (fig. 76; pl. 13). The last two are especially interesting since they collaborated on many portraits, using just initials for the first names of their signatures. Several portraits are signed by Mrs. R. W. Shute alone, so she may have been the primary artist. Her co-artist was S. A. Shute. Traveling folk portraitists such as Goldsmith, Waters, and the Shutes were meeting the demand of prosperous, middle-class Americans to have their likenesses preserved for posterity. Whereas wealthy patrons expected the use of academic techniques in their portraits, middle-class clients were inclined to be more tolerant of the self-taught artist's shortcomings in such matters as perspective, proportion, and modeling. Besides, the price was usually right, a modest fee of a few dollars, which made portraits available to all but the most indigent. Although portraiture had existed in this country since the seventeenth century, it flourished from the beginning of the nineteenth century until the end of the Civil War, with the greatest number of portraits being made between 1825 and 1850.[63] The invention of the daguerreotype in the 1830s was an important factor that led to the eventual decline of the "primitive" portrait made by the self-taught artist. By mid-century the daguerreotype portrait had for the most part

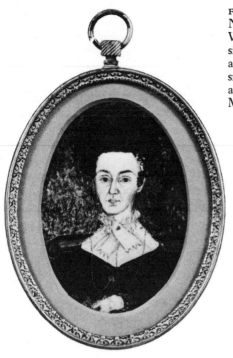

FIG. 76. R. W. Shute: Portrait. Newport, New Hampshire. September 28, 1833. Watercolor on ivory. 3½″ × 2¾″, framed size. Although not so masterfully executed as her large watercolor portraits, still this small work documents Mrs. Shute's adaptability as an artist. (Collection of Mr. and Mrs. Norbert H. Savage)

FIG. 77. Emily Eastman: *Young Girl with Stylish Coiffure*. Loudon, New Hampshire. 1820. Watercolor on paper. 14″ × 10″. Adapted from prints, the stylized portraits of fashionable young ladies by this artist reflect her preoccupation with graceful curvilinear designs. (Collection of Peter Tillou)

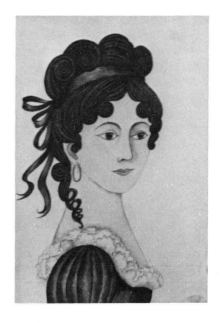

replaced the painted one, especially the miniature. Daguerreotype photographers often took to the road, just as itinerant limners had done, and where once it had been fashionable to have one's portrait painted, now having a daguerreotype taken was the "in" thing to do. Although the popularity of the photograph brought an end of opportunity to self-taught portrait painters, it at least opened up new lines of work for women. By 1885 thousands of young women were employed as photocolorists and many had become photographers in their own right.[64]

Visual Expressions of Faith
~~~

During the nineteenth century, America experienced a religious "re-awakening" that affected the lives of women on every social level. The cult of true woman-

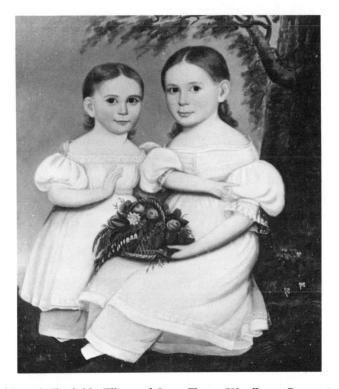

FIG. 78. Hannah Fairfield: *Ellen and Lucy Tracy*. Windham, Connecticut. 1839. Oil on canvas. 35" × 30". Two large-eyed young girls are depicted in this competently done painting. Although the soft modeling of the children's faces might suggest some trained ability on the part of the artist, the proportions of the figures have not been successfully resolved. (Collection of Peter Tillou)

hood had decreed that women were more pious than men, and indeed the women gave the religious revival its greatest support. In the major denominations women played a quiet role by instructing their children in the tenets of the faith, observing their own private devotions, attending church services, and supporting the minister with their "tithes and offerings." Numerous well-known preachers published hundreds of tracts on spiritual and social themes, a few of which have been quoted in this essay. Traveling evangelists moved from town to town, holding "tent meetings" where they encouraged the faithful and exhorted the fallen to "repent and return to the fold." Women were the mainstay of these activities, attending the meetings and providing meals and lodging for

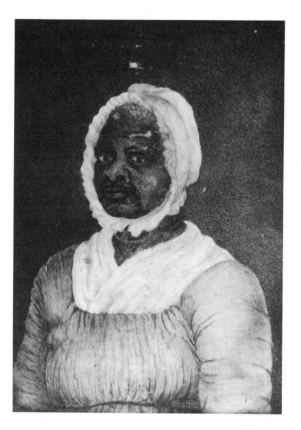

FIG. 79. Susan Sedgwick: *Elizabeth Freeman* (*Mumbet*). Massachusetts. 1811. Watercolor on ivory. 4½″ × 3¾″. Proudly bearing the mark of her former slave status, a scar from a blow inflicted by her cruel master, Elizabeth Freeman posed for her portrait. Long before the emancipation of all slaves, this remarkable woman known as "Mumbet" successfully sued in court for her freedom, basing her case on the laws that had declared all Americans to be free and equal. (Massachusetts Historical Society)

these men of God, but they were not expected to become religious leaders themselves.

Two movements that developed in the nineteenth century did give women the opportunity to express actively their religious convictions. One was the missionary movement, which enlisted women as well as men. As missionaries to heathen lands, women were permitted to preach and to practice medicine. Women who had to remain at home supported the missionary work by organizing into associations, such as the Boston Female Society for Propagating the Diffusion of Christian Knowledge established in 1801.[65] Through their pennies and their prayers, women undergirded the efforts of those who labored "in the

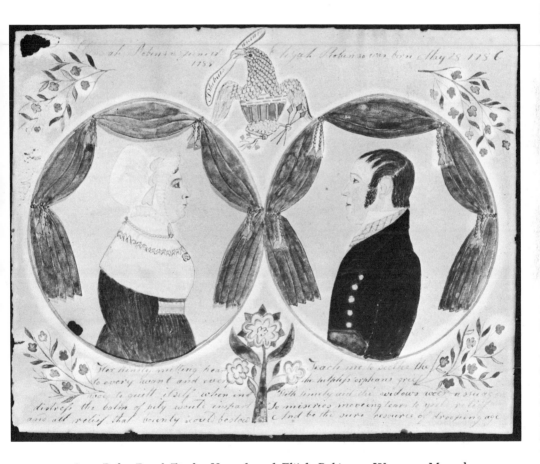

FIG. 80. Ruby Devol Finch: *Hannah and Elijah Robinson*. Westport, Massachusetts. c. 1830. Watercolor and cut paper on paper. Framed together: 8″ × 5″ (approx.). These companion profile likenesses of husband and wife, enclosed within painted frames, are examples of many miniature portraits done by the artist. (Abby Aldrich Rockefeller Folk Art Center)

field." In addition to the missionary movement, women also found spiritual expression through the formation of charitable organizations that attempted to alleviate the sufferings of widows and orphans, or worked for the abolition of slavery. As in other fields of endeavor there were a few women, like Antoinette Brown and Anna Howard Shaw, who broke down the barriers raised against women becoming ministers, or like Mary Baker Eddy, who founded a new faith, Christian Science, in 1879.

Some women managed to express their religious fervor by keeping diaries, writing poetry and novels, or creating works of art based on religious themes. Much schoolgirl art falls into this last category, since it was one of the aims of a fashionable academy to instill a properly pious attitude in its young students. The mourning picture with its Christian symbology was one vehicle for the expression of religious faith. According to one authority on this art form, "the verdant garden is a setting for the Resurrection, the great Christian symbol of everlasting hope. The mourning picture is, therefore, an implicit statement of this Christian vision."[66] Biblical stories were the basis for other types of pictorial art. An unusual accomplishment from the hands of a young artist is Jenny Emily Snow's ambitious oil painting *Belshazzar's Feast* (c. 1850), undertaken without previous training at the age of fifteen (fig. 81). Snow's painting is remarkable for its use of the oil medium by a young artist, for the black-and-white color scheme, uncommon in that medium, and for the artist's unfolklike obsession with perspective and depth. Mature women also were attracted to biblical subjects, as the work of Ruby Devol Finch reveals (pl. 14). Even the quiltmaker found inspiration in her Bible. Harriet Powers's magnificent quilt is filled with the great heroes of the Bible, those who endured great trials and emerged victorious: Job, Jonah, Noah, Moses (pl. 6). According to the buyer of her first quilt, Powers had memorized sermons heard at church, and this was her storehouse of biblical knowledge from which she drew her heroes and animals.

Unlike the major Protestant denominations where the role of women was subordinate, there were a number of smaller religious sects that gave to women full equality in the government of their groups. It was in one such sect, where women enjoyed equal status with men, that the most personal and intense artistic expressions of faith occurred. The Shakers, brought to America from England in 1774 by Mother Ann Lee, held that God is both male and female, a belief reflected in the equal division of responsibility between the Elders and Eldresses of each Shaker community. It was during and immediately after the "era of manifestations" from 1837 to 1847, when the Shakers were experiencing a spiritual renewal, that the sisters of the order produced a great number of "spirit drawings" inspired by private mystical visions. These inspirational drawings and paintings recorded messages and visions given to their makers, the "instruments," during moments of close communion with the departed saints of the spirit world (figs. 82, 83). Many divine revelations were received and recorded by artists such as Hannah Cohoon (figs. 84, 85) and Eliza Ann Taylor (pl. 15). According to authorities on Shaker inspirational drawings, they were

neither automatic nor spiritistic but rather "expressions of deeply moving experiences."[67] The explanatory inscription written below her *Tree of Light or Blazing Tree* (1845) by Hannah Cohoon reads in part: "I saw a whole Tree as the Angel held it before me as distinctly as I ever saw a natural tree. I felt very cautious when I took hold of it lest the blaze should touch my hand."[68] Since the Shakers favored simplicity in their dress and surroundings, the inspirational drawings were never openly displayed. Many of these manifestations of a deep spirituality were preserved, however, and today we admire them both for their beauty of design and for their reflection of faith. Most of the drawings were done during the 1840s and 1850s when the effects of spiritual energy were strongest, but by 1860 the revival had ended and pictorial expressions of mystical visions were no longer produced.

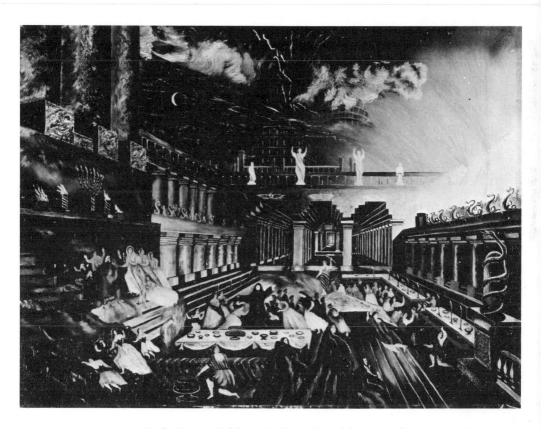

FIG. 81. Jenny Emily Snow: *Belshazzar's Feast*. Hinsdale, Massachusetts. c. 1850. Black and white oil paint on canvas. 22″ × 28″. This remarkable version of a biblical event was the work of an untrained artist of fifteen, using a color scheme uncommon for the oil medium and displaying a fascination with perspective and space. (Abby Aldrich Rockefeller Folk Art Center)

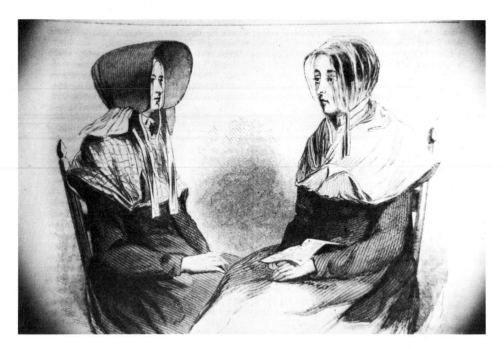

FIG. 82.  *Sisters in Everyday Costume*. Illustration from *Harper's* monthly magazine. July 1857. Two Shaker women sit stiffly in contemplation, perhaps in anticipation of becoming instruments for a "spirit drawing." Photograph courtesy Michigan State University.

FIG. 83.  *Interior of the Meeting-House*. Illustration from *Harper's* monthly magazine. July 1857. Worshiping in somber, stark settings, Shaker women sometimes experienced celestial visions. Photograph courtesy Michigan State University.

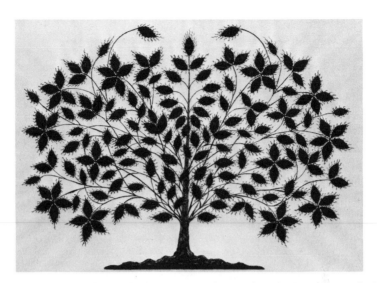

FIG. 84.   Hannah Cohoon: *The Tree of Light or Blazing Tree*. Hancock, Massachusetts. 1845. Ink and watercolor on paper. 18⅛″ × 22⁹⁄₃₂″. Inscribed below the tree are the words: "Seen and received by Hannah Cohoon in the City of Peace Sabbath Oct. 9th 10th hour A.M. 1845, drawn and painted by the same hand." (Hancock Shaker Community, Inc.)

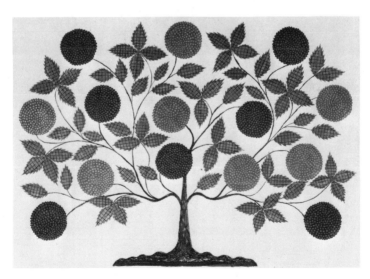

FIG. 85.   Hannah Cohoon: *The Tree of Life*. New Lebanon, New York. 1854. Ink and watercolor on paper. 18⅛″ × 23⁵⁄₁₆″. Having first seen this tree during a spiritual experience, the artist recorded her vision and later received its name from the spirit of Mother Ann, who told her "Your tree is the tree of life." (Hancock Shaker Community, Inc.)

". . . Not Even Rags to Make Patches . . ."

~ ~ ~

Among those major events of the nineteenth century that shaped the lives of many American women was the great westward migration from the older established communities of the East toward those relatively unknown frontiers of the West where fortunes might be found. Preceded by explorers and trappers, the settlers of the West came in large numbers, enduring incredible hazards and hardships on their arduous journey by wagon train. Among them were many women, impelled by loyalty to their adventurous husbands and by various inducements used to entice women away from their homes in the East and into

FIG. 86. Postcard. *Dinner Call*. Michigan. Late nineteenth century. Photograph. 3½″ × 5½″. A scene at L. B. Curtis and Company's camp at Midland County, Michigan, showing a cook and his family standing outside their crude, snow-covered log cabin, poignantly captures the harshness of pioneer life. (Michigan History Division, State Archives)

the "promised land." One such lure was the Oregon Land Donation Act of 1850, which gave 640 acres to husband and wife (half of which she held separately) and 320 acres to a single woman.[69] Although these pioneers carried with them the cultural values of the East, including those ideas that defined and confined the "true woman," the exigencies of life on the frontier and the struggle for mere survival demanded everyone's active participation and modified to a great extent the myths of womanly weakness and her need of protection. A delicate woman was a hindrance and a strong woman much esteemed, according to the new husband interviewed on an Illinois riverboat:

> I calculate 'taint of much account to have a woman if she ain't of no use . . . every man ought to have a woman to do his cookin' and such like, 'kase it's easier for them than it is for us. They take to it kind o' naturally . . . I reckon women are some like horses and oxen, the biggest can do the most work, and that's what I want one for.[70]

As in the early Colonial days, women were valued all the more because they were outnumbered, with the ratio of men to women running as high as twenty to one in some regions. Their very scarcity gave to women advantages they had not enjoyed in their previous settings. In 1838 Kentucky gave to widows or single women who owned taxable property the right to vote in district school elections. Women in Colorado and the Wyoming territory gained the right to vote after the Civil War.[71] But in spite of the social and political gains, the life of a pioneer woman was hard and lonely. Perhaps the most difficult part of her experience was the realization that she might never again see the family and friends she had left behind. Many frontier women felt compelled to commit their thoughts and feelings to diaries and letters that bare their sense of loneliness and longings for home. America Rollins Butler, traveling west by covered wagon in the 1860s, wrote the following entry in her diary:

> Raining tonight. Looks rather dreary to me when it storms, and I cast a thought upon that quiet little home that once sheltered us from wind and rain, but it is never to be seen again perhaps by me. And again does my mind linger around those fond ones I've left, those that sleep in death, and those that surround the fireplace.[72]

Many of these pioneer women, raised in relative comfort, were totally unprepared for the rude way of life that awaited them in the wilderness. Anna Howard Shaw's account of her family's arrival at their new home in the wilds of Michigan gives a vivid picture of the sort of cultural shock such women experienced:

> What we found awaiting us were the four walls and the roof of a good-sized log house, standing in a small cleared strip of wilderness, its doors

and windows represented by square holes, its floor also a thing of the future, its whole effect achingly forlorn and desolate. It was late in the afternoon when we drove up to the opening that was its front door, and I shall never forget the look my mother turned upon the place. Without a word, she crossed the threshold and, standing very still, looked slowly around her. Then something within her seemed to give way, and she sank upon the floor. She could not realize even then, I think, that this was really the place father had prepared for us, that here he expected us to live. When she finally took it in she buried her face in her hands, and in that way she sat for hours, without speaking or moving . . . [Much later] my mother came to herself but her face when she raised it was worse than her silence had been . . . [It] never lost the deep lines those first hours of her pioneer life had cut upon it.[73]

Although her day might be filled with innumerable chores, the woman in the wilderness longed for "something to do," as one woman's reminiscences reveal:

I think the most unhappy period of my life was the first year spent on Clatsop, simply for the want of something to do. I had no yarn to knit, nothing to sew, not even rags to make patches . . . One day Mrs. Parrish gave me a sack full of rags and I never received a present before nor since that I so highly appreciated as I did those rags.[74]

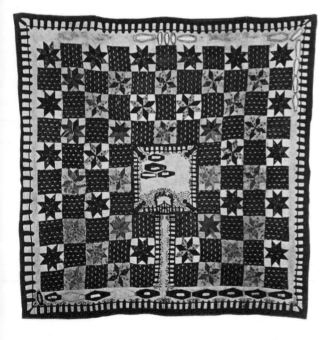

FIG. 87. Elizabeth Roseberry Mitchell: Coffin Quilt. Lewis County, Kentucky. 1839. Patchwork and appliqué with embroidery. 79½″ × 80″. This appears to be the equivalent in the quilting medium of the embroidered and watercolored mourning picture. When a member of the quiltmaker's family died, she would remove a coffin from the border of the quilt and place it within the graveyard depicted in the center of the quilt. (Kentucky Historical Society)

FIG. 88. Celestia Young: *Adam's Mill*. Plymouth, Michigan. 1856. Oil on paper. 11″ × 17″. This young girl's painting documents a major industry in early Michigan history. (Greenfield Village and Henry Ford Museum)

Living in simple sod or log dwellings that were sparsely furnished with the few things she had been able to bring with her, the pioneer woman, like her sisters in more settled eastern communities, brightened her home and her life by creating colorful quilts and rugs, or by painting the scenes before her. In 1849 Susan McCord, newly married, began keeping house in a log cabin on an Indiana farm, raised a large family, did all her household tasks, made butter and soap, milked cows, kept chickens, tended a big garden, canned fruits and vegetables, treated her neighbors' illnesses with medicinal herbs, went to church regularly, read her Bible through yearly, and still found time and energy to produce her quilt masterpieces. In Kentucky, Elizabeth Mitchell made a touching personal statement about life's uncertainty with her Coffin Quilt (fig. 87), recording family deaths as they occurred by taking labeled coffins from the borders of the quilt and moving them to the graveyard depicted in the center of the quilt. Sallie Cover looked through her window and painted the sod house of her neighbor, capturing the isolation and loneliness of life on the prairie (pl. 16). Other women painted scenes that reflected the industrial activity of the West: Celestia Young's *Adam's Mill* (1856) in Michigan (fig. 88), Mary Brown's *Hydraulic Mining in the Boise Basin* (c. 1875) in Idaho (fig. 89). These women and countless others played a significant role in the settling and devel-

FIG. 89. Mary Brown: *Hydraulic Mining in the Boise Basin.* Idaho. c. 1875. Oil on canvas. 27⅚₆″ × 21¼″. Although many events in the westward expansion of industry were documented by photography, this depiction of mining in Idaho is an exceptional oil painting, made more unusual by the fact that it was done by a woman. (Idaho State Historical Museum)

oping of the American frontier; through their innate artistry they have left us doubly in their debt.

## "Leave Women, then, to Find Their Sphere"
~~~

Throughout the nineteenth century self-taught women artists looked about them, then re-created, with brush or needle, the scenes they saw. In a few instances their views focused upon the natural and structural elements of their environments: the hills and fields, the lakes and streams, the buildings and roads. More frequently the artist's interest was in depicting her contemporaries engaged in the myriad activities of American life. These landscape and genre scenes were less common in the early years of the century, when subject matter tended to be portraits, or biblical and literary scenes based upon print sources. Nevertheless, even then there were those who attempted to record the look and the life of America. Painting from her window at Brookline, Massachusetts, in 1813, Susan Heath carefully included all recognizable landmarks in her view of the Boston State House (fig. 91). Mary Keys found pleasure in revealing the rhythmic pattern provided by the houses, hills, and locks in her *Lockport on the Erie Canal* (1832; pl. 17). Susan Merritt's picnic scene of 1845 also delights in the recurrent accents of human figures gathered to celebrate the nation's birthday, and perhaps also the marriage of the artist's sister (pl. 18).

As the century progressed, women moved out into the mainstream of American life, by banding together in the fight against slavery and for suffrage, and by pressing individually for admittance to the professional fields. In 1837 women had joined the struggle for abolition by forming the National Female Anti-Slavery Society. The effort to win freedom for slaves expanded to encompass the pursuit of the vote for women, formally launched at the Seneca Falls Convention in New York in 1848, beginning a movement that would span the next seventy years. In the 1840s Antoinette Brown, the first American woman to be ordained a minister, graduated from Oberlin College; Elizabeth Blackwell, destined to become the first woman doctor in America, was admitted to Geneva College medical school; and Maria Mitchell, America's first woman astronomer, discovered a new comet. Other women followed these pioneers into professional roles so that by the end of the century women were represented in almost every field of endeavor. With the widening of woman's sphere of interest and activity, a new sensitivity to her environment encouraged more pictorial observations of the American scene. Among needlework examples, Phebe Kriebel's embroidered *Townscape* (1857; pl. 19) and Celestine Bacheller's crazy quilt landscapes (pl. 20) preserved these artists' impressions of their own natural and architectural settings. Leila Bauman's painted summary of nineteenth-century transportation shows America on the move (fig. 92), Elizabeth Miner's portrayal of a county fair documents a still-popular American event (fig. 94), while Anna Hart's depiction of a lakeside outing of 1870 is early evidence of the American custom of camping (fig. 93).

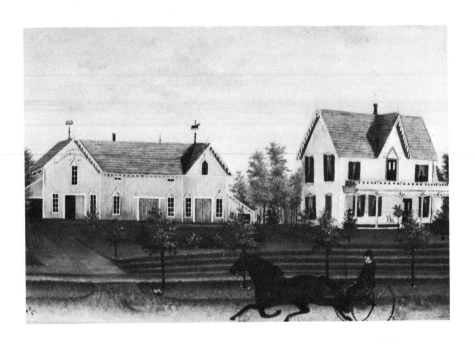

FIG. 92. Leila T. Bauman: *Geese in Flight.* New Jersey. c. 1870. Oil on canvas. 20¼″ × 26¼″. The artist has attempted to record all the means of travel in the nineteenth century in this busy scene. (National Gallery of Art; Gift of Edgar William and Bernice Chrysler Garbisch)

FIG. 90. (*Opposite page, top*) Antoinette (Nettie) Cortrite: *Fanning Mill Factory.* Detroit, Michigan. 1887. Oil on board. 18″ × 24″. Apparently the owners of the industry housed within this American Gothic barn were successful enough to commission a "portrait" of their establishment. Photograph courtesy The Museum, Michigan State University. (Collection of Henry and Evelyn Raskin)

FIG. 91. (*Opposite page, bottom*) Susan Heath: *Boston State House from Brookline.* Brookline, Massachusetts. 1813. Watercolor on paper. 15¾″ × 22″. This early nineteenth-century landscape is unusual for its factual representation of an American scene documented by the youthful artist from the window of her family home. (Private collection)

FIG. 93. Anna S. Hart: *Landscape with Lake, Tents, and Figures.* Battle Creek, Michigan. 1870. Oil on canvas. 18″ × 23″. Like today's campers, nineteenth-century Americans occasionally escaped city cares and routines by retreating to the woods and lakes. A banjo player provides musical entertainment, perhaps anticipating the present-day use of pocket radios, portable television sets, and amplified stereo systems. (Abby Aldrich Rockefeller Folk Art Center)

FIG. 94. (*Opposite page, top*) Elizabeth Campbell Miner: *The Canton Fair.* Canton, New York. 1871. Oil on canvas. 29″ × 36″. The color and excitement of a popular American institution, the county fair, is captured in this genre scene. (Griffiths Arts Center, Saint Lawrence University; Gift of Mary Wead Weeks)

FIG. 95. (*Opposite page, bottom*) Ella Emory: *Alice Cushing in the Sitting Room of the Peter Cushing House.* Hingham, Massachusetts. 1878. Oil on canvas. 12¾″ × 17½″. The artist, an aunt of the child pictured here, spent the summer of 1878 in the Cushing home. (Private collection)

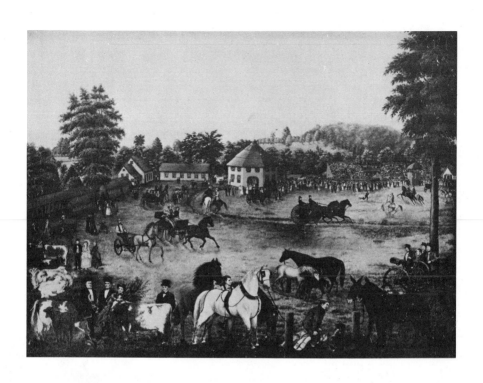

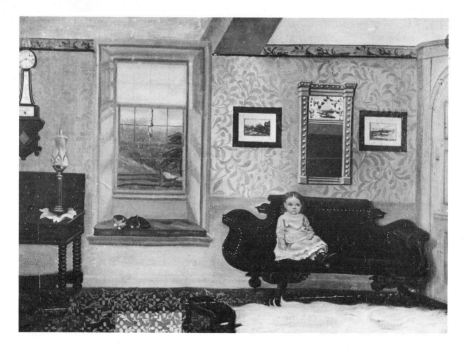

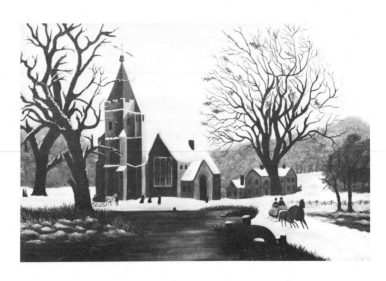

FIG. 96. Celesta Huff: *Winter Landscape in Maine*. Maine. 1889. Oil on canvas.
19¾" × 29⅞". Simplified shapes offer sharp contrast to the snow-filled setting in this
reconstruction of a familiar Sunday scene. (Colby College Art Museum; Collection
of Peter Tillou)

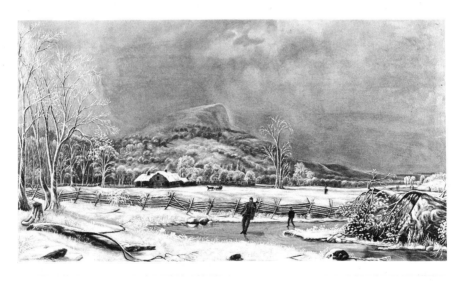

FIG. 97. Frances Clark: *Skating*. New England. c. 1885. Oil on canvas. 23" × 42".
Her technical competence in the treatment of light and space indicates that the artist
might have had some training. (New York State Historical Association)

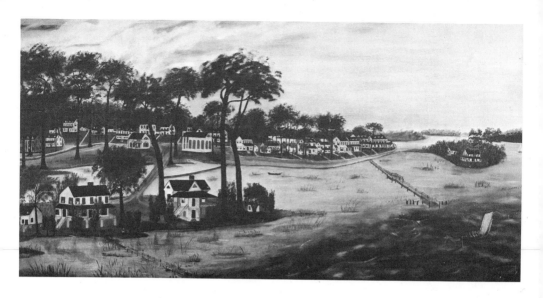

FIG. 98. Portia Trenholm: *Legareville, South Carolina*. South Carolina. c. 1850. Oil on canvas. 28⅞″ × 52¼″. This island town was a summer haven for the families of wealthy cotton planters such as the father and grandfather of the artist. The town was burned in 1864 to prevent its capture by advancing Union gunboats. (Abby Aldrich Rockefeller Folk Art Center)

It is interesting to note the infrequent appearance of certain subjects in the work done by women folk painters of the nineteenth century. In spite of the impact upon their lives produced by the abolitionist movement, the pursuit of the vote, and the Civil War, there are few, if any, examples of paintings that deal with these divisive developments. Perhaps it was necessary for women first to define themselves fully as individuals, each endowed with unique abilities, before their art could deal effectively with larger issues. In contrast to the painted works, numerous quilts contain visible or veiled references to contemporary political and social events through both the design motifs and the names assigned to them. The use of such designs as Lincoln's Platform (also known as Sherman's March), the Underground Railroad, and the Slave Chain gave opportunity for the quiltmaker to express her views on the Civil War and slavery. As in some folk paintings, other quilt designs, such as Crown of Thorns and Jacob's Ladder, reflected religious sentiments, whereas Rocky Road to California and Trail of the Covered Wagon were inspired by the migration West.

Throughout the century women had joined the debate waged over their true place in society. In 1855 suffragist Lucy Stone had summed up the progressive position in these words:

> Wendell Phillips says, "The best and greatest thing one is capable of doing, that is his sphere." I have confidence in the Father to believe that when He gives us the capacity to do anything He does not make a blunder.

Leave women, then, to find their sphere. And do not tell us before we are born even, that our province is to cook dinners, darn stockings, and sew on buttons . . . The same society that drives forth the young man, keeps woman at home—a dependent—working little cats on worsted, and little dogs on punctured paper, but if she goes heartily and bravely to give herself to some worthy purpose, she is out of her sphere and she loses caste.[75]

By the last quarter of the century, many women were willing to forgo the dubious privileges of the pedestal by forsaking their predestined sphere and were actively engaged in the work force, in the struggle for suffrage, in humanitarian movements, and in numerous professions, including serious personal commitments to art. The sort of support and recognition that quiltmakers had long given to one another was now given to professional women artists by other women interested in and active in the arts. Women played a critical role in raising the requisite funding for the Centennial Exposition of 1876, held in Philadelphia. Denied space within the Main Exhibition Hall for a display of women's work, they enlisted further financial support to provide their own Woman's Pavilion (figs. 99, 100) where the products of women's hands and

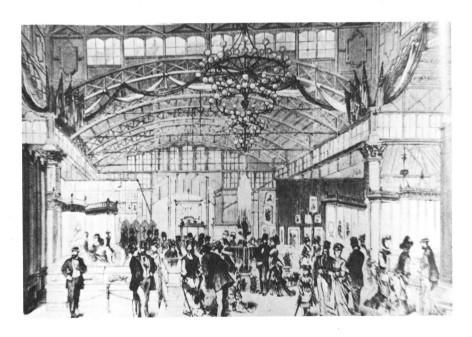

FIG. 99. Interior of the Woman's Pavilion. Philadelphia. 1876. The Woman's Pavilion attracted crowds of fashionably dressed visitors who were curious to see the products of women's hands and minds. From Joseph M. Wilson, *The Masterpieces of the Centennial Exhibition,* Vol. III (Philadelphia, 1876).

minds might be shown.[76] The same spirit of sisterhood was evident in the organization and exhibition of women's art and handicraft at the World's Columbian Exposition, held in Chicago in 1893. By then, it was even possible to engage a woman architect, Sophia G. Hayden, for the design of the Woman's Building (fig. 101), an encouraging evidence of the progress that women had made toward the full realization of their potential.

Very little of the art created by self-taught women artists was included in the expositions of 1876 and 1893. Folk art in general was not accorded serious appraisal or appreciation until the third decade of the twentieth century. And it is only now, in the final quarter of this century, that we have begun to grasp the significance of the creative work done by women folk artists of the past under those special circumstances that have shaped both their lives and the character and content of their art. Confined by custom and by choice to their domestic spheres, women of nineteenth-century America channeled their creative energies into the exploration of areas consistent with their interests and experience. By following their own paths of visual expression, these women went well beyond the expectations of society in the extent and excellence of their impressive artistic output.

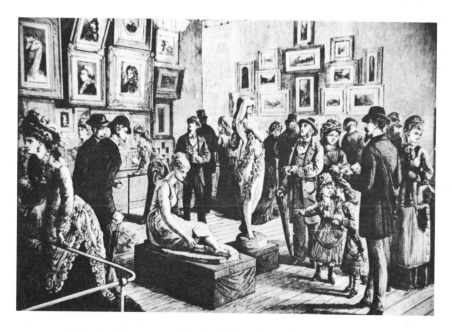

FIG. 100. The Art Department in the Woman's Pavilion. Philadelphia. 1876. In the Art Department, works of art done in various media testified to the creativity and competence of women artists. From Frank Leslie, *Historical Register of the U.S. Centennial Exposition* (New York, 1877).

FIG. 101. *Woman's Building.* Designed by Sophia G. Hayden. Chicago. 1893. For the World's Columbian Exposition, a trained woman architect was available to design the building that housed displays of women's art and handicrafts. From *Art and Handicraft in the Woman's Building of the World's Columbian Exposition,* ed. Maud Howe Elliott (New York: Boussod, Valadon & Co., 1893).

FIG. 102. *(Opposite page) Art and Handicraft in the Woman's Building of the World's Columbian Exposition,* Maud Howe Elliott, ed. (New York: Boussod, Valadon & Co., 1893). Frontispiece. The "creative woman," surrounded by the symbols of her various media of expression, is posed against the backdrop of the Woman's Building at the World's Columbian Exposition of 1893.

ART AND HANDICRAFT
IN THE
WOMAN'S BUILDING

NOTES

1. *Godey's Lady's Book* (August 1879).

2. Barbara Welter, *Dimity Convictions: The American Woman in the Nineteenth Century* (Athens: Ohio University Press, 1976), p. 21.

3. "Female Irreligion," *Ladies' Companion*, 13 (May–October 1840), III.

4. William Alcott, *The Young Man's Guide* (Boston: Perkins and Marvin, 1836), p. 249.

5. Walter Raleigh, ed., *The Complete Works of George Savile, First Marquess of Halifax* (Oxford: Clarendon Press, 1912), p. 8.

6. W. A. Beach, *An Improved System of Midwifery* (New York, 1847), p. 45.

7. William P. Dewees, *Treatise on the Diseases of Females*, 2d ed. (Philadelphia, 1828), p. 19.

8. Charles D. Meigs, *Lecture on Some of the Distinctive Characteristics of the Female*, delivered before the class of the Jefferson Medical College, January 1847 (Philadelphia, 1847), p. 17.

9. Mrs. A. J. Graves, *Woman in America: Being an Examination into the Moral and Intellectual Condition of American Female Society* (New York: Harper & Bros., 1841), pp. 143–149.

10. Thomas R. Dew, "Dissertation on the Characteristic Differences Between the Sexes, and on the Position and Influence of Woman in Society," *Southern Literary Messenger* (Richmond, Va.), 1 (May 1835), pp. 493–512.

11. Samuel K. Jennings, *The Married Lady's Companion, or Poor Man's Friend*, rev. 2d ed. (New York: Lorenzo Dow, 1808), p. 61.

12. Maria J. McIntosh, *Woman in America: Her Work and Her Reward* (New York: D. Appleton & Company, 1850), p. 22.

13. *The Lawes Resolutions of Womens Rights; or The Lawes Provision for Women* (London, 1632), pp. 124–125.

14. Graves, *Woman in America*, p. 164.

15. Jonathan F. Stearns, *Female Influence, and the True Christian Mode of Its Exercise: A Discourse Delivered in the First Presbyterian Church in Newburyport, July 31, 1837* (Newburyport, Mass., 1837), p. 8.

16. *Godey's Lady's Book* (August 1879).

17. Sarah Josepha Hale, quoted in *Herstory: A Woman's View of American History*, by June Sochen (New York: Alfred Publishing Co., 1974), p. 119.

18. Charles W. Marsh, *Recollections, 1837–1910* (Chicago: Farm Implement News, 1910), p. 298.

19. Constantia [Judith Sargent Murray], "The Equality of the Sexes," *Massachusetts Magazine* (March–April 1790), pp. 132–133.

20. Eliza Southgate, *A Girl's Life Eighty Years Ago: Letters of Eliza Southgate Bowne*, edited by Clarence Cook (New York: Charles Scribner's Sons, 1887), p. 38.

21. Sojourner Truth, quoted in *The History of Woman Suffrage*, edited by Elizabeth Cady Stanton, Susan B. Anthony, and Mathilda Joslyn Gage (Rochester, N.Y., 1881), vol. 1, pp. 115–117.

22. Stearns, *Female Influence*, pp. 8–24.

23. "Pastoral Letter of the General Assembly of Massachusetts (Orthodox) to the Churches Under Their Care," *The Liberator* (Boston), August 11, 1837.

24. Grant Allen, "Woman's Place in Nature," *The Forum*, 7, no. 3 (May 1889), p. 263.

25. Dinah M. Craik, *A Woman's Thoughts About Women* (New York: Rudd & Carleton, 1859), pp. 50–53.

26. Harriet Goodhue Hosmer, *Letters and Memories*, edited by Cornelia Carr (London: Lane, 1913), p. 35.

27. Jane Grey Swisshelm, *Half a Century* (Chicago: Jansen, McClurg & Company, 1880), pp. 47–50.

28. Lydia Huntley Sigourney, *Letters to Young Ladies* (Hartford, 1835), p. 25.

29. Allen H. Eaton, *Handicrafts of New England* (New York: Bonanza Books, 1969), p. 341.

30. Carleton L. Safford and Robert Bishop, *America's Quilts and Coverlets* (New York: E.P. Dutton, 1972), p. 86.

31. "The Quilting Party," attributed to Stephen Collins Foster, and first published in 1858.

32. Caroline R. Clarke, *Diary of Caroline Cowles Richards, 1852–1872* (New York, 1908), p. 102.

33. Pattie Chase, "Quilting: Reclaiming Our Art," *Country Women*, Issue 21 (September 1976), p. 9.

34. Marguerite Ickis, *The Standard Book of Quilt Making and Collecting* (New York: Dover Publications, 1960), p. 270.

35. Patricia Mainardi, "Quilts: The Great American Art," *The Feminist Art Journal* (Winter 1973), p. 19.

36. Gladys-Marie Fry, "Harriet Powers: Portrait of a Black Quilter," in *Missing Pieces: Georgia Folk Art 1770–1976*, edited by Anna Wadsworth, exhibition catalogue (1976), pp. 17–19.

37. Anita Schorsch, "Mourning Art: A Neoclassical Reflection in America," *The American Art Journal* (May 1976), pp. 5–15.

38. Gerda Lerner, *The Female Experience: An American Documentary* (Indianapolis: The Bobbs-Merrill Company, 1977), p. 211.

39. Nina F. Little, *Country Art in New England 1790–1840* (Sturbridge, Mass.: Old Sturbridge Village, 1960), p. 25.

40. Southgate, *A Girl's Life Eighty Years Ago*, p. 17.

41. *Ibid.*, p. 25.

42. Welter, *Dimity Convictions*, p. 10.

43. Laverne Muto, "A Feminist Art—The American Memorial Picture," *Art Journal*, 35/4 (Summer 1976), pp. 352–358.

44. Eliza Leslie, "Pencil Sketches" (1835), in *Homespun Handicrafts* by Ella Shannon Bowles (Philadelphia: J. B. Lippincott Company, 1931), p. 141.

45. Dean A. Fales, Jr., and Robert Bishop, *American Painted Furniture 1660–1880* (New York: E.P. Dutton, 1972), pp. 182–183.

46. Sarah Stickney Ellis, "The Daughters of England: Their Position in Society, Character, and Responsibilities" in *The Family Monitor and Domestic Guide* (Philadelphia: G.S. Appleton, 1843), pp. 38–39.

47. Sarah Moore Grimké, "Intellect of Woman," *The Liberator*, January 26, 1838 (a letter to her sister in which she attacks such a position).

48. Emma Willard, "An Address to the Public; Particularly to the Members of the Legislature of New York, Proposing a Plan for Improving Female Education," 2d ed. (Middlebury, Vt.: S. W. Copeland, 1819).

49. Robert S. Fletcher, *History of Oberlin College to the Civil War* (Oberlin, Ohio: Oberlin College, 1943), vol. 1, p. 291.

50. Christine Jones Huber, *The Pennsylvania Academy and Its Women,* exhibition catalogue (1973), p. 12.

51. *Ibid.*, p. 21.

52. *The Horticulturalist* (August 1851), pp. 390–391; reprinted in The Magazine *Antiques* (April 1975), p. 687.

53. *Godey's Lady's Book*, 1858, and *Ladies' Home Journal*, 1887.

54. Linda Nochlin, "How Feminism in the Arts Can Implement Cultural Change," *Women and the Arts: Arts in Society,* 11, no. 1 (Spring–Summer 1974), pp. 87–88.

55. Fry, *Harriet Powers*, p. 18.

56. Henry S. Borneman, *Pennsylvania German Illuminated Manuscripts* (New York: Dover Publications, 1973), pp. 1–8.

57. John Ebert and Katherine Ebert, *American Folk Painters* (New York: Charles Scribner's Sons, 1975), p. 185.

58. Alice Van Leer Carrick, *A History of American Silhouettes: A Collector's Guide 1790–1840* (Rutland, Vt.: Charles E. Tuttle, 1968), pp. 104–108.

59. Dinah M. Craik, *Olive* (New York: Harper & Bros., 1875), pp. 164–168.

60. *Ibid.*, p. 420.

61. Jean Lipman and Alice Winchester, *Primitive Painters in America, 1750–1950* (New York: Dodd & Mead, 1950), p. 54.

62. *Ibid.*, p. 96.

63. Ebert, *American Folk Painters*, p. 43.

64. Mrs. M. L. Rayne, *What Can a Woman Do: or Her Position in the Business and Literary World* (Detroit: F.B. Dickerson, 1885), pp. 120–127.

65. Linda Grant DePauw and Conover Hunt, *"Remember the Ladies": Women in America 1750–1815* (New York: The Viking Press, 1976), exhibition catalogue, p. 78.

66. Anita Schorsch, *Mourning Becomes America: Mourning Art in the New Nation*, exhibition catalogue (1976), p. 3.

67. Edward Deming Andrews and Faith Andrews, *Visions of the Heavenly Sphere: A Study in Shaker Religious Art* (Charlottesville, Va.: The University Press of Virginia, 1969), p. 62.

68. *Ibid.*, p. 16.

69. Eleanor Flexner, *Century of Struggle: The Woman's Rights Movement in the United States* (New York: Atheneum, 1974), p. 157.

70. Eliza W. Farnham, *Life in Prairie Land* (New York: Harper & Bros., 1846), pp. 37–38.

71. Sochen, *Herstory: A Woman's View of American History*, p. 114.

72. Brett Harvey Vuolo, "Pioneer Diaries: the Untold Story of the West," *Ms.* (May 1975), p. 34.

73. Anna Howard Shaw, *The Story of a Pioneer* (New York: Harper & Bros., 1915), pp. 25–26.

74. Vuolo, "Pioneer Diaries," p. 34.

75. Lucy Stone, speech delivered at the National Women's Rights Convention in Cincinnati in October 1885, in *The History of Woman Suffrage,* vol. 1, pp. 165–166.

76. Judith Paine, "The Woman's Pavilion of 1876," *The Feminist Art Journal,* 4, no. 4 (Winter 1975/76), pp. 6–7.

FIG. 103. "In a Spirit of Freedom." Photographed at Yosemite National Park, California. c. 1895. Posed daringly in an improbable setting, these two women of the late nineteenth century symbolize the spirit of the "new woman," free to explore all of life's opportunities. Photograph courtesy National Park Service.

"The Women Have Leaped
from Their Spheres . . ."

Confusion has seized us, and all things go wrong,
The women have leaped from "their spheres,"
And instead of fixed stars, shoot as comets along
And are setting the world by the ears.[1]

The image of women shooting as comets that "have leaped from their spheres" was perhaps poetically excessive, yet women were no longer "fixed stars" in a male-dominated universe by the late nineteenth century. The period from 1880 to 1920 brought significant social changes in the lives of American women. Once unquestioned, the cult of "true womanhood" was under serious scrutiny by the very women who were raised within its power. Women became a part of the ever-present industrial revolution that reshaped the nature of not only the social institutions but also the mores of day-to-day life. Although still a powerful and deeply rooted force, religion ceased to reign supreme as the central agent underlying the values espoused by both women and men, for science and empiricism now also governed an awakened spirit in the hearts and minds of America.

Women, no longer resigned to their place in the home, set out to find a place for themselves in their communities. A wave of immigrants contributed to the growing number of women seeking work during the late nineteenth century and the first two decades of this century. Many sought employment merely to survive, as immigrants struggled to find a piece of the American dream, which dimmed when they confronted limited opportunities for women in America. As women found their way into the work force, primarily in factories, they were generally relegated to unskilled jobs, where more often than not they were paid a piece rate rather than a standard daily wage. The days were long and the mere notion of upward mobility was a virtual impossibility.

Long associated with the production of textile forms, women found extensive opportunities for employment in the expanding textile field. By the 1880s, in places such as the cotton mill town of Cohoes, New York, four out of five first- or second-generation women between the ages of fifteen and nineteen were employed in the textile factories.[2] Such a situation was typical of young immigrant women of this period, although some immigrant nationalities, such as the Italians, exercised strict control over the lives of their daughters and restricted their entry into the work force. Women were never able to divorce themselves from the postulated "natural affinity" they inherited for the tedious work of the

hands. Sweatshops and factories were the destiny of many of these immigrant women because their employment was vital to the very survival of their families. The needlework tradition had been a part of their early years before their departure for a new life in America. One Russian immigrant named Rose Cohen remembered her childhood training this way, "As soon as we were able to hold a needle, we were taught to sew."[3] But their "new life" dramatically reduced the creative needlework of these women, for their energies were sapped because of the long hours of the struggle merely to put food on the table. Although needlework was still produced during these years, the popularity of the ladies' magazines and the "how-to" articles resulted in a pruning of much of the individual creativity of handwork. Needlework kits complete with stamped embroidery patterns were commonplace, and instruction books were in wide circulation. The emphasis was clearly on pragmatic needlework and sewing skills for working women. New generations of young women had to forgo the opportunity for personal expression and they yielded to the dominant mood of the day, which was expedient production in the dawning modern industrial age.

The middle-class woman began seeking an active role to be played outside the domestic setting where she had long been relegated. The promise of mechanization brought with it dreams of mechanized kitchens and home conveniences that would allow women more free time and release them from the responsibilities for which they had been raised and praised. The period from 1890 to 1920 was one of dramatic social change for American women.

> Neither middle-class mothers nor immigrant workers rested complacently in their assigned places for long after 1890. By 1920, eight million American women were engaged in gainful employment outside the home, and thousands of them had taken to union meetings and picket lines . . . becoming housekeepers to the nation rather than the private servants of husbands and children.[4]

"The Rush of American Women"

~ ~ ~

With the industrial revolution came a change in political ideology, as socialism gained support in the face of rapid capital expansion. The prospect of women being freed from the bondage of the home by new home conveniences was coupled with an altruistic desire to extend the time-honored "helping" role women have always played to the greater society. In Chicago Jane Addams began a movement that spread rapidly in the next twenty years by founding Hull House, a settlement house that served as the model for those to follow. Established in 1889, the original intention was to civilize immigrants through classes in English, prenatal and maternity care, personal hygiene, art classes, and genteel handcrafts.[5] But the settlement-house movement took on deeper philosophical

meaning as the settlements became the dominant instrument of the educated middle- and upper-class woman's reawakened social conscience. The plight of the immigrant woman working in the oppressive environment of the industrial sweatshop became a unifying issue that was to serve as a rallying point for socialist reformers. Studies during the period from 1880 to 1920, which indicated that the average wage paid to women workers was well below what was considered a living wage and that there was no change in sight, brought the issue of equality in the workplace to the forefront. Eleanor Flexner has written, "Not only were wages for highly skilled work as low as $6.00 a week; they were often withheld, and poor immigrant girls had no means of collecting the money owed to them . . . There were endless fines: for talking, laughing, or singing, for stains from machine oil on the goods, for stitches either too crooked or too large which had to be ripped out, at the risk of tearing the fabric, resulting in more fines."[6] Such conditions also led to the successful development of trade labor unions such as the International Ladies Garment Workers Union, which was established in 1900.

Settlement houses were a manifestation of the movement of American women into the mainstream of society. They were a legitimatized institution through which women could test their own abilities outside the confines of the home but still within the parameters of domestic duties. "By 1910, more than 400 settlement houses had been established, and thousands of young people, three-fifths of them women, gathered there, assured of a chance to put their talents as well as their compassions to work."[7] The deep involvement that many young women felt in the assistance they provided for the "less fortunate" brought women of all classes closer together than ever before. Social Darwinism, recognized as the philosophical underpinning of the modern industrialized society, brought with it the Darwinian thesis that there existed in the female of the species a fundamental altruistic nature that stressed "the care of individuals outside of self."[8] Such a conclusion naturally met with acceptance because of the historical pattern women had followed in the nurturing and care of the immediate and extended family. And, "as women emerged from their homes to enter clubrooms, settlement houses and reform groups, they absorbed some of the spirit and techniques of the scientific era as well as the doctrine of female altruism."[9] The settlement houses served as an organizational catalyst for women to begin uniting together for an increasingly vital role in American society.

By the turn of the century it was obvious that the country was undergoing a dramatic reappraisal of woman's role. The United States Commissioner of Labor reported that by 1890, according to the Bureau of the Census, women were employed in 360 of the 369 reporting industries in America.[10] An ever-increasing number of first-generation female college graduates broke new ground by entering the professions. "The ideal of home-mother itself came under attack as thinking women demanded the practical equality for themselves and for all classes of American women. The late nineteenth and early twentieth century brought into sharp focus the inherent contradictions and inevitable exceptions

to the cult of domestic womanhood."[11] Changing moral values accompanied the changing attitudes toward women. Birth control became not merely an issue but an accepted practice by the woman of the day. Society was rapidly acknowledging the desire of women to work. The *Ladies' Home Journal* suggested at the turn of the century that child care was no longer the responsibility only of women but that it should be shared. The ambivalent position of the *Ladies' Home Journal* was evident though, as demonstrated by this editorial in January 1899, titled "The Rush of American Women."

> There is no denying the all too apparent fact that our women have drifted away from much of the simplicity of living, and instead have complicated their lives by trying to crowd too much into them . . . Organizations have taken by far too great a hold upon the lives of our women . . . It is high time that our women should lead calmer lives and get away from the notion that what we call "progress" in these days demands that they shall fill their thoughts and lives with matters at the cost of their health and peace of mind.[12]

The writing of Charlotte Perkins Gilman was particularly revealing in attempting to measure the tenor of the times. In *Women and Economics* (1898) she concluded that women must strive for economic equality with men and that the home was essentially an archaic vestige of preindustrial society that should be revolutionized through modern mechanical and social engineering.[13] Undoubtedly Gilman's position was colored by an optimism that was characteristic of the leading social reformers of the day, who were experiencing personal exhilaration as they foresaw dramatic social upheaval. Nevertheless, the creative role of women that we are concerned with here was not acknowledged by even such an avid social reformer. Mary Ryan has written that, when speaking of the potential of women, Gilman "made note of only one field of experience in which the nurturers of mankind would not excel: Giving birth satisfied woman's creative urge, diminishing the energy that drove men to excell in the plastic arts."[14] This notion had long been espoused by those who sought to restrict women's entry into the art schools and classes of America, but women had long since entered those halls of learning and were achieving a level of excellence that would not be fully acknowledged until the mid-twentieth century.

What had once been the untrained hand of a woman artist underwent a true metamorphosis in the late nineteenth century. Although seldom fully self-taught up to that time, women who displayed a hint of talent or the propensity to study art seriously were now able to do so in increasing numbers. Public education itself influenced the nature of the art being produced. Principles of design had been widely taught in lessons such as *The Drawing Master* in *Godey's Lady's Book* as early as the 1850s, yet what brought more sweeping stylistic developments were the design schools and art classes offered in the domestic or decorative arts tradition. Historically, women were first admitted to design schools and

only later to art schools. Even in England women were first accepted as students in schools of design before they were able to enter the teaching facilities of the Royal Academy.[15] Stressing basic compositional values and the nature of perspective, formal educational institutions of art replaced the home and the female seminary, previously the centers of learning artistic skills.

Beyond the influence of the design schools, the growth of colleges during the late nineteenth century, after the Morrill Act of 1862, also provided opportunity for women to enter all the professions once barred to them. Schools like Bryn Mawr (1885), Smith (1875), Wellesley (1875), and the coeducational state universities cleared the way to an impressive number of professional careers for women between 1890 and 1920. During that period the number of professional women increased 226 percent, almost triple the rate of male professional advancement.[16] This was a period of remarkable social change and she who fifty years earlier had been labeled the "true" woman was to become widely acknowledged as the "new" woman.[17] Only when compared to the years that were to follow can one understand the strides women made during the late nineteenth century and into the first decade of the twentieth century. When the Bureau of the Census released the Occupational Statistics in 1932, it reported that in 1910 women comprised 45.2 percent of the total persons employed as artists and art teachers. That figure was to decline to 41.3 percent in 1920 and again to 37.8 percent in 1930.[18]

The impressive, even revolutionary changes in society made by women by the second decade of this century were the result of women working together and uniting behind a common banner, the pursuit of the vote. Women's organizations based on political, cultural, and social leanings were breeding women skilled in complex organizational development techniques and possessed of a new assertive attitude. Settlement houses were only one type of institutionalized agent of social reform that were becoming deeply entrenched.

By 1920 women had organized in great numbers and such organizational strength was evident in the fact that the General Federation of Womens Clubs had perhaps one million members; the YWCA, five hundred thousand; there were four hundred thousand women union members; and it has been estimated that close to two million women participated in the suffrage campaign.[19] Women were beginning to "feel their oats" in the political arena and their power was courted by political parties and their candidates. Climaxing a bitter, long, and hard fight, which spanned a lifetime for many women, the Nineteenth Amendment, granting the vote to women, became law in 1920. One writer concluded that "The ratification of the Nineteenth Amendment not only testified to women's adroitness in manipulating the American political system, it finally raised the second sex to the full rights of citizenship in the U.S."[20]

Women still continued to create in their homes throughout these years as not every woman could afford either the time or the cost of art training, even if she

FIG. 104. Frost's Colored Rug or Mat Patterns. Boston. c. 1870. Advertising brochures such as this one by Edward Sands Frost popularized stenciled rug patterns that included fruit, flower, and animal motifs, and geometric designs. Photograph courtesy Greenfield Village and Henry Ford Museum.

were interested. Quilts, needlework, and other textile forms such as rugs were widely produced for home use. The marketing of stamped embroidery patterns for rugs (as early as the 1850s) (fig. 104) influenced their limited creative potential, for women had previously expressed themselves in a more personal way. *Lippincott's Monthly Magazine, Scribner's Magazine,* and even Montgomery Ward's catalogues of the 1880s advertised patterns and the latest rug-hooking machines.[21] Quilt patterns were equally as popular and were reproduced in columns such as "Patchwork," featured in *Godey's Lady's Book.* These columns also provided a forum for women seeking needlework advice from other readers. The popularity of stencils for standardizing quilt patterns restricted the creative inspiration of an increasing number of women during this age of mechanization and standardization. Photography had entrenched itself as an American social activity to be enjoyed by all. The consequence was declining efforts on the part of the lower and the growing middle class to reproduce the likenesses of those around them in paint, pencil, or ink. Those who did were likely to be under the influence of a newly educated eye, tutored in the fundamental precepts of the fine arts.

Women's artistic endeavors have been primarily recognized for the role they have played in the history of American decorative arts. The very barriers that prevented women from entering the competitive educational milieu and the professional art scene strengthened in many ways the aesthetic values of the work they did create. Although not engaging in the perilous career of a professional artist, women found support in the ranks of other women for their quilts, rugs, and needlework (fig. 105). Each town had an acknowledged quilting champion whose works were recognized not only for their technical proficiency but also for their color sensitivity and design excellence. And, as women were able to venture out and assume a more vital place in society, they continued

exploring media associated with the domestic domain: at first fabric, and later the areas of furniture, metalwork, and even architecture. All of these fields of endeavor radiated from the functions of the home, a link that even today women have never truly been able to sever. Now, at last, great strides in recent years have begun to break down the barriers that have stood between the fine arts and the decorative arts. Craft forms and folk art have finally been acknowledged for their interrelationship with the fine arts tradition in this country. Women's creative enterprises have been instrumental in paving the way for this synthesis; thus the "trend toward dissolving the divisions between the fine arts and the useful arts has always been connected with attitudes toward women artists."[22]

The early twentieth century saw the entry of women into the field of textile design, as many women with artistic abilities were channeled into vocational programs for industrial design positions. Weaving design, fabric design, and costume design were disciplines in which women were sought out and

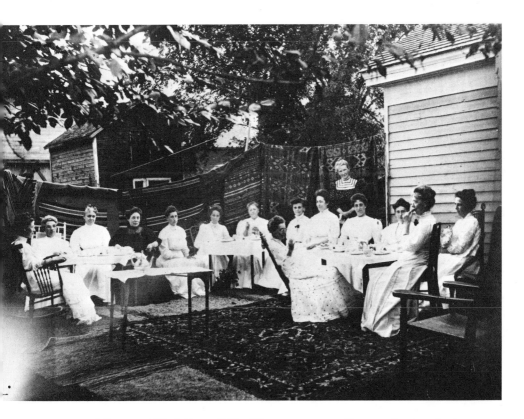

FIG. 105. Women of Black River Falls, Wisconsin. 1923. Photograph. A gathering for tea, talk, and crocheted needlework provided a pleasant outing for these women of Black River Falls, Wisconsin. Photograph courtesy State Historical Society of Wisconsin at Madison. (C. J. Van Schaick Collection)

encouraged. Although still unable to move readily into the production of "high art," women were able to reach a tremendous audience through their design work. When the Armory Show opened in New York City in 1913, introducing "modern art" to an unsuspecting public, there was, curiously, a piece of a crazy quilt on display in the exhibition. *The New York Evening Sun* ran a cartoon titled "The Original Cubist" that, although obviously intended to mock the Cubist movement, also unconsciously acknowledged the traditional involvement by American women with abstract reasoning in resolving design problems[23] (fig. 106). In the generations to follow, women artists would continue their active participation in expression through textiles. An accomplished modern artist, Sonia Delaunay, has been acclaimed for her exploration of the abstract style of Orphism not only through her painting but in the fabrics, tapestries, stage designs, and even furniture she designed. It has been said that "we owe perhaps to her more than anyone else the penetration of abstract art into everyday life."[24] Her work grew out of a patchwork blanket she made for her son in 1912. The

FIG. 106. "The Original Cubist." Cartoon. *New York Evening Sun.* 1913. Following the introduction of Cubism to America at the Armory Show, this drawing deriding the new art style unknowingly acknowledged the long-established use of abstract designs in quiltmaking. (The Museum of Modern Art)

pieced blanket was a traditional form from her native Ukraine, but its design was decidedly her own abstract creation.[25] Another important professional woman artist, Marguerite Zorach, "turned from painting to embroidered tapestries after the birth of her second child and it has been postulated that it was due to the fact that, 'she no longer had the hours of uninterrupted concentration that she required to work out her personal views on canvas.' "[26] Such was the dilemma of even the most dedicated trained artist, for her life was shaped by her physical as well as by her social circumstances.

> There are several genres of women's work, quilts and blankets for example, which are an assemblage of fragments pieced together whenever there is time, which in both their method of creation as well as in their aesthetic form, are visually organized into many centers. The quilting bee, as well as the quilt itself, is an example of an essentially non-hierarchical organization. Certainly the quality of time in a woman's life, particularly if she is not involved in the career thrust toward fame and fortune, is distinct from the quality of time experienced by men and women who are caught up in the "progress" of a career . . . Women's tasks in the home are equally varied and open-ended—child rearing is the classic example . . . The Assemblage of fragments, the organization of forms in a complex matrix suggests depth and intensity as an alternative to progress.[27]

And certainly women working in the folk tradition conceded to their circumstances by integrating their desire to express themselves visually with the other responsibilities and pleasures of their lives.

In the 1920s, the pendulum began to swing after the passage of the Nineteenth Amendment. Women's political power and position declined shortly after a series of bills were passed to increase consumer protection, reform the citizenship requirements for married women, and strengthen the child labor laws.[28] The mystique of the roaring twenties brought yet another ideal woman, epitomized by the "flapper." No longer was the dedicated social work of women praised as evidence of their fundamental nature. Once again, in reaction to the reform efforts, women were cast in the domestic role they sought to expand. An editorial in a 1930 issue of *Ladies' Home Journal* read:

> (A) new keynote is creeping into the lives of American women. Yesterday, and for a decade past, the great desideratum was smartness. Today, and for the years that lie immediately before us, it is charm. Charm—that which exerts an irresistible power to please and attract. It is a pleasant formula for homes, for gardens, for furnishings, for food, for entertainment, for art, for music, for books, and for styles of dress. For what woman, young or old, has not yearned to be above all things in the wide world, charming.[29]

During the 1920s, many women found employment in the growing number of service-oriented retail stores. They accounted for thirty percent of the nation's retail store personnel at that time.[30] Opportunity for employment shifted from agricultural and manufacturing enterprises to the retail sales, services, trades, and government. Where previously women frequently dedicated themselves to careers, now women were more likely to work only briefly until they were married, as the country was enjoying economic growth and prosperity. As so frequently happens after sober reform struggles with moral overtones, the period that followed the suffrage victory was in direct contrast, as women reveled in the man's world of speakeasies and flirted with the liberalized moral values of the day. The historical realities of what has come to be known as the roaring twenties, which actually began in the late teens, began to die out by the mid-1920s. Women were the targets of a more sophisticated media campaign that shaped the flapper and her world. The emphasis was on superficial sophistication in direct opposition to the "new woman" of just a few years before. To fill the empty hours of the "modern" homemaker, women's domestic accomplishments in crafts and home arts were again widely endorsed.

The Depression years became a period of introspection for many men and women. People returned to a simpler existence, and the home once again became the focal point. A nostalgic attitude led to a remarkable revival of the quilting tradition that, although never lost, had declined with the advent of modern textile achievements. Quilting clubs, church groups, and determined individuals filled their days and covered their beds at night with quilts. For some, it was to pass the time of day and for others it was a social occasion. The following verse conveys this feeling:

> *Life is like a patchwork quilt*
> *And each little patch is a day,*
> *Some patches are rosy, happy and bright,*
> *And some are dark and gray.*[31]

Women met in the homes of friends as well as in church basements on a regularly appointed schedule to share in the hard times and the pleasures of social intercourse. Scenes such as the one shown in figure 107 at a Detroit area home were common, not only in rural settings but in urban areas as well. Newspaper accounts from *The Detroit News* reveal that a local quilt show in 1938 attracted more than 18,000 women in one day and was judged by "an Instructor in Home Economics at Wayne State University who will pay special attention to the stitchery and an Instructor in Design at the art school of Detroit Society of Arts and Crafts who will consider the design and color in the quilts."[32] Obviously a more sophisticated appreciation of quilts was emerging, linked closely with fine arts values. A headline in a newspaper announcing the winner of a quilting show confirms this development, "Quilt Beautiful as a Painting Wins Its Skilled Maker $50."[33]

The quilts and other textiles created by American women during the 1930s reflected new technological developments in the composition of fabrics, printed materials, and the popularity of certain colors and patterns because of innovations in dye chemistry. Newspapers across the country ran regular columns on quilting featuring helpful hints, competitions, and the schedules of local fairs. Many quilters kept scrapbooks that documented every nuance of the "science" of quilting. Yet, it was the artistic achievement of these years of the resurgence in quilting that was most important. Quilts such as Mrs. Cecil White's not only serve as an exercise in complex composition but also capture life in the 1930s through individual blocks of genre scenes (pl. 21). Such social documentation has always been an invaluable contribution of folk art. Fannie Lou Spelce's painting of a quilting bee records the quilt frame hung from the ceiling and the musical accompaniment of the piano (pl. 22). Even the one male figure is humorously shown napping in the corner chair, obviously not a part of this particularly female social event.

Since the mid-nineteenth century Amish women have created quilts that reflect their religious and social values. By spurning popular printed fabrics and synthetic fibers, they clung to their preference for fabrics of solid and deeply saturated colors, which was in keeping with their religious edicts. In the male-dominated Amish communities the women found creative expression through their quilting tradition, which has continued to flourish even today. Although customs vary from Pennsylvania to Ohio and Indiana, generally the creative

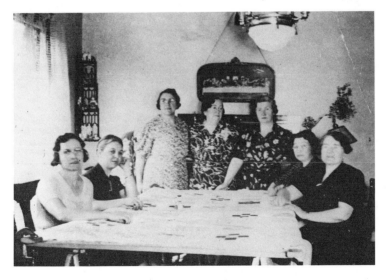

FIG. 107. Photograph of quilters. Detroit, Michigan. 1930s. During the quilting revival in the 1930s many quilt clubs were organized, such as the Rain or Shine club, which met every Thursday regardless of weather. (Collection of Marsha Mac-Dowell and C. Kurt Dewhurst)

process is still a collaborative one. Pattern selection often is based on a standard family preference, and the cutting and piecing involve the older women in the Amish community. Since its inception, the treadle sewing machine has been widely utilized by the Amish in the piecing of quilt tops. The culmination of the hours of work preparing the top is realized in the quilting bee or frolic, where friends and family all engage themselves in meticulous hand-quilting. Much attention has been given to the aesthetics of Amish quilts because of their intuitive reflection of the modern dictum of Ludwig Mies van der Rohe, "Less is

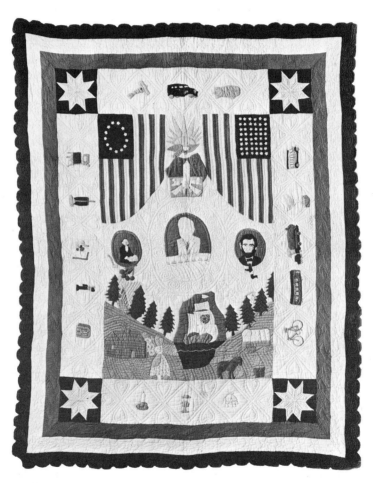

FIG. 108. Mrs. W. B. Lathouse: Appliqué quilt. Warren, Ohio. 1933. Cotton. 82″ × 66″. This quilt commemorates the Century of Progress Exhibition of 1933 in Chicago. It includes, in addition to the presidential figures, a border that contains evidence of progress in transportation, communication, and home conveniences. Examples of the last are a vacuum cleaner and a washing machine. (America Hurrah Antiques)

more." Probing the possibilities of color interacting within a standard geometric format, Amish quiltmakers have been exploring design potentials in a manner that seems to have been a precursor to the academic artists of today.

Since the 1930s many Amish quilts have been influenced more readily by innovations in fabric dyes and composition. And yet, Amish quilts are admired for their traditional patterns and evolving resolutions to color problems. Long compared to paintings, they are now frequently exhibited in gallery settings with other pieced quilts. Jonathan Holstein has attempted to explain the enthusiasm for this recent phenomenon:

> Pieced quilts are the most "painterly" products of the vernacular tradition, both in appearance because of the use of geometric elements and abstract images, rectangular format, size, and flatness and in decorative technique: quiltmakers, in effect, "paint" with fabrics, choosing first a format and the ultimate look they want, then selecting colors, patterns, and textures among their available materials, their "palette," and manipulating these elements in conjunction with form to achieve the effects they wish.[34]

Unfortunately, almost all of the quilts made by Amish women are unsigned, and, because of the limitations of a subculture that relies totally on oral history, few Amish quiltmakers can be acknowledged personally. Thanks to conscientious research on the part of collectors, three of these quiltmakers can be identified, and the work of one is shown in plate 23.

The 1930s bred egalitarianism in ways never before imagined for the trained artist. It has been noted that, "In the case of the remarkable efflorescence of women artists in America during the 1930s, the issue [was] not so much that of radical stylistic innovation as [that] of the sheer numbers of women involved and the range and variety of their practical expression."[35] The resurgence of the textile output of American women was widely felt, and those women with professional training played a major role in the New Deal federal arts program. At the height of the program's activity a survey of professional and technical workers on relief indicated that women comprised forty-one percent of all the artists receiving support.[36] Artists, both men and women, submitted proposed sketches and designs for projects, unsigned according to the rules governing selection of artists, thus enabling many women to gain recognition that might have otherwise been barred to them.

Although self-taught artists had been painting and exploring various media for years, in the 1940s a growing number of artists called *naïves, primitives,* and other related descriptive terms emerged in America. Because of the contemporary artists' interest in collecting the artifacts of African and Oceanic cultures, primitivism gained a new respectability. The initial exhibitions of American folk art, beginning with that at the Whitney Studio Club in 1924 and those that

followed in the years to come, acknowledged the relationship between the folk tradition and the fine arts tradition in America. While modern artists such as Robert Laurent, Elie Nadelman, Charles Sheeler, and others praised the strength and simplicity of the folk sensibility, a new sensitivity developed for the unique vision of the primitive folk artist. In 1942 Sidney Janis published *They Taught Themselves*,[37] a series of profiles of self-taught artists at work in this country. Because of the acceptance of this recently recognized phenomenon by the art community, artists such as Anna Mary Robertson Moses ("Grandma Moses") became household names in the years to follow. At one time when untrained painters (Clara McDonald Williamson, Fannie Lou Spelce, and many others)

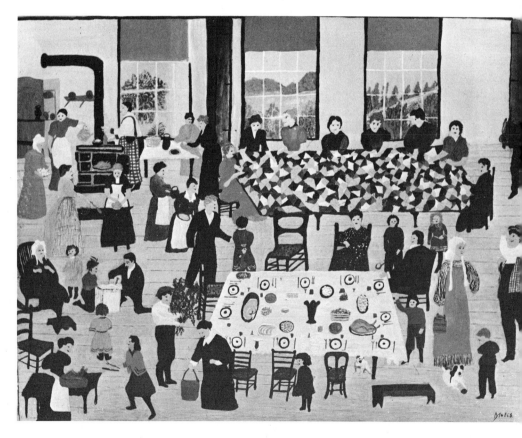

FIG. 109. Anna Mary Robertson Moses: *The Quilting Bee*. Eagle Bridge, New York. 1973. Oil on canvas. 20″ × 24″. The quilting itself was but a part of the bee, as food was prepared for the families of the quilters when they completed their cooperative needlework. Grandma Moses lovingly records the activity that surrounded such special days. Copyright Grandma Moses Properties, Inc. (Private collection)

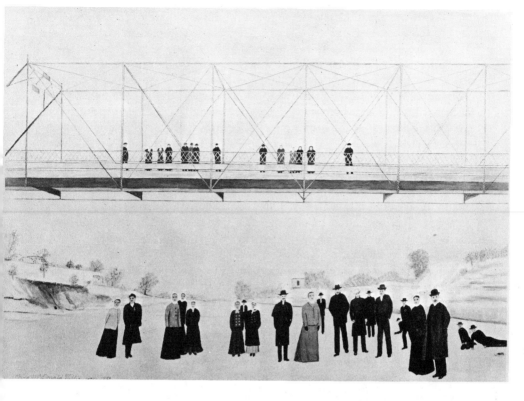

FIG. 110. Clara McDonald Williamson: *The Day the Bosque Froze Over*. Dallas, Texas. 1953. Oil on panel. 20″ × 28″. Folk artists often recorded significant events from their own lives and communities for future generations. Williamson began painting at age sixty-eight, recording life all around her. (The Museum of Modern Art; Gift of Albert Dorne, 1954)

enrolled in local art classes to pursue their hobby of painting, they would have been rapidly reeducated in the academic tradition. Now such artists were told to pursue their work by relying on their own unique solutions to problems of perspective and composition. The following account of Fannie Lou Spelce's experience in an art class at Laguna Gloria Art Museum, Austin, Texas, is typical:

> She had never painted before, but as she put it, "I always wanted to draw." The first assignment was a still life. When the instructor walked past, he saw that she was painting in only a very small portion in the center of the large canvas. He suggested she start over. Concerned, she took the paints and canvas home and painted the still life from memory. When she took the finished work back to the class the next week, the instructor exclaimed

that it was an outstanding example of primitive art. He told her to drop out of the class, never take art lessons, and to paint what she wanted as she wanted. Fannie Lou didn't understand. ("I may be old, but I'm not a primitive: and, I paid for these lessons, why can't I keep taking them?")[38]

Such artists were praised for their personal expression, uninhibited by the dictates of art schools. The unconscious quality of the work of these folk painters was recognized because of the growing interest in psychology, and folk art was also widely accepted because of the influence of nonrepresentational art in the twentieth century. Art was no longer measured by a preeminent artist or a single set of standards.

The search for the secluded folk artist brought numerous rural folk painters to the forefront in the years that followed. They enjoyed a similar pattern of discovery, first by word of mouth, then the first sales, and finally a one-woman show in New York or a nearby large city. Since the 1940s many fascinating women have come to the attention of the public. Minnie Evans, whose early pencil sketches later developed into visionary crayon drawings, received wide attention that culminated in a one-woman show at the Whitney Museum of American Art in 1975 (pl. 24). Sister Gertrude Morgan, Clementine Hunter, and Minnie Evans, black artists whose work began late in their lives, acknowl-

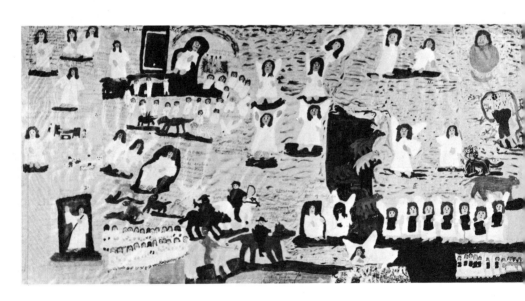

FIG. 111. Gertrude Morgan: *Revelations*. New Orleans, Louisiana. c. 1970. Ink and watercolor on window shade. 35¾" × 72". The successful use of calligraphic patterns is an integral part of Gertrude Morgan's painted sermons. (Collection of Herbert W. Hemphill, Jr.)

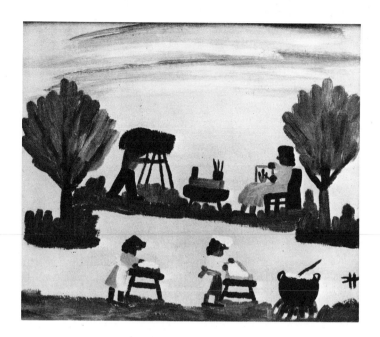

FIG. 112. Clementine Hunter: *Clementine Hunter at Her Easel While Her Photograph Is Taken*. Natchitoches, Louisiana. 1960. Oil on academy board. 12″ × 14″. This painting summarizes the dilemma of many artists in aprons who, although appreciated for their art, never forget the domestic responsibilities they were raised to assume. Photograph courtesy Anglo-American Art Museum, Louisiana State University, Baton Rouge. (Collection of Mrs. H. Payne Breazeale, Sr.)

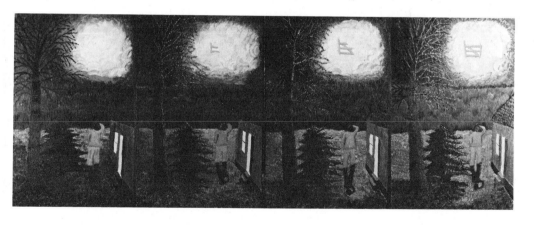

FIG. 113. Theora Hamblett: *The Vision*. Oxford, Mississippi. 1954. Oil on composition board. 17⅞″ × 48″. The simple and direct compositions of this artist's paintings emphasize the single human figure experiencing the evolution of a spiritual vision. (The Museum of Modern Art; Gift of Albert Dorne)

edge it was largely to fill a void left by a family grown up and away or a deep-seated inspiration to create. Their work, like those of their contemporaries, "exists in the complex social, historical, psychological, and political matrix within which it is actually produced."[39] It is virtually impossible today to discuss the work of these women without some understanding of the complexities of the setting and circumstances wherein it was accomplished.

"Fusing Creation and Life"
~~~

The heightened consciousness of American women artists is reflected in this introduction to *Artists, Past and Present* by Vicki Lynn Hill.

> In *A Room of One's Own*, Virginia Woolf writes, "When, however, one reads of a witch being ducked, of a woman possessed by devils, or of a wise woman selling herbs . . . then I think we are on the track of a novelist, a suppressed poet, of some mute and inglorious Jane Austen, some Emily Brontë who dashed her brains out on the moor, or mopped and mowed about the highways crazed with the torture that her gift had put her to. In-

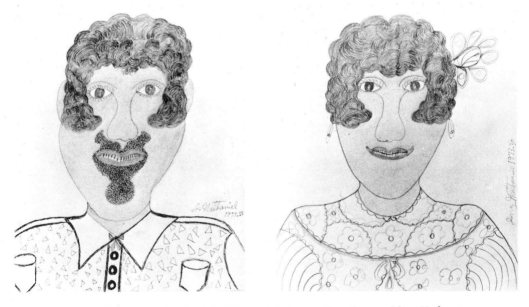

FIG. 114a & b. Inez Nathaniel. *Man* and *Woman*. Port Bryon, New York. 1973. Pencil on paper. 17" × 14" each. Much like the portrait painters of an earlier era, Inez Nathaniel recorded with pencil and felt pen simple line portraits of those around her. (Collection of Julie and Michael Hall)

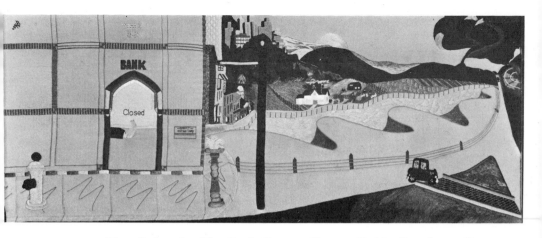

FIG. 115. Mary Borkowski: *The Crash*. Dayton, Ohio. 1968. Needlework on silk. 39½" × 16". Carrying on the needlework tradition of previous centuries, Borkowski used her needle as a paintbrush, embroidering deeply personal, dreamlike images in her "string pictures." Courtesy Museum of International Folk Art. (Collection of Herbert W. Hemphill, Jr.)

deed I would venture to guess that Anon., who wrote so many poems without signing them, was often a woman."

I would like to extend her hypothesis to include all those women in art history whose identities are hidden from us behind male signatures, to all those women whose quilting, needlework and pottery were dismissed as mere "women's work" by the dominant male-oriented standards of production and aesthetics, to all those women today who remain in effect anonymous because their work fails (refuses?) to conform to those same male criteria.[40]

Indeed some of the most powerfully adventurous work produced by folk artists such as Theora Hamblett, Mary Borkowski, and Minnie Evans would surely have been dismissed a century ago as "eccentric," and they too would have been "crazed with the torture that [their] gift has put [them] to." Until recently women distrusted their own inner instincts when they did not converge with the values of the world around them. Minnie Evans recounted her initial impulse to create this way, "I had day visions—they would take advantage of me," and that finally, "Something had my hand."[41] Only now, because of the supportive role played by sister artists and a sensitized art community, have these women begun to share their dreams by communicating with an audience beyond their families and friends.

In the catalogue for the exhibition "Women Artists 1550–1950" Linda Nochlin raises the question, "Have women simply been shunted off into the

so-called minor or decorative arts because these were considered less demanding and were certainly less prestigious?"[42] To this, one can respond affirmatively, but it was as a result of both conscious and subconscious social practices through the years. Clearly women, once entrenched in the domestic role that reached its most excessive state in the mid-nineteenth century, were still encouraged to create in the guise of homemaker, where they were no threat to the male-dominated art community. Their decorative approach to art was supported by their female neighbors and friends. Later, the printed media and, today, the electronic media continue to reinforce the domestic image of womanhood. Yet it is most important to recognize that, as a result of this situation, women's creative energies have had a dramatic influence well beyond the impact of the professional art community. There exists a vital and valid tradition of expression that has long been dismissed and even overlooked.

One value of reconsidering such a vast body of work comes from applying new tools and insights to further the assessment of the work itself. In *American Painting of the Nineteenth Century,* Barbara Novak has written,

> The psychology of the folk artist demands further historical investigation—as we learn more about the psychology of perception and art. It has always amazed me that the primitive can work directly in front of the object, aiming

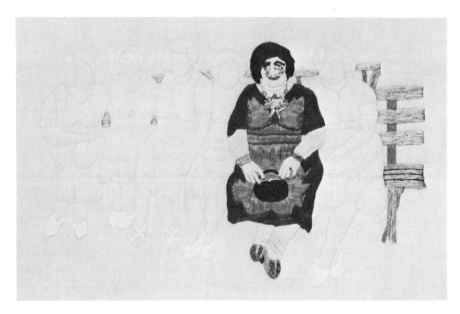

FIG. 116. Mary Borkowski: *Next to Me You Are Nothing.* Dayton, Ohio. c. 1970. Embroidery on silk. 11½" × 15½". In thread Mary Borkowski conveys the feeling of "next to me you are nothing" by recording only the outlines of those around the central figure. (Collection of Elias Getz)

hard for realism, checking constantly back to the object as he works, and yet end up with something that is much truer to his mind's eye than to anything his physical eye has perceived.[43]

It is that very truth to an inner vision that has allowed folk artists to trust their unselfconscious talents today at last in a freer way. Recent years have seen extensive research in the psychology of perception and the factors that influence the organizational patterns in the human brain. Undoubtedly, the prevailing socialization processes have molded human perceptual systems. In time, evidence may emerge that will verify some uniquely male and female patterns of interacting with the visual elements within the total environment.

Although little has been written on the subject, some feminist artists have attempted to discover if there is such a thing as female imagery and compositional patterns. One theory worth considering is based upon the surprising number of trained women artists who employ grid systems in the organization of their work. Evidence has been collected through an empirical random sampling of the works of her women artist friends by painter Joan Snyder. She recounts her own personal experience, "In 1968 I did flock paintings . . . They were sensuous paintings and they were about me. And then I needed to make them more layered, maybe to tell a story. Now when I look back, to try to figure out where my grids came from, I see that I started doing them about a month before I got married. When I made the decision to put structure into my life, structure appeared in my painting."[44] Such an account, although lacking in supporting evidence, proposes a curious connection to consider. Early exercises taught to young women, such as the one in figure 117, indicate the emphasis on geometric principles of organization for young women, and such lessons were applied practically to the creation of quilt patterns. Obsessive repetition of the same small block pattern comprised the entire quilt, which was, in essence, a grid system. Women's lives throughout time have required organizational skills to cope with their diverse responsibilities stemming from the home and family. Eliza Calvert Hall, in "Aunt Jane of Kentucky," explains it this way, "How much piecin' a quilt is like livin' a life! You can give the same kind of pieces to two persons, and one will make a 'nine-patch' and one'll make a 'wild goose chase,' and there will be two quilts made out of the same kind of pieces, and jest as different as they can be. And that is jest the way with livin'."[45]

Perhaps the commonest experience shared by contemporary women folk artists is "I paint what I know."[46] From this perspective evolves the desire to tell a story that reflects personal recollections, at times with painstaking detail. When asked to describe her painting of a local baptism, Queena Stovall said, "I went up there to see where they baptize. It was a pretty scene, this high rock that came up in the water with the water running around it. While I was sitting there, they were having some kind of business meeting. They saw their friend Stovall and said they'd like to have a few expressions. Well, you know, I can't express myself in private, let alone in public"[47] (fig. 118). Artists such as Queena

FIG. 117. Girl's art workbook. Midwest. 1899. Cut paper. 8″ × 8″. "The work of the hands clears the thought of the head" advises the inscription on this geometric design exercise, found in a schoolgirl's workbook. (Collection of Kurt Dewhurst and Marsha MacDowell)

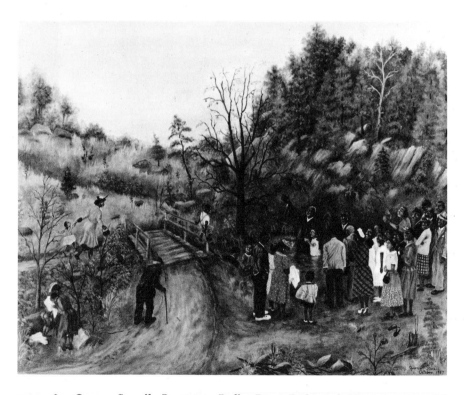

FIG. 118. Queena Stovall: *Baptizing—Pedlar River*. Richmond, Virginia. 1957. Oil on canvas. 26″ × 34″. Deeply involved in her community, the artist reverently depicts a baptism that she was asked to attend. (Virginia Museum of Fine Arts)

Stovall strive for a re-creation of events and times by focusing especially on the people involved in them. Lucy Lippard's observations about women's art have direct application to folk art produced by American women: "I do feel that women are more interested in people, probably because you [women] live vicariously if you're isolated. So women become more interested in soap opera and fiction. But women also care more about variety than men, and variety connects to fragmentation and to the autobiographical aspect too—as a sort of defiance. We play so many roles in our lives, while most men play only one or two."[48] Such an inclination renders many women folk artists masters of the genre scene, as evidenced by the works of such artists as Susan Merritt and Anna Hart right up to the recent work of Queena Stovall. These artists set out to record individuals involved in their everyday existence. Their paintings remain as valuable historical documents that convey the subtleties of dress, furnishings, and social manners of the day.

Time and time again women folk artists rely on their memories as well as their dreams for inspiration. Artists such as Gertrude Rogers, Tella Kitchen, and Mattie Lou O'Kelley, all of whom began painting late in their lives, create

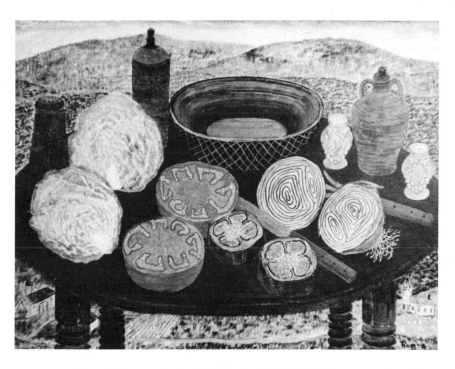

FIG. 119. Gertrude Rogers: *Fruit of the Earth*. Sunfield, Michigan. c. 1965. Oil on board. 16″ × 20″. Gertrude Rogers's painting displays her investigation of pattern in vegetables set in the context of the earth from which they were produced. (Collection of the artist)

scenes that are autobiographical and often deeply personal in choice of subject matter. Mattie Lou O'Kelley has recorded in verse her autobiography, which ends with these two stanzas:

> *A public job I acquired and never liked,*
> *Ten public jobs I got,*
> *Ten jobs never did I like,*
> *The boss never forgot.*

> *Now my one room house has only me,*
> *I never roam,*
> *No lessons have I, but I paint*
> *And paint,*
> *And stay at home.*[49]

Joan Snyder, a contemporary fine artist, speaking at a *Ms.* Forum on Art, has said, "My work is an open diary. . . . Men talk about art a lot and I don't think women talk about art as much as they talk about life."[50] Gertrude Rogers has described with surprise her critical acclaim, "People were so kind to me; I just can't express how I feel . . . I never paint anything that I don't like very much. I paint something that I like *very* much."[51]

FIG. 120. Gertrude Rogers: *Calico Cat.* Sunfield, Michigan. c. 1960. Oil on board. 20″ × 16″. Here a favorite subject of folk artists, the cat, is recorded with obvious affection and directness. (Collection of Mr. and Mrs. Melborn Sandborn)

In her diary, Anaïs Nin has written, "The woman artist has to fuse creation and life in her own way, or in her own womb . . . Woman has to create within the mystery, storms, terrors, in infernos of sex, the battle against abstractions and art. She has to sever herself from the myth man creates, from being created by him . . . Woman wants to destroy aloneness, recover the original paradise."[52] To escape the solitude of their domestic duties, many women turned to work that has resulted in profound creative expression. The very fact that women have found time to create, primarily before raising a family and/or after doing so, has

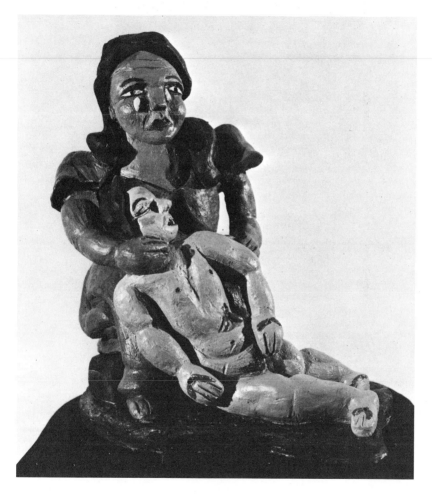

FIG. 121. Malcah Zeldis: *Pietà*. New York City. c. 1970. Plasticene. 10" × 8" (approx.). Few women attempted three-dimensional media before the twentieth century, but Malcah Zeldis explores sculpture in clay and paint. (Collection of Elias Getz)

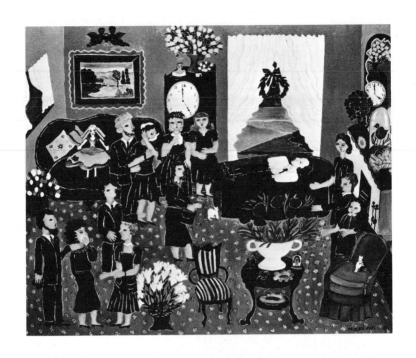

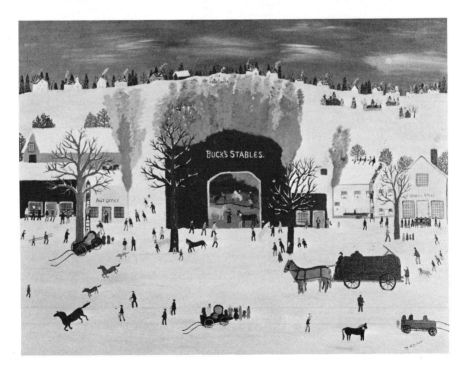

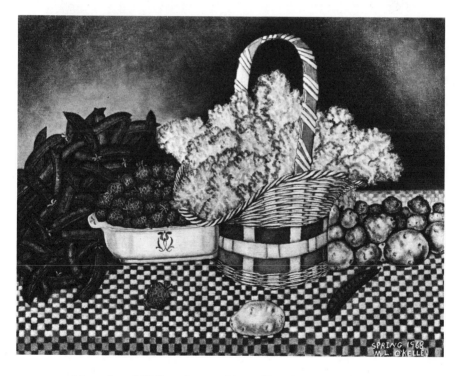

FIG. 124. Mattie Lou O'Kelley: *Spring—Vegetable Scene*. Maysville, Georgia. 1968. Oil on canvas. 17⅜″ × 23″. Aside from the earlier theorem paintings, very few still-life paintings by women artists are extant, and this lively contemporary one is particularly captivating. (The High Museum of Art)

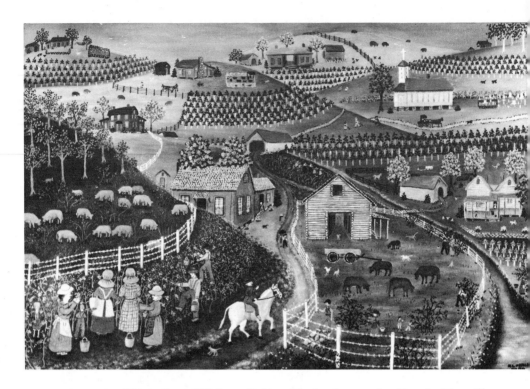

FIG. 125. Mattie Lou O'Kelley: *Picking Blueberries on the Fourth*. Maysville, Georgia. 1974. Oil on canvas. 24″ × 36″. The activity of the blueberry pickers is portrayed against the stylized hills of the landscape. (Robert Bishop)

FIG. 126. (*Opposite page, top*) Anna Mary Robertson Moses: *Sugaring Off in Maple Orchard*. Eagle Bridge, New York. 1940. Oil on canvas. 18⅛″ × 24⅛″. Women folk artists began actively recording community activities in the late nineteenth century. Frequently the emphasis was on individual people involved in the scene as well as on the various roles that people played. Copyright Grandma Moses Properties, Inc. (Private collection)

FIG. 127. (*Opposite page, bottom*) Rhoda B. Stokes: *The Longest Village Street*. Baton Rouge, Louisiana. 1967. Oil on masonite. 22¼″ × 28¼″. Such paintings as this one illustrate the varying abilities of folk artists to resolve problems of perspective successfully. Still, the painting captures a scene of personal acquaintance by the artist. Photograph courtesy Anglo-American Art Museum, Louisiana State University, Baton Rouge. (Collection of Mr. and Mrs. H. Wallace Eversberg)

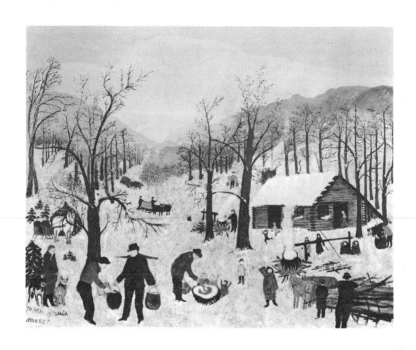

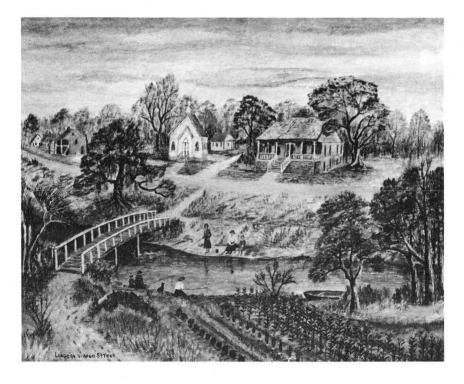

FIG. 129. (*Opposite page, top*) Albina Felski: *The Circus*. Chicago. 1971. Acrylic on canvas. 47″ × 47″. This painting is an excellent example of the folk artist's desire to include extensive content with little regard for technical precision. (Collection of Mr. and Mrs. L. R. Knobel)

FIG. 130. (*Opposite page, bottom*) Harriet French Turner: *Benediction*. Virginia. 1963. Oil on presswood panel. 19½″ × 23″. This painting of a Dunkard meeting in Roanoke exhibits the folk artist's interest in repeating images and linear forms. (Abby Aldrich Rockefeller Folk Art Center)

FIG. 128. Ethel Mohamed: *The Storm*. Belzoni, Mississippi. c. 1970. Needlework on cotton. 22″ × 30″. Using stitchery techniques, this twentieth-century folk artist has recorded many scenes of her family life in Mississippi. Photograph courtesy Mississippi Department of Archives and History. (Collection of the artist)

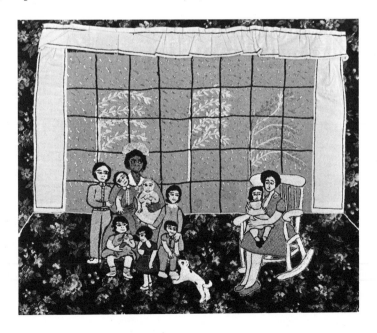

been reflected in the biographies of most of the artists included in this exhibition. These women, whose work is predominantly pictorial in character, seem to be striving to fill their lives with scenes of human activity to escape the "aloneness" Anaïs Nin so painfully describes. Their work truly is an affirmation of life, for it bridges the separation between the domestic setting that most women folk artists inhabit and their own communities that they value so deeply.

From women's earliest exploration of artistic expression in needlework to the more recent blossoming of painting, women have continued to build on a creative tradition rooted in the decorative arts. The folk art produced by American women reflects their evolving role in society. The media explored in the seventeenth, eighteenth, and early nineteenth centuries were textile forms that had a useful role to play within the home, for example, bed rugs, quilts, and other needlework. Only as women began to enjoy more leisure time to create did they first turn their hands to painting interior scenes and portraits. The slow movement from the home in the nineteenth century can be traced from paintings such as Sallie

FIG. 131. Tressa Prisbrey: *Doll House, Bottle Village*. Santa Susana, California. c. 1965. Mixed media. Assemblage as a technique has been widely recognized by artists in this century, and women artists working in the folk tradition, such as Grandma Prisbrey, explore the potential of combining objects and forms of daily life. Photograph courtesy Michelle Vignes and John Turner, Berkeley, California.

Cover's (pl. 16) view of the neighboring homestead, painted through her window, as she began to look out into the world. The genre scenes and local landscapes were the next logical development as women began to move into the mainstream of society in the late nineteenth century. Today women are still continuing to expand their creative horizons. Only recently have women folk artists begun to journey into the plastic media. Grandma Tressa Prisbrey's *Doll House, Bottle Village* is a testament to how far American women folk artists have come since those early needlework samplers (fig. 131).

Women working in the folk tradition have produced an immense body of work that will assume a more important place in American art history in the years to come. The folk art created by women will gain in stature as we come to understand the limitations within which their art was produced. American women folk artists have never set out to compete in the tumultuous world of fame-seeking avant-garde art. They are best characterized as having traditionally assumed the prevailing domestic responsibilities demanded of women of their time. While often wearing the symbol of domestic servitude, these "artists in aprons" from Prudence Punderson to Tressa Prisbrey have shared a common place in society. Lacking the time and inclination for training, they pursued their creative propensities by exploring media that merged readily with their domestic role. Seldom overtly challenging the social system of which they were an integral part, they quietly created work that reflected their time and displayed a folk sensibility that has influenced our conception of American art. Marya Mannes has recently observed, "In television soap operas the apron is the mark of a good woman, the career the sign of the frustrated one, the single existence the proof of a desperate one."[53] Clearly these good women were "artists in aprons."

## NOTES

1. Maria Weston Chapman, in *The History of Woman Suffrage,* edited by Elizabeth Cady Stanton, Susan B. Anthony, and Mathilda Joslyn Gage (Rochester, N.Y., 1881), vol. 1, pp. 82–83.

2. Daniel Walkowitz, "Working-Class Women in the Gilded Age: Factory, Community and Family Life Among Cohoes, N.Y., Cotton Workers," *Journal of Social History,* 5, no. 4 (Summer 1972), p. 468.

3. Mary P. Ryan, *Womanhood in America* (New York: New Viewpoints, 1975), p. 207.

4. *Ibid.,* p. 196.

5. June Sochen, ed., *Herstory: A Woman's View of American History* (New York: Alfred Publishing Co., 1974), pp. 213–218.

6. Eleanor Flexner, *Century of Struggle* (New York: Atheneum, 1974), p. 241.

7. Ryan, *Womanhood in America,* p. 229.

8. *Ibid.,* p. 226.

9. Eliza Burt Gamble, *The Evolution of Women* (New York: Putnam, 1894), p. 17.

10. Elizabeth Faulkner Baker, *Technology and Women's Work* (New York: Columbia University Press, 1964), p. 77.

11. Ryan, *Womanhood in America*, p. 197.

12. Editorial, *Ladies' Home Journal*, 16, no. 2 (January 1899), p. 14.

13. Charlotte Perkins Gilman, *Women and Economics* (Boston: Small, Maynard & Company, 1898), pp. 5–39.

14. Ryan, *Womanhood in America*, p. 240.

15. Ann Sutherland Harris and Linda Nochlin, *Women Artists: 1550–1950* (New York: Alfred A. Knopf, 1976), p. 59.

16. Ryan, *Womanhood in America*, p. 232.

17. Barbara Welter, *Dimity Convictions: The American Woman in the Nineteenth Century* (Athens: Ohio University Press, 1976), p. 41.

18. *Bureau of the Census, Occupational Statistics*, 1932.

19. Ryan, *Womanhood in America*, p. 231.

20. *Ibid.*, p. 248.

21. Joel and Kate Kopp, *American Hooked and Sewn Rugs: Folk Art Underfoot* (New York: Dutton Paperbacks, 1975), p. 80.

22. Karen Petersen and J. J. Wilson, *Women Artists* (New York: Harper & Row, 1976), p. 176.

23. "The Original Cubist," *The New York Evening Sun*, 1913.

24. Petersen and Wilson, *Women Artists*, p. 112.

25. *Ibid.*

26. Harris and Nochlin, *Women Artists: 1550–1950*, p. 60.

27. Sheila de Bretteville, "A Re-examination of Some Aspects of the Design Arts from the Perspective of a Woman Designer," *Women and the Arts: Arts in Society*, 11, no. 1 (Spring–Summer 1974), pp. 117–118.

28. William Henry Chafe, *The American Woman* (New York: Oxford University Press, 1972), pp. 28–29.

29. Editorial, *Ladies' Home Journal*, 47 (May 1930), p. 34.

30. Ryan, *Womanhood in America*, p. 307.

31. Elizabeth Decoursey Ryan, quoted in *The Romance of the Patchwork Quilt in America*, by Carrie A. Hall and Rose G. Kretsinger (New York: Bonanza Books, 1935), p. 93.

32. "Quilters Column," *The Detroit News*, October 5, 1938, and October 9, 1938.

33. *Ibid.*, May 25, 1940.

34. Jonathan Holstein, *The Pieced Quilt; An American Design Tradition* (New York: Galahad Books, 1973), p. 116.

35. Harris and Nochlin, *Women Artists: 1550–1950*, p. 63.

36. *Ibid.*

37. Sidney Janis, *They Taught Themselves: American Primitive Painters of the Twentieth Century* (New York: Dial Press, 1942).

38. *Fannie Lou Spelce*, exhibition catalogue (Kennedy Galleries, New York, 1972), p. 4.

39. Nina Howell Starr, *Minnie Evans*, exhibition catalogue (Whitney Museum of American Art, 1975).

40. Vicki Lynn Hill, Introduction, *Artists, Past and Present* (Berkeley: Women's History Research Center, April 1974), p. 3. Virginia Woolf, *A Room of One's Own* (New York: Harcourt, Brace and Company, 1929), pp. 84–85.

41. Nina Howell Starr, *Minnie Evans*, pp. 1–2.

42. Harris and Nochlin, *Women Artists: 1550–1950*, p. 59.

43. Barbara Novak, *American Painting of the Nineteenth Century* (New York: Praeger Publishers, 1969), p. 100.

44. Lucy Lippard, "What Is Female Imagery?," *From the Center* (New York: Dutton Paperbacks, 1976), pp. 86, 88.

45. Eliza Calvert Hall, "Aunt Jane of Kentucky," in *The Romance of the Patchwork Quilt in America,* by Carrie Hall and Rose G. Kretsinger (New York: Bonanza Books, 1935), p. 83.

46. Mattie Lou O'Kelley, personal interview with the artist, New York City, June 1977.

47. *Queena Stovall,* exhibition catalogue (Utica, N.Y.: Brodock Press for New York State Historical Association, 1974), p. 16.

48. Lippard, "What Is Female Imagery?," p. 88.

49. Mattie Lou O'Kelley, "Autobiography" (unpublished autobiographical poem), 1975.

50. Lippard, "What Is Female Imagery?," p. 86.

51. Gertrude Rogers, personal interview with the artist, Sunfield, Michigan, June 1977.

52. Anaïs Nin, *Diary of Anaïs Nin,* vol. 2 (1934–1939) (New York: Harcourt, Brace & World, 1967), p. 234.

53. Marya Mannes, "The Problems of Creative Women," in *The Potential of Women,* edited by Seymour M. Farber and Roger H. L. Wilson (New York: McGraw-Hill Book Co., 1963), p. 121.

# Brief Biographies

BACHELLER, CELESTINE (active c. 1900). Known for a pieced and embroidered crazy quilt made in Wyoma, Massachusetts. Using silks and velvet, she created landscapes and seascapes said to represent actual scenes near Wyoma, now part of Lynn on the north shore of Boston, and combined her pictorial squares to fashion a quilt that is now owned by the Museum of Fine Arts, Boston.

BARNARD, LUCY (active c. 1860). Known for three hooked rugs that depict a hilltop house overlooking a valley. She lived in Dixfield Common, Maine. Her trio of rugs is now owned by The Metropolitan Museum of Art, New York.

BASCOM, RUTH HENSHAW (1771–1848). Born in Leicester, Massachusetts. Known for pastel crayon portraits. She was the eldest of ten children of Colonel William and Phoebe Swan Henshaw. Colonel William's mother was Elizabeth Alden, daughter of John and Priscilla Alden. In 1804 Ruth Henshaw married Dr. Asa Miles, a Dartmouth professor who died two years later. She then married Reverend Ezekiel Lysander Bascom, whose calling took him to many towns, ending up in Ashby, Massachusetts. The artist's diaries, kept for over fifty-seven years, have

FIG. 132. Ruth Henshaw Bascom: *Self-Portrait.* Massachusetts or New Hampshire. 1830. Pastel. 18⅜″ × 13¼″. One of several known self-portraits by Bascom, this one displays a softened image marked only by a sharply defined facial outline. (Old Sturbridge Village)

provided us with an interesting account of the life of a pastor's wife. Although there were many references to her needlework endeavors in these diaries, no mention was made of her crayon portraits except for a notation telling of a profile of Susan Rice in September 1819 when Ruth was nearly forty-seven. She is said never to have accepted money for her portraits.

BATSON, MARY JANE (active mid-nineteenth century). Known for the Couples Quilt made at the Batson plantation near Richmond, Virginia, before the Civil War. The maker of the pieced squares was a slave on the plantation, and she fashioned her quilt units from scraps of her mistress's ball gowns. Her designs depict twelve sets of couples dressed in different outfits, representing the various dress-up occasions attended by the slaves: weddings, baptisms, dances, church meetings, etc. After the war the artist remained with her former mistress at the plantation. She gave the pieced squares to her granddaughter, Mariah Chapman, who completed the quilt, in the 1870s at the age of eighty-eight, by joining the squares together and quilting them.

BAUMAN, LEILA T. (active 1860–1870). Landscape painter whose scenes record the various modes of transportation in nineteenth-century America. She worked in New Jersey.

BILLINGS, PHOEBE (1690–1775). Attributed artist of a bed rug owned by the Addison Gallery of American Art, Andover, Massachusetts. Married April 2, 1706, to Ebenezer Billings, Jr.

BLACKSTONE, ELEANOR (active 1880–1890). Rugmaker of Macon, Illinois, who hooked six large rugs that record family events. Married and the mother of six children, she used her rug artistry to depict their portraits, pastimes, and pets, working in strands of each child's hair along with the yarn. She also included names, birth dates, and phrases describing each child. One of her creations can be seen at Greenfield Village and Henry Ford Museum, Dearborn, Michigan.

BORKOWSKI, MARY (1916–). Born in Sulphur Springs, Ohio, lives in Dayton, Ohio. She began creating her "string pictures" in 1965 when she attempted her first as a memorial for a close friend who had died. The inspiration of her work she insists is deeply emotional. She captures fantasylike episodes from her mind's eye with needle and thread on felt or velvet background cloth.

MARY BULMAN (active c. 1745). A resident of York, Maine, Mrs. Bulman reportedly created her crewel-worked bed ensemble while her husband, Dr. Alexander Bulman, served as surgeon under Sir William Pepperell at the siege of Louisburg in Nova Scotia. This rare intact set of hangings is now owned by the Old Gaol Museum, York, Maine.

BURPEE (CONANT), SOPHIA (1788–1814). Born and died in Sterling, Massachusetts. A painter in watercolors, sometimes combined with embroidery, Burpee belonged to a prominent Sterling family. She was married to Samuel Conant in 1813 and died the following year during an epidemic of typhoid fever. Her portrait by an unknown artist hangs in the National Gallery of Art in Washington, D.C.

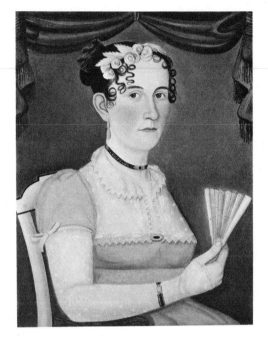

FIG. 133. Mary Borkowski. Ohio. c. 1975. Photograph courtesy the artist.

FIG. 134. Unidentified artist: *Sophia Burpee*. Massachusetts. Early nineteenth century. Oil on canvas. 22⅛″ × 17″. (National Gallery of Art; Gift of Edgar William and Bernice Chrysler Garbisch)

Burpee's style and choice of subjects (shepherds and lovers in landscapes) suggest schoolgirl training in "fashionable" accomplishments.

BUTLER, ANN (1813–?). Born in East Greenville, New York. Tinware decorator. She was the eldest of eleven children born to Aaron Butler and Sarah Cornell. Although all of the Butler women were involved in the family tin business, she was the most active. She literally put her heart into her work, using as her signature a heart framing her initials. After her marriage to Eli Scott, a farmer, in 1835, her tinware production considerably lessened although she still managed occasional trips back home to help out with her parents' business.

CADY, EMMA JANE (1854–1933). Originally known for a single watercolor. It has recently been discovered that several other works done by her exist, including

another *Fruit Compote,* complete with mica flakes. Emma Cady lived in East Chatham, New York, never marrying. In 1920 she moved west to Michigan to live with her sister and her family. She died in Grass Lake, Michigan. Little is known about her painting activities, but one person who remembers her recalls her beautiful handwriting.

CASWELL, ZERUAH HIGLEY GUERNSEY (active 1832–1835). Known for the Caswell carpet, made at Castleton, Vermont. Young Zeruah Guernsey sheared the wool from her father's sheep, spun it into yarn that she dyed assorted colors, and then embroidered varied designs on the seventy-six wool squares that comprise her carpet, working her initials, *ZHG,* and the year of its completion, *1835,* into the top edge. Two other squares bear the initials of young Indian medical students residing in the Guernsey home while the carpet was being made. Each contributed a square marked by his initials. Among Zeruah's designs was a pair of lovers thought to represent the couple who would some day "keep house on her carpet," according to her own prophecy. In 1846 she married a Mr. Caswell, fulfilling the promise of the embroidered pair. She continued to live in Castleton until quite old and always took pride in displaying her master-work which is now owned by The Metropolitan Museum of Art, New York.

CLARK, FRANCES (1835–1916). Landscape painter in oils who depicted rural scenes with considerable skill. Clark's canvases capture the American countryside at different seasons. Her handling of space and light suggests some technical training.

COHOON, HANNAH (1788–?). Known for several inspirational drawings done as a member of the Shaker community in Hancock, Massachusetts, which she

joined with her two children in 1817. Her ink and watercolor designs are records of divine revelations from Shaker founder Mother Ann Lee and other members of the spirit world. She did her drawings during her late fifties and sixties and was one of the few Shaker artists who signed her work.

CORTRITE, NETTIE (active c. 1887). Known for her oil painting of a Michigan farm, she lived in Detroit.

COVER, SALLIE (active 1880–1890). Known for her oil painting of her neighbor's farm in Garfield County, Nebraska. She and her husband, Ferdinand Cover, were among the settlers after the open range became available to homesteaders in the 1880s. Cover recorded the rugged simplicity of prairie life in her painting.

EASTMAN (BAKER), EMILY (1804–?). Born in Loudon, New Hampshire, the daughter of David Eastman. A portrait painter in watercolors who worked in Loudon between 1820 and 1830, Eastman probably relied on prints in doing her stylized portraits of women. A note on one of her drawings indicates that she was married to Dr. Daniel Baker in 1824.

EMORY, ELLA (active 1878). Known for the interior-view paintings of the Peter Cushing house in Hingham, Massachusetts, Ella, the aunt of Alice Cushing, spent the summer of 1878 at this house.

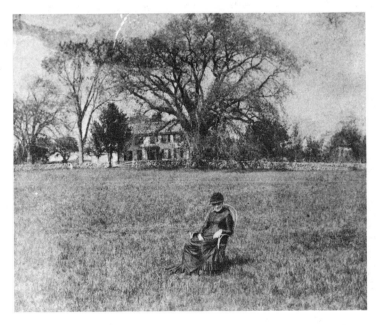

FIG. 136.   Ella Emory in front of the Peter Cushing house in the 1880s. Photograph by Richard Merrill. (Courtesy Nina Fletcher Little)

EVANS, MINNIE (1892–). Born in Long Creek, Pender County, North Carolina, she started her first drawings in 1935 and began creating pen, ink, and crayon drawings in 1940. Later, in 1954, she began painting in oils and also attempted some collages in the 1960s. She worked as a domestic servant until 1948 when she became a gatekeeper. Known as a visionary artist because of her deeply personal imagery and provocative use of eyes, her work is primarily symmetrically patterned and vividly illustrated. The Book of Revelation and her affinity for nature are forces that have been influential in the emergence of her unconscious, dreamlike style. She now lives at Airlie Gardens, Wilmington, North Carolina.

FAIRFIELD, HANNAH (active c. 1839). Known as the painter of a double portrait done in Windham County, Connecticut.

FELSKI, ALBINA (1925?–). Born in Ternie, British Columbia, lives in Chicago, Illinois. Began painting in 1963, paints scenes that she has experienced. She is known for her paintings of coal mining, shipyards, lumbering, and scenes with animals. Her work is rigidly linear, with many figures and a complex composition recording action in every area of her paintings.

FINCH, RUBY DEVOL (1804–?). Known primarily for the watercolor paintings depicting the Parable of the Prodigal Son, she also executed full- and half-length

FIG. 137. Minnie Evans in the gatehouse of Airlie Gardens. Wilmington, North Carolina. 1974. Photograph by Nina Howell Starr.

miniatures and family records. Working mainly in the Westport, Massachusetts, area, she married William Finch of New Bedford on November 30, 1832.

GOLDSMITH, DEBORAH (1808–1836). Born at North Brookfield, New York, died at Hamilton, New York. A self-taught portrait painter in oils and watercolors, she was active from about 1820 until 1832, when marriage and a family ended her travels and career. The youngest daughter of Ruth Miner and Richard Goldsmith, she began her professional life in her early twenties in order to support her aged parents. She met her husband, George Throop, while staying at the Throop home in Hamilton where she painted the family portraits including one of George. They were married the next year after a quiet courtship by correspondence, during which she confessed "that my teeth are partly artificial." Two children were born before she died of an illness at the age of twenty-seven. Her paintings are usually signed "D. Goldsmith."

GOVE, JANE (1834–?). Known for an appliquéd rug made at her farm home near Wiscasset, Maine, when she was eleven years old. According to a family tradition young Jane is thought to have created her rug from fragments of her dead mother's clothing, but the design is lively and bright rather than mournful and subdued. Trees, birds, horses, stars, flowers, a cow, and Jane's own house fill the black background squares with exuberant shapes and colors, somewhat reminiscent of Pennsylvania German decorative motifs.

HAMBLETT, THEORA (1895–1977). Born near Paris, Mississippi, lived in Oxford, Mississippi. Known for her sparse dream paintings, often in triptych form.

FIG. 138. Deborah Goldsmith: *Self-Portrait*. Upstate New York. 1833. Watercolor on paper. Oval, 2½″ × 2″. Her comely countenance and pleasant manner captivated one client who courted and married this itinerant limner. (Collection of Dan Throop Smith)

FIG. 139. Theora Hamblett, from film, *Four Women Artists*. Oxford, Mississippi. 1976. Photograph courtesy Center for Southern Folklore, Memphis, Tennessee. Photograph by Frank Fourmy.

After almost twenty-five years as a teacher in a one-room schoolhouse, she embarked on her painting career. Emphasizing the point of view of the observer by incorporating a human figure(s) as participant(s), her paintings depict the onlookers' perspective while observing a vision.

HART, ANNA S. (active c. 1870). Known for a landscape and genre painting done at Battle Creek, Michigan. Her picture is an early visual record of Americans enjoying a tenting vacation beside the lake.

HEATH, SUSAN (1798–?). Known for a landscape watercolor painting showing Brookline, Massachusetts, in the foreground and Boston in the distance, she was the daughter of Ebenezer and Hannah Williams Heath. A label on the back of her painting indicates that it was done in 1813 from a window of the Heath residence in Brookline. Several landmarks, including the Boston State House, are clearly recognizable.

HEEBNER, SUSANNA (active c. 1807). A Fraktur artist belonging to the Schwenkfelder group, she lived in Montgomery County, Pennsylvania. Her illuminated manuscript pages combine religious poetry and moral precepts with brightly colored decorations.

HONEYWELL, MARTHA ANN (1787–1848?). Born at Lempster, New Hampshire. Silhouette artist, active from 1806 to 1848, who was born without arms but who learned to cut profile portraits and other designs by holding the scissors in her mouth. She traveled both in America and in Europe, where she performed publicly and sold her work. Her creations were usually signed "Cut without hands by M. A. Honeywell." One of her specialties was the Lord's Prayer

written in dime-sized spaces or cut from two-inch circles of paper. As part of her exhibition she also did paintings and needlework using her teeth and her toes.

HUFF, CELESTA (active 1875–1889). Known for an oil painting, signed and dated 1889, of a winter scene in Maine, and for a similar scene of 1875, attributed to her, depicting a wintry Sunday in Norway, Maine. This painting is based on a contemporary print.

HUNTER, CLEMENTINE (1882–). Born in the Cane River region, Louisiana. She began painting in 1946 while living on Melrose Plantation, Natchitoches Parish, Louisiana. After a full career as a field hand and kitchen maid on a cotton plantation, she started her painting utilizing a paintbrush left behind by a New Orleans artist. Her paintings are powerful and expressive statements. Plantation scenes, religious ceremonies, and daily community life served as the subjects for her brush. A highly stylized rendering of human figures and objects, with little regard for scale and perspective, is characteristic of her work. She rarely attempts to paint anyone she knows, preferring to rely on her imagination and focusing primarily on black life in the rural South.

KITCHEN, TELLA (1902–). Born in Vinton County, Ohio (near Londonberry), self-taught painter active in Adelphi, Ohio. She began painting in 1963 after the death of her husband. With a set of paints given to her by her son, she settled into a personal style that reflects her remembrances of an earlier time in her life. An extremely active woman, she succeeded her husband as mayor of her town for two years after he died.

KRIEBEL, PHEBE (1837–1894). Born in Worcester, Pennsylvania. Known for her embroidered landscape of a town, done in 1857, she lived in Towamencin Township, Montgomery County, Pennsylvania, with her husband Abraham K. Kriebel, a *Vorsinger* in the Schwenkfelders community church.

KURTZ, SADIE (active 1960s). Lives in Bayonne, New Jersey, and paints primarily with poster paints on paper.

LATOURETTE, SARAH (active mid-nineteenth century). The only known female jacquard coverlet weaver, Sarah learned the intricate weaving technique in her father's Indiana shop. Quite noted for her skill, she produced a large number of coverlets in Fountain County, Indiana. In 1870, she married and moved to Kentucky.

MAY, SIBYL HUNTINGTON (1734–?). Known for a fireboard or overmantel painting of a Haddam, Connecticut, landscape. Born in Lebanon, Connecticut, she married the Reverend Eleazor May, a Yale graduate, in 1754. He was said to have seen her paintings and vowed he would marry the artist. Mother of ten children, Sibyl was thought to have taught the rudiments of painting to young John Trumbull.

MCCALL, PHILENA (1783–1822). Known for a single bed rug. The daughter of Ozias and Elizabeth (Williams) McCall of Lebanon, Connecticut. She married Deacon Eliphalet Abell, also of Lebanon, in 1806.

MCCORD, SUSAN NOKES (1829–1909). Born possibly in Ohio, died at McCordsville, Indiana. A quiltmaker known for a number of pieced and appliqué quilts, she lived with her husband Green McCord and their seven children on a farm in the McCordsville area, where they had settled after their marriage in 1849. Their first home was a log cabin, later replaced by a frame house. In addition to her many domestic duties and farm chores, she acted as neighborhood doctor, using her knowledge of medicinal herbs to treat simple illnesses. A faithful member of the Methodist church, she read her Bible through yearly. Somehow she also found time for her hobbies of embroidery and quilting. Her quilts, several of which are owned by Greenfield Village and Henry Ford Museum, are admired for her skill in combining minute scraps of fabric into superb designs. She died from complications at the age of eighty after having been kicked over by a cow.

MERRITT, SUSAN (1826–1879). Originally known for a single watercolor, recent research has uncovered information about at least sixty-six works done by her. Susan Merritt spent her life, unmarried, in Weymouth, Massachusetts, where from 1867 to 1878 she entered her artwork in the yearly fair sponsored by the Weymouth Agricultural and Industrial Society. She won awards every year and was mentioned in the local newspapers for her artistic skill.

MILLER, MINERVA BUTLER (1821–1912). Born in East Greenville, New York. A tinware decorator, she was the youngest of the eleven children of tinsmith Aaron Butler and Sarah Cornell. In 1843 she married tinsmith John Miller, who

FIG. 140. Susan McCord and her family. McCordsville, Indiana. c. 1900. Photograph courtesy Greenfield Village and Henry Ford Museum.

FIG. 141. Ethel Wright Mohamed, from film, *Four Women Artists*. Belzoni, Mississippi. 1976. Photograph courtesy Center for Southern Folklore, Memphis, Tennessee. Photograph by Bill Ferris.

helped run the Butler business for many years. An album kept by Minerva illustrates some of the designs used in painting tinware.

MINER, ELIZABETH (ELIZA) GRATIA CAMPBELL (1805–1891). Known for her oil painting of a county fair done in Canton, New York. The daughter of Dr. Daniel Campbell of Canton, she married a local merchant, Ebenezer Miner, in 1829 and had four children. The county fair was founded in 1851 by her husband and two other men, all of whom are portrayed in the painting done in 1871, the year of Mr. Miner's death. The painting has been called "an accurate picture" of an event staged annually for over seventy years. The artist also excelled in needlework and made an embroidered carpet filled with flowers and "strange-looking animals." During her last years she spent the winters in California, confined to a wheelchair, and painted sets of china for her children.

MITCHELL, ELIZABETH ROSEBERRY (active c. 1839). Known for the Kentucky Coffin Quilt made in Lewis County, Kentucky, she used the quilt to record the deaths of family members whose labeled coffins along the border were moved to predesignated plots in the fenced central graveyard as their deaths occurred. Fabricated from printed and plain cotton, the latter dyed brown with walnut shells, and embellished with embroidered details, her quilt is an unusual interpretation of the mourning picture done in a utilitarian form.

MOHAMED, ETHEL WRIGHT (1907–). Born in Webster County, Mississippi, lives in Belzoni, Mississippi. She exhibited a mural at the Smithsonian Institution's "Festival of American Folklife" in 1976 that was also used on the publicity for the festival.

MOHLER, ANNY (active c. 1830). Known for a single watercolor "presentation piece" painted in Stark County, Ohio. Her painting, done with the aid of stencils, includes traditional motifs brought to America by German immigrants.

MORGAN, SISTER GERTRUDE (1900–). Born in Lafayette, Alabama, lives in New Orleans, Louisiana. Known for her deeply religious paintings. She has painted on paper, cardboard, and virtually every household container available to her. Her work reflects her extensive missionary career, for she has worked since 1934 as a "preacher" and gospel singer. She conveys her evangelical messages in a pedantic way through her paintings. Relying on crayon, watercolors, and recently acrylics, she chronicles biblical passages, enriching them with her own written admonishments. She began painting about 1960, adding yet another medium in which she could express her convictions.

MOSES, ANNA MARY ROBERTSON (1860–1961). Born in Greenwich, New York, died in Hoosick Falls, New York. Known for her long years of prolific painting, Grandma Moses started her career as a painter in 1933 at the age of seventy-seven. Her work is characterized by detailed daily scenes, with an uninhibited use of bright colors. The success of her painting career popularized folk art as the work of "Sunday painters" and bred a following of folk "stylists" who consciously attempted to work in a similar style.

NATHANIEL, INEZ (1911–). Born in Sumter, South Carolina, lives in upstate New York. Began her drawings in 1971, during her stay in the Bedford Hills Correctional Institution. Her portraits are characterized by their profile orientation with a frontal eye position. She is now a migrant worker and has continued her drawing using colored pencils and crayons.

FIG. 142. Gertrude Morgan. New Orleans, Louisiana. c. 1970. Photograph courtesy Robert Bishop.

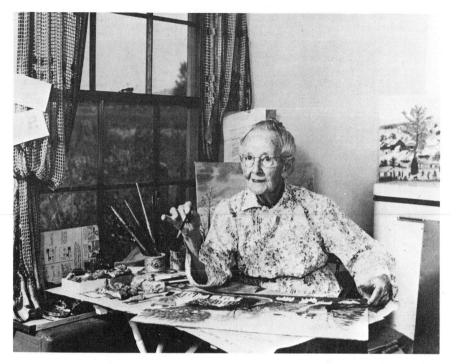

FIG. 143. Anna Mary Robertson Moses. 1955. Photograph by Ifor Thomas. Photograph courtesy Grandma Moses Properties, Inc.

FIG. 144. Inez Nathaniel (Walker). New York. 1973. Photograph courtesy Michael D. Hall.

FIG. 145. Mattie Lou O'Kelley. New York. 1977. Photograph courtesy Marsha MacDowell.

O'KELLEY, MATTIE LOU (1908–). Born in Banks County, Georgia. Still active in Maysville, Georgia, creating landscapes, still lifes, and some portraits. She creates by combining objects and images that catch her eye and then using them in a setting that she feels is suitable. She has been quite prolific since her first painting in 1950 and recently was given a special award by the governor of Georgia for her contribution to the state.

PARKE, MARY (active c. 1805). Known for a watercolor painting of a biblical scene, *Rebecca at the Well,* she was probably a schoolgirl artist. She must have felt insecure about rendering animal forms, for her friendly camels' faces peering around the tree lack the rest of their bodies. Her painting is almost identical to one in the Abby Aldrich Rockefeller Folk Art Center, Williamsburg, Virginia, except for the addition of a water pitcher and bracelet.

PERKINS, SARAH (1771–1831). Pastelist who worked in Plainfield, Connecticut, where she did several portraits, mainly of her family, during the 1790s. That she did not execute work later in her life can probably be attributed to the fact that by the age of twenty Sarah had assumed the entire charge of her family of seven brothers and sisters. In 1801 she married General Lemuel Grosvenor, a widower with five children, and they proceeded to have four more of their own.

PINNEY, EUNICE GRISWOLD HOLCOMBE (1770–1849). Born at Simsbury, Connecticut, probably died there. A prolific painter in watercolors, she did most of her work in the first three decades of the nineteenth century when she was already a mature woman. After the early death of her first husband by whom she had two children, Pinney married again and had three more children. Apparently she began to paint for pleasure during her second marriage, despite her domestic responsibilities. Her vigorous style and varied themes are attributed both to her maturity and to a self-confidence born of her eighteenth-century background.

Pinney often relied on engravings for inspiration, but was never a mere copyist. Her watercolors are signed "Eunice Pinney."

POWERS, HARRIET (1837–1911). Born near Athens, Georgia, died near there. Quilt-maker known for two appliquéd and pieced narrative quilts that combine Bible stories with astronomical events and local legends. Born a slave, Powers lived with her husband and three children on a small farm after the Civil War. Financial hardship forced her to sell one quilt to Athens artist Jennie Smith. When Miss Smith exhibited the quilt in 1895, a second quilt was commissioned by several women of Atlanta. Powers's appliqué technique reflects both American and African traditions.

PRIOR, JANE OTIS (active 1822). Known for the decoration of a wooden sewing box. She may have been a student at Miss Tinkham's school at Wiscasset, Maine, where painting on wood was part of the curriculum.

PRISBREY, TRESSA (1895–). Born in Minot, North Dakota, lives in Santa Susana, California. "Grandma" Tressa Prisbrey built thirteen buildings and various other structures that comprise *Bottle Village*, in Santa Susana. Utilizing bottles, car

FIG. 146. Harriet Powers. Georgia. c. 1875. Photograph courtesy Museum of Fine Arts, Boston.

FIG. 147. Tressa Prisbrey. Santa Susana, California. 1976. Photograph courtesy Michelle Vignes and John Turner, Berkeley, California.

headlights, and other assorted objects, she worked for twenty years assembling her own unique village around her trailer. The bottle-and-concrete walls provide the setting for buildings that feature her collections of pencils, dolls, gourds, and other odds and ends she collected on her trips to the junkyard in her Studebaker truck. Her assemblage stands as one of the few major environmental works produced by an American women. Efforts are underway by the California Arts Council to preserve *Bottle Village*.

PUNDERSON, HANNAH (1776–1821). Known for a watercolor mourning picture, Hannah was the sister-in-law of Prudence Punderson Rossiter, and the wife of Cyrus Punderson.

PUNDERSON, PRUDENCE GEER (1735–1822). Born in Groton, Connecticut, she married Ebenezer Punderson, Jr., in 1757. The mother of eight children, including the artist Prudence Punderson Rossiter, she died in Preston, Connecticut.

PUNDERSON (ROSSITER), PRUDENCE (1758–1784). The daughter of Ebenezer and Prudence (Geer) Punderson, she is well known for her needlework pictures the *Mortality Scene* and the *Twelve Disciples*. She was married to Dr. Timothy Wells Rossiter.

RIDDLE, HANNAH (active c. 1870). Known for a single appliqué coverlet, made in Woolwich, Maine. The coverlet, created of brightly colored felt designs arrayed against a dark ground, suggests the dazzling brilliance of stained glass. It won First Prize at the Woolwich Fair in 1870.

ROGERS, GERTRUDE (1896–). Born in Ionia County, Michigan. Lives in Arcadia, Florida, and Sunfield, Michigan. She began painting in 1945 when she was stricken with arthritis. After reading that Winston Churchill had said that

FIG. 148. Gertrude Rogers. Sunfield, Michigan. 1977. Photograph courtesy Marsha MacDowell.

anyone can paint, she attempted painting with paints given to her by her grand-children. The eldest of ten children, she was raised on a farm and it was this life that serves as much of her subject matter. She has since recovered from her illness, and her continuing fascination with nature is clearly obvious in her more recent work. She stresses that, "I never paint anything unless it gives me pleasure."

SEDGWICK, SUSAN (active c. 1811). Known for her portrait of Elizabeth Freeman (Mumbet), a former slave woman who had won her freedom in 1781 after suing the master who had mistreated her. Having learned of her rights "by keepin' still and mindin' things," Mumbet had successfully taken her case to court and then become the paid housekeeper for the family of her lawyer, Theodore Sedgwick. Her story was recorded by one of the Sedgwick daughters, novelist Catherine, and her portrait painted by another daughter, Susan. Mumbet's face bears the scar of a blow received while she was still a slave. The painting is inscribed on the back: "Elizabeth Freeman/Mumbet/Susan Sedgwick/fecit 1811/E.M.B. Sedgwick/1868."

SHUTE, MRS. R. W. and S. A. (active 1828–1835). Little is known about this duo of watercolor and oil portrait painters. Although it could be a husband and wife, mother and daughter, or a sister combination, there are several portraits signed by Mrs. R. W. Shute alone, so it is believed that she was the primary artist. The pair was known to have worked in Lowell, Massachusetts, in 1828, New Hampshire in 1833, and by 1835 they were executing work in Vermont. At least twenty-four works have been attributed to them.

SNOW, JENNY EMILY (c. 1835–?). Known for several paintings done at Hinsdale, Massachusetts. Without previous training, she painted her biblical picture *Belshazzar's Feast* in black and white oil paints on canvas, when she was just fifteen.

SPELCE, FANNIE LOU (1908–). Born in Dyer, Arkansas. In 1966, while living in Austin, Texas, she enrolled in an art class at Laguna Gloria Art Museum. Unable to paint the still life assigned according to the dictates of her instructor, she returned home to paint relying on her own memories. Encouraged, then, by her instructor, she never again took another lesson and embarked on her new summer career. She had worked for more than forty years as a nurse but retained her affection for her early years of growing up on a farm in the Ozark Mountains. It was this life that she attempted to re-create in meticulously detailed paintings.

STOKES, RHODA BRADLEY (1901–). Born in Franklin County, Mississippi, lives in Liberty, Mississippi. Painting since 1952, her work records her childhood on a farm and life in the bayou of southern Louisiana. In re-creating her past, she incorporates local buildings and scenes as compositional elements.

STOVALL, QUEENA (1887–). Born in Lynchburg, Virginia. She began painting in 1949 and created approximately forty-five paintings, the last in 1967. She is known for her attempts to capture human events around her on canvas. The

genre quality of her paintings stresses with careful accuracy her people and the subtleties of their lives. Both the black and the white communities in which she lived were the subjects for her studies in oil, many of which have a photographic attention to detail and a visible sensitivity to human relationships.

TAYLOR, ELIZA ANN (active c. 1850). An Eldress of the Shaker religious order, this artist produced many spirit drawings.

THORN, CATHERINE (active 1724–1728). Known for a single bed rug made for her sister, Mary. They were daughters of Deacon Thorn of Ipswich, Massachusetts. In 1728 Catherine Thorn married Francis King.

TRENHOLM, PORTIA ASH BURDEN (1813–1892). A painter of landscapes, fruit, and flower pictures, the artist was the daughter of Kinsey and Mary Legare Burden of Charleston, South Carolina. Her father and maternal grandfather, Thomas Legare, were cotton planters and developers. In 1835 she married Charles L. Trenholm, a member of a wealthy cotton-exporting family. Her oil painting of Legareville depicts a popular summer resort located on Johns Island, where planters' families retreated to avoid malarial fever on the mainland. The town was intentionally burned in 1864 to prevent its capture by Union gunboats.

FIG. 149. Fannie Lou Spelce. Texas. 1972. Photograph courtesy Fannie Lou Spelce Association.

FIG. 150. Queena Stovall. 1974. Photograph courtesy New York State Historical Association. Photograph by Patti Zaskowski.

TURNER, HARRIET FRENCH (1886–1967). Born in Giles County, Virginia. Although she started painting while in high school, her work was not recognized until 1954 when she began creating paintings of the Blue Ridge Mountains all around her. She is recognized as the first living artist to have her work exhibited at the Abby Aldrich Rockefeller Folk Art Center, Williamsburg, Virginia.

WARNER, SARAH FURMAN (active 1800–1815). Known for a single appliqué and embroidered coverlet made at Greenfield Hill, Connecticut. Warner's bedcover, created from a great variety of fabric scraps, pictures a part of the town.

WATERS, SUSAN C. (1823–1900). Born in Binghamton, New York, died in Bordentown, New Jersey. Primarily a portrait painter, she also painted still lifes and animal pictures, using oil paints. As a child she moved with her family to Friendsville, Pennsylvania, where she attended a female seminary at the age of fifteen, helping to pay for her tuition by doing drawings for her natural history class. She was married to William Waters of Friendsville in 1841. Apparently they moved to southern New York State, for she painted portraits in that area from 1843 until 1845 when she and her husband traveled as far west as Iowa. By 1854 they had returned east to New Jersey where they purchased land in Bordentown. Their stay there was interrupted by another period of travel, but by 1866 they had again settled in Bordentown, permanently. Waters spent the rest of her life painting still life and animal pictures, exhibiting her work at the Centennial Exposition in Philadelphia in 1876.

WHITE, MRS. CECIL (active c. 1930). Hartford, Connecticut, quiltmaker known for one elaborate appliqué quilt, *Scenes from Life,* in the 1930s.

WILLIAMSON, CLARA MCDONALD (1875–). Born in Iredell, Bosque County, Texas. She began painting in 1943 and is known for over 160 works. Many

FIG. 151. Susan C. Waters. Bordentown, New Jersey. c. 1860. Photograph courtesy Bordentown Historical Society.

reflect her experiences as a child, for her family was among the early settlers in the area. She worked as an assistant to a county clerk and later, with her husband, she operated a dry goods store and then a boardinghouse.

WILLSON, MARY ANN (active 1810–1825). Watercolorist who lived and painted in Greenville, New York, where she shared a log cabin with her companion, a Miss Brundage. While the latter farmed their few acres, Willson created and sold colorful paintings of biblical scenes, portraits, birds, and flowers, using paints concocted from berries, brick dust, and vegetable dyes, sometimes supplemented with "store paints." When her friend died, the artist was grief-stricken and left the area for an unknown destination. The few facts of her life were preserved by "An Admirer of Art" in an anonymous letter that records that Willson's "rare and unique works of art" were sold as far as Canada and "clear to Mobile."

YOUNG, CELESTIA (active c. 1856). Known for her oil painting of a sawmill in Plymouth, Michigan. According to the inscription on the back of the painting, she was "a schoolgirl who used to live across the road from the mill." Her picture records an aspect of the lumber industry, which throve in Michigan in the nineteenth century.

ZELDIS, MALCAH (1932?–). Born in Detroit, Michigan, now lives in New York City. She began painting in her late thirties, utilizing strong deep colors in an active and linear manner. Her subject matter includes current and past historical events and figures, Jewish religious themes, family scenes, and personal memories of the past. She usually incorporates self-portraits and portraits of her family in the works. An extremely prolific artist, she has created close to two hundred paintings.

FIG. 152. Clara McDonald Williamson. Austin, Texas. 1966. Photograph courtesy Amon Carter Museum of Western Art.

# Bibliographies

## 1. The Society
~~~

GENERAL REFERENCES

Blackstone, Sir William. *Commentaries of the Laws of England.* Philadelphia: R. Bell, 1771–1773.

Finkelstein, Sidney. *Art and Society.* New York: International Publishers, 1947.

Harris, Neil. *The Artist in American Society.* New York: Simon & Schuster, 1966.

Hauser, Arnold. *The Social History of Art,* vol. 1. New York: Alfred A. Knopf, 1951.

Kavolis, Vytautas. *Artistic Expression: A Sociological Analysis.* Ithaca, N.Y.: Cornell University Press, 1968.

Martineau, Harriet. *Society in America.* Gloucester, Mass.: Peter Smith, 1968.

Nye, Russel Blaine. *The Cultural Life of the New Nation, 1776–1830.* New York: Harper Torchbook, 1960.

———. *Society and Culture in America.* New York: Harper & Row, 1974.

Quarles, Benjamin. *The Negro in the American Revolution.* Chapel Hill: University of North Carolina Press, 1961.

WOMEN IN SOCIETY (HISTORICAL ASPECTS)

Beard, Mary R., ed. *America Through Women's Eyes.* New York: The Macmillan Company, 1933.

Bell, Margaret. *Women of the Wilderness.* New York: E. P. Dutton, 1938.

Benson, Mary Sumner. *Women in Eighteenth-Century America.* New York: Columbia University Press, 1935.

Breckinridge, Sophonisba P. *Women in the Twentieth Century.* New York and London: McGraw-Hill Book Co., 1933.

Camden, Carroll. *The Elizabethan Woman.* rev. ed. Mamaroneck, N.Y.: Paul P. Appel, 1975.

Cather, Willa Sibert. *O Pioneers.* Boston and New York: Houghton Mifflin Company, 1913.

Chafe, William Henry. *The American Woman.* New York: Oxford University Press, 1972.

Cook, Clarence, ed. *A Girl's Life Eighty Years Ago: Letters of Eliza Southgate Bowne.* New York: Charles Scribner's Sons, 1887.

Dewees, William P. *Treatise on the Diseases of Females.* 2d ed. Philadelphia, 1828.

Dexter, Elisabeth Anthony. *Career Women of America, 1776–1840.* Boston: Houghton Mifflin Company, 1950.

————. *Colonial Women of Affairs*. Boston and New York: Houghton Mifflin Company, 1924.

Earle, Alice Morse. *Child Life in Colonial Days*. New York: The Macmillan Company, 1899.

————. *Colonial Dames and Good Wives*. Boston: Houghton Mifflin Company, 1895.

————. *Home Life in Colonial Days*. New York: The Macmillan Company, 1925.

Ellet, Elizabeth. *The Women of the American Revolution*. New York: Haskell House, 1969.

Farnham, Eliza W. *Life in Prairieland*. New York: Harper and Bros., 1846.

Fletcher, Robert S. *History of Oberlin College to the Civil War*. vol. 1. Oberlin, Ohio: Oberlin College Press, 1943.

Fowler, William W. *Woman on the American Frontier*. Hartford: S.S. Scranton and Co., 1877.

Gamble, Eliza Burt. *The Evolution of Women*. New York: Putnam, 1894.

Gilman, Charlotte Perkins. *Women and Economics*. Boston: Small, Maynard and Co., 1898.

Holliday, Carl. *Woman's Life in Colonial Days*. Boston: The Cornhill Publishing Company, 1922.

Larcom, Lucy. *A New England Girlhood, Outlined from Memory*. Boston and New York: Houghton Mifflin Company, 1889.

The Lawes Resolutions of Women's Rights: or, The Lawes Provisions for Women. London, 1632.

Ossoli, Margaret Fuller. *Woman in the Nineteenth Century*. Boston: Brown, Taggard and Chase, 1860.

Rowbotham, Sheila. *Hidden from History: Rediscovering Women in History from the Seventeenth Century to the Present*. New York: Random House, 1974.

Spruill, Julia Cherry. *Women's Life and Work in the Southern Colonies*. New York: Russell and Russell, 1969.

Stanton, Elizabeth Cady; Anthony, Susan B.; and Gage, Mathilda Joslyn, eds. *The History of Woman Suffrage*, 1. Rochester, N.Y., 1881.

Thompson, Roger. *Women in Stuart England and America: A Comparative Study*. London and Boston: Routledge and Kegan Paul, 1974.

Tyron, Rolla M. *Household Manufactures in the United States, 1640–1860*. Chicago, 1917.

Vuolo, Brett Harvey. "Pioneer Diaries: The Untold Story of the West." *Ms.* (May 1975), pp. 32–36.

Walkowitz, Daniel. "Working-Class Women in the Gilded Age: Factory, Community and Family Life Among Cohoes, N.Y., Cotton Workers." *Journal of Social History*, 5, no. 4 (Summer 1972).

Warren, Ruth. *A Pictorial History of Women in America*. New York: Crown Publishers, 1975.

Willard, Emma. *An Address to the Public, Particularly to the Members of the Legislature of New York, Proposing a Plan for Improving Female Education*. 2d ed. Middlebury, Vt.: S. W. Copeland, 1819.

Woody, Thomas. *A History of Women's Education in the United States*. New York: The Science Press, 1929.

WOMEN AND SOCIETY (SOCIOLOGICAL ASPECTS)

Alcott, William. *The Young Man's Guide.* Boston, 1833.

Allen, Grant. "Woman's Place in Nature." *The Forum*, 7, no. 3 (May 1889), p. 263.

Baker, Elizabeth Faulkner. *Technology and Woman's Work.* New York: Columbia University Press, 1964.

Beach, W. A. *An Improved System of Midwifery.* New York, 1847.

Cable, Mary, *et al.*, eds. *American Manners and Morals : A Picture of How We Behaved and Misbehaved.* New York: The American Heritage Publishing Co., 1969.

Calhoun, Arthur W. *A Social History of the American Family*, vol. 2. Cleveland: The Arthur H. Clark Company, 1918.

Cheney, Ednah D., ed. *Louisa May Alcott, Her Life, Letters and Journals.* Boston: Roberts Brothers, 1889.

Constantia [Judith Sargent Murray]. "Equality of the Sexes." *Massachusetts Magazine* (March–April 1790), pp. 132–133.

Cott, Nancy, ed. *Root of Bitterness: Documents of the Social History of American Women.* New York: Dutton Paperbacks, 1972.

Craik, Dinah M. *A Woman's Thoughts About Women.* New York: Rudd & Carleton, 1859.

Dew, Thomas R. "Dissertation on the Characteristic Differences Between the Sexes." *Southern Literary Messenger*, 1 (Richmond, Va.) (May 1835), pp. 493–512.

Ditzion, Sidney. *Marriage, Morals and Sex in America: A History of Ideas.* New York: Bookman Associates, 1953.

Ellis, Sarah. "The Daughters of England: Their Position in Society, Character and Responsibilities." *Family Monitor and Domestic Guide.* Philadelphia: G. S. Appleton, 1843.

Farber, Seymour M., and Wilson, Roger H. L., eds. *The Potential of Woman.* Symposium report. New York: McGraw-Hill Book Co., 1963.

"Female Irreligion." *Ladies Companion*, 13 (May–October 1840), p. III.

Flexner, Eleanor. *Century of Struggle: The Woman's Rights Movement in the U.S.* New York: Atheneum, 1974.

Godey's Lady's Book, August 1879.

Goodsell, Willystine, ed. *Pioneers of Women's Education in the United States.* New York: McGraw-Hill Book Co., 1931.

Graves, Mrs. A. J. *Woman in America: Being an Examination into the Moral and Intellectual Condition of American Female Society.* New York: Harper and Bros., 1841.

Grimké, Sarah. "Intellect." *The Liberator*, January 26, 1838.

Grimké, Sarah M. *Letters on the Equality of the Sexes and the Condition of Woman.* New York: Burt Franklin, 1838.

Haviland, Laura S. *A Woman's Life Work: Labors and Experiences.* Chicago: C. V. Waite and Company, 1887.

Jennings, Samuel K. *The Married Lady's Companion or Poor Man's Friend.* rev. 2d ed. New York: Lorenzo Dow, 1808.

Kraditor, Aileen S. *Up from the Pedestal: Selected Writings in the History of American Feminism.* Chicago: Quadrangle Books, 1968.

Lerner, Gerda. *The Female Experience: An American Documentary.* Indianapolis: The Bobbs-Merrill Company, 1977.

Marsh, Charles W. *Recollections, 1837–1910.* Chicago: Farm Implement News, 1910.

McIntosh, Maria J. *Woman in America: Her Work and Her Reward.* New York: D. Appleton & Company, 1850.

Melder, Keith. "Mask of Oppression: The Female Seminary Movement in the United States." *New York History,* 55 (July 1974), pp. 260–279.

Meigs, Charles. *Lecture on Some of the Distinctive Characteristics of the Female.* Philadelphia, 1847.

Merriam, Eve, ed. *Growing Up Female in America: Ten Lives.* New York: Dell Publishing Co., 1971.

Nearing, Scott. *Woman and Social Progress.* New York: The Macmillan Company, 1914.

"Pastoral Letter of the General Assembly of Massachusetts (Orthodox) to the Churches Under Their Care." *The Liberator* (Boston), August 11, 1837.

Pruette, Lorine, ed. *Women Workers Through the Depression.* New York: The Macmillan Company, 1934.

Rayne, M. L. *What Can a Woman Do; or Her Position in the Business and Literary World.* Detroit: F.B. Dickerson & Co., 1885.

Rennie, Susan, and Grimstad, Kirsten, eds. *The New Woman's Survival Catalog.* New York: Coward, McCann, & Geoghegan, 1973.

Report on the Condition of Woman and Child Wage-Earners in the United States, vol. 1. Washington, D.C.: Government Printing Office, 1910.

Riegel, Robert E. *American Feminists.* Lawrence, Kans.: University of Kansas Press, 1963.

————. *American Women: A Story of Social Change.* Rutherford, N.J.: Fairleigh Dickinson University, 1970.

Ryan, Mary P. *Womanhood in America.* New York: New Viewpoints, 1975.

Sangster, Margaret E. *Fairest Girlhood.* Chicago: Fleming H. Revell Company, 1906.

Schneir, Miriam. *Feminism, The Essential Historical Writings.* New York: Random House, 1972.

Savile, George, Marquis of Halifax. *A Lady's New Year's Gift, or Advice to a Daughter.* London, 1688.

Sheehan, Marion Turner, ed. *The Spiritual Woman: Trustee of the Future.* New York: Harper & Brothers, 1955.

Sigourney, Lydia Howard. *Letters to Young Ladies.* Hartford, Conn., 1835.

Smuts, Robert W. *Women and Work in America.* New York: Columbia University Press, 1959.

Sochen, June. *Herstory: A Woman's View of American History.* New York: Alfred Publishing Co., 1974.

Stearns, Jonathan F. "Female Influence and the True Christian Mode of Its Exercise: A Discourse Delivered in the First Presbyterian Church in Newburyport, July 30, 1837." Newburyport, Mass., 1837.

Swisshelm, Jane Grey. *Half a Century*. Chicago: Jansen, McClurg and Company, 1880.

Thomson, Patricia. *The Victorian Heroine: A Changing Ideal, 1837–1873*. London: Oxford University Press, 1956.

Welter, Barbara. *Dimity Convictions: The American Woman in the Nineteenth Century*. Athens: Ohio University Press, 1976.

Westin, Jeane. *Making Do: How Women Survived the '30s*. Chicago: Follett Publishing Co., 1976.

WOMEN AND THE ARTS

The American Woman as Artist, 1820–1965. Exhibition catalogue. Pollock Galleries–Owen Arts Center, Southern Methodist University, Dallas, Tex., 1966.

Armstrong, Geneva. *Woman in Art*. Privately printed.

The Art Journal, 35/4 (Summer 1976).

ARTnews Magazine. Special Issue. Women's Liberation, Women Artists, and Art History. New York: The Macmillan Company, January 1971.

Craik, Dinah Maria Muloch. *Olive*. New York: Harper and Bros., 1875.

DePauw, Linda Grant, and Hunt, Conover. *"Remember the Ladies": Women in America, 1750–1815*. Exhibition catalogue. New York: The Viking Press, 1976.

Ellet, Mrs. Elizabeth Fries Lummis. *Women Artists in All Ages and Countries*. New York: Harper and Bros., 1859.

Female Artists: Past and Present. Berkeley, Calif.: Women's History Research Center, 1974.

Gerdts, William. *Women Artists of America, 1707–1964*. Exhibition catalogue. Newark, N.J.: The Newark Museum, 1965.

Groce, George, and Wallace, David, ed. and comp. *New-York Historical Society's Dictionary of Artists in America, 1564–1860*. New Haven: Yale University Press, 1957.

Harris, Ann Sutherland, and Nochlin, Linda. *Women Artists: 1550–1950*. Exhibition catalogue. New York: Los Angeles County Museum of Art and Alfred A. Knopf, 1976.

Hess, Thomas B., and Baker, Elizabeth C., eds. *Art and Sexual Politics*. New York: Collier Books, 1971.

Huber, Christine Jones. *The Pennsylvania Academy and Its Women*. Exhibition catalogue. Philadelphia: Pennsylvania Academy of the Fine Arts, 1973.

Kamarck, Edward, ed. *Women and the Arts: Arts in Society* (Madison, Wis.), 11, no. 1. (1974).

Leslie, Eliza. "Pencil Sketches," 1835. Cited in Ella Shannon Bowles, *Homespun Handicrafts*. Philadelphia: J.B. Lippincott, 1931.

Lippard, Lucy. *From the Center: Feminist Essays on Women's Art*. New York: Dutton Paperbacks, 1976.

Merritt, Anna Lea. "A Letter to Artists: Especially Women Artists." *Lippincott Magazine*, 65 (1900), pp. 463–469.

Moore, Julia Gatlin. *History of the Detroit Society of Women Painters and Sculptors, 1903–1953*. Detroit: Privately printed, 1953.

Nemser, Cindy. "Towards a Feminist Sensibility: Contemporary Trends in Women's Art." *The Feminist Art Journal*, 5, no. 2 (Summer 1976), pp. 19–23.

Nin, Anaïs. *Diary of Anaïs Nin*, vol. 2 (1934–1939). New York: Harcourt, Brace, and World, 1967.

Nochlin, Linda. "How Feminism in the Arts Can Implement Cultural Change." *Women and the Arts: Arts in Society* (Madison, Wis.), 11, no. 1 (1974).

————. "Why Have there Been No Great Women Artists?," *ARTnews*, 69, no. 9 (January 1971), pp. 22–49.

Petersen, Karen, and Wilson, J. J. *Women Artists*. New York: Harper & Row, 1976.

Tufts, Eleanor. *Our Hidden Heritage: Five Centuries of Women Artists*. New York: Paddington Press, 1974.

Waters, Mrs. Clara Erskine Clement. *Women in the Fine Arts*. Boston and New York: Houghton Mifflin Company, 1904.

Women. Exhibition catalogue. Winston-Salem, N.C.: Salem College and North Carolina Museum of Art, 1972.

Wolfe, Ruth. "When Art Was a Household Word." *Ms.*, 2, no. 8 (February 1974), pp. 29–33.

Woolf, Virginia. *A Room of One's Own*. New York: Harcourt, Brace and Company, 1929.

2. The Arts

~~~

## GENERAL REFERENCES AND SURVEYS

Armstrong, Tom; Craven, Wayne; Haskell, Barbara; Krauss, Rosalind E.; Robbins, Daniel; and Tucker, Marcia. *Two Hundred Years of American Sculpture*. Exhibition catalogue. New York: Whitney Museum of American Art, 1976.

Christensen, Edwin O. *The Index of American Design*. Washington, D.C.: The National Gallery of Art, 1950.

Davidson, Marshall B. *The American Heritage History of Colonial Antiques*. New York: The American Heritage Publishing Co., 1967.

————. *The American Heritage History of American Antiques from the Revolution to the Civil War*. New York: The American Heritage Publishing Co., 1968.

————. "The Legacy of Craftsmen." *American Heritage* (April 1972), pp. 81–96.

Dow, George Francis. *The Arts and Crafts in New England, 1704–1775*. New York: Da Capo Press, 1967.

Drepperd, Carl W. *American Pioneer Arts and Artists*. Springfield, Mass.: Pond-Ekberg Company, 1942.

Driskell, David C. *Two Centuries of Black American Art*. Exhibition catalogue. New York: Alfred A. Knopf, Inc., and the Los Angeles County Museum of Art, 1976.

Eaton, Allen H. *Handicrafts of New England*. New York: Bonanza Books, 1949.

Elliot, Maud Howe, ed. *Art and Handicraft in the Woman's Building of the World's Columbian Exposition*. New York: Goupil and Co., 1893.

Flexner, James Thomas. *First Flowers of Our Wilderness*. New York: Dover Publications, 1967.

————. *The Light of Distant Skies*. New York: Dover Publications, 1969.

*Frontier America: The Far West*. Exhibition catalogue. Boston: Museum of Fine Arts, 1975.

Goldwater, Robert. *Primitivism in Modern Art*. rev. ed. New York: Vintage Books, 1967.

Goodrich, Lloyd, and Black, Mary. *What Is American in American Art?* Exhibition catalogue. New York: M. Knoedler & Co., 1971.

Hornung, Clarence P. *Treasury of American Design*. 2 vols. New York: Harry N. Abrams, 1972.

Hunter, Sam, and Jacobs, John. *American Art of the 20th Century*. Englewood Cliffs, N.J.: Prentice-Hall and Harry N. Abrams, 1973.

Lipman, Jean, ed. *What Is American in American Art*. New York: McGraw-Hill Book Co., 1963.

*Massachusetts Historical Society, Portraits of Women, 1700–1825*. Boston: Massachusetts Historical Society, 1954.

Miles, Ellen, ed. *Portrait Painting in America: The Nineteenth Century*. New York: Main Street Press and Universe Books, 1977.

Novak, Barbara. *American Painting of the Nineteenth Century*. New York: Praeger Publishers, 1969.

Perry, Regenia A. *Selections of Nineteenth Century Afro-American Art*. New York: The Metropolitan Museum of Art, 1976.

Quimby, Ian M. G., ed. *Arts and Crafts of the Anglo-American Community in the Seventeenth Century*. Winterthur Conference Report. Charlottesville, Va.: The University Press of Virginia, 1975.

Rawson, Marion Nicholl. *Candleday Art*. New York: E.P. Dutton, 1938.

Richardson, E. P. *A Short History of Painting in America*. New York: Thomas Y. Crowell Company, 1963.

Taylor, Joshua, and Dillenberger, Jane. *The Hand and the Spirit: Religious Art in America, 1700–1900*. Exhibition catalogue. Berkeley, Calif.: University Art Museum, 1972.

Van Devanter, Ann C., and Frankenstein, Alfred V. *American Self-Portraits, 1670–1973*. Exhibition catalogue. Washington, D.C.: International Exhibitions Foundation, 1974.

Williamson, Scott Graham. *The American Craftsman*. New York: Bramhall House, 1940.

Wright, Richardson. *Hawkers and Walkers in Early America*. Philadelphia: J.B. Lippincott, 1927.

Wroth, Lawrence C. *A History of Printing in Colonial Maryland, 1686–1776*. Baltimore: Typothetae of Baltimore, 1922.

## FOLK ART, MIXED MEDIA

*American Folk Art from the Ozarks to the Rockies*. Exhibition catalogue. Tulsa, Okla.: Philbrook Art Center, 1975.

*Americana: Midwest Collector's Choice*. Exhibition catalogue. Dearborn, Mich.: Henry Ford Museum, 1960.

Bihaliji-Merin, Oto. *Masters of Naive Art: A History and Worldwide Survey*. New York: McGraw-Hill Book Co., 1970.

Blasdell, Gregg. *Symbols and Images: Contemporary Primitive Artists*. Exhibition catalogue. New York: American Federation of Arts, 1970.

Bradshaw, Elinor Robinson. "American Folk Art in the Collection of The Newark Museum." *The Museum New Series*, 19, nos. 3 and 4 (Summer–Fall 1967).

Brazer, Esther Stevens. *Early American Decoration*. Springfield, Mass.: Pond-Ekberg Company, 1940.

Cahill, Holger. *American Folk Art: The Art of the Common Man in America, 1750–1900*. Exhibition catalogue. New York: The Museum of Modern Art, 1932.

———. *American Primitives*. Exhibition catalogue. Newark, N.J.: The Newark Museum, 1930.

———. "Early Folk Art in America." *Creative Art* (December 1932) pp. 254–270.

Carlisle, Lilian Baker. *18th and 19th Century American Art at the Shelburne Museum*. Shelburne, Vt.: Shelburne Museum, 1961.

Christensen, Edwin O. *Popular Art in the United States*. London: Penguin Books, 1948.

DeJonge, Eric, ed. *Country Things*. Princeton, N.J.: The Pyne Press, 1973.

Dewhurst, C. Kurt, and MacDowell, Marsha. *Michigan Folk Art, Its Beginnings to 1941*. Exhibition catalogue. East Lansing, Mich.: Michigan State University Press, 1976.

*Early American Art*. Exhibition catalogue. New York: Whitney Studio Club, 1924.

*An Eye on America: Folk Art from the Stewart E. Gregory Collection*. Exhibition catalogue. New York: Museum of American Folk Art, 1972.

*Folk Art in America: A Living Tradition*. Exhibition catalogue. Atlanta, Ga.: The High Museum of Art, 1974.

Ford, Alice. *Pictorial Folk Art/New England to California*. New York: Studio Publications, 1949.

Goldin, Amy. "Problems in Folk Art." *Artforum* (June 1976), pp. 48–52.

Hall, Stuart, and Whannel, Paddy. *The Popular Arts*. London: Hutchinson Educational Ltd., 1964.

Hemphill, Herbert W., Jr., and Weissman, Julia. *Twentieth-Century American Folk Art and Artists*. New York: E.P. Dutton, 1974.

Horwitz, Elinor Lander. *Contemporary American Folk Artists*. Philadelphia and New York: J.B. Lippincott, 1975.

Janis, Sidney. *They Taught Themselves: American Primitive Painters of the Twentieth Century*. New York: Dial Press, 1942.

Jones, Agnes Halsey, and Jones, Louis C. *New-Found Folk Art of the Young Republic*. Cooperstown, N.Y.: New York State Historical Association, 1960.

Kauffman, Henry. *Pennsylvania Dutch American Folk Art*. rev. and enl. ed. New York: Dover Publications, 1964.

Kind, Phyllis. "Some Thoughts About Contemporary Folk Art." *American Antiques* (June 1976), pp. 28–44.

Lichten, Frances. *Folk Art of Rural Pennsylvania*. New York: Charles Scribner's Sons, 1946.

Lipman, Jean, and Winchester, Alice. *The Flowering of American Folk Art, 1776–1876*. Exhibition catalogue. New York: The Viking Press, 1974.

————. *Provocative Parallels*. New York: Dutton Paperbacks, 1975.

————, and Meulendyke, Eve. *American Folk Decoration*. New York: Dover Publications, 1972.

Little, Nina Fletcher. *The Abby Aldrich Rockefeller Folk Art Collection*. Catalogue. Williamsburg, Va.: Colonial Williamsburg, 1957.

————. *Country Art in New England, 1790–1840*. Sturbridge, Mass.: Old Sturbridge Village, 1960.

*Louisiana Folk Art*. Exhibition catalogue. Baton Rouge, La.: Anglo-American Art Museum, Louisiana State University, 1972.

MacFarlane, Janet R. *American Folk Art at Fenimore House*. Cooperstown, N.Y.: New York State Historical Association, 32 (January 1951), pp. 121–127.

*Masterpieces of American Folk Art*. Exhibition catalogue. Lincroft, N.J.: Monmouth Museum, 1975.

*Outward Signs of Inner Beliefs: Symbols of American Patriotism*. Exhibition catalogue. Cooperstown, N.Y.: New York State Historical Association, 1975.

Polley, Robert L., ed. *America's Folk Art*. New York: G.P. Putnam's Sons, 1968.

*Popular Art in America*. Exhibition catalogue. Brooklyn: The Brooklyn Museum, 1939.

Robacker, Earl F. *Pennsylvania Dutch Stuff*. Philadelphia: University of Pennsylvania Press, 1944.

Sears, Clara E. *Some American Primitives*. New York: Houghton Mifflin Company, 1941.

*Selected Treasures of Greenfield Village and Henry Ford Museum*. Dearborn, Mich.: The Edison Institute, 1969.

*Six Naïves*. Exhibition catalogue. Akron, Ohio: Akron Art Institute, 1973.

Stoudt, John J. *Early Pennsylvania Arts and Crafts*. New York: A.S. Barnes, 1964.

Wadsworth, Anna, ed. *Missing Pieces: Georgia Folk Art, 1770–1976*. Exhibition catalogue. Atlanta, Ga.: Georgia Council for the Arts, 1976.

Welsh, Peter C. *The Art and Spirit of a People: Folk Art from the Eleanor and Mabel Van Alstyne Collection*. Washington, D.C.: Smithsonian Institution, 1965.

Wheeler, Robert G. *Folk Art and the Street of Shops*. Dearborn, Mich.: The Edison Institute, 1971.

Winchester, Alice. "Antiques for the Avant-Garde." *Art in America*, 49, no. 2 (April 1961), pp. 64–73.

————, ed. "What Is American Folk Art?," The Magazine *Antiques*, 57, no. 5 (May 1950), pp. 355–362.

## FOLK ART, QUILTS

Bishop, Robert. *New Discoveries in American Quilts*. New York: Dutton Paperbacks, 1975.

————, and Safanda, Elizabeth. *A Gallery of Amish Quilts*. New York: Dutton Paperbacks, 1976.

Carlisle, Lilian Baker. *Pieced Work and Appliqué Quilts at Shelburne Museum*. Shelburne, Vt.: Shelburne Museum, 1957.

Chase, Pattie. "Quiltmaking: Reclaiming Our Art." *Country Women*, Issue 21 (September 1976).

Curtis, Phillip H. "American Quilts in The Newark Museum Collection." *The Museum*, n.s., 25, nos. 3 and 4 (Summer–Fall 1973).

Finley, Ruth E. *Old Patchwork Quilts*. Newton Centre, Mass.: Charles T. Branford Co., 1929.

*The Great American Cover-up: Counterpanes of the Eighteenth and Nineteenth Centuries*. Exhibition catalogue. Baltimore: The Baltimore Museum of Art, 1971.

Gutcheon, Beth. *The Perfect Patchwork Primer*. Baltimore: Penguin Books, 1974.

Haders, Phyllis. *Sunshine and Shadow: The Amish and Their Quilts*. New York: Universe Books, 1976.

Hall, Carrie, and Kretsinger, Rose, eds. *Romance of the Patchwork Quilt in America*. Caldwell, Idaho: Caxton Printers, 1936.

Holstein, Jonathan. *The Pieced Quilt: An American Design Tradition*. New York: Galahad Books, 1973.

Ickis, Marguerite. *The Standard Book of Quilt Making and Collecting*. New York: Dover Publications, 1960.

Johnson, Bruce. *A Child's Comfort*. Exhibition catalogue. New York: Harcourt, Brace and Jovanovich, 1977.

Mainardi, Patricia. "Great American Cover-ups." *ARTnews* (Summer 1974), pp. 30–32.

———. "Quilts: The Great American Art." *The Feminist Art Journal* (Winter 1973), pp. 1, 18–23.

Orlofsky, Patsy, and Orlofsky, Myron. *Quilts in America*. New York: McGraw-Hill Book Co., 1974.

"Quilter's Column." *The Detroit News*, October 5, 1938, October 9, 1938, May 25, 1940.

"Quilting at Miss Jones." *Godey's Lady's Book*, January 1868.

*Quilts and Counterpanes in The Newark Museum*. Exhibition catalogue. Newark, N.J.: The Newark Museum, 1948.

"Quilts—Historic and Artistic." *Hobbies Magazine*, 82, no. 5 (July 1977).

Safford, Carleton L., and Bishop, Robert. *America's Quilts and Coverlets*. New York: E.P. Dutton, 1972.

## FOLK ART, SAMPLERS, RUGS, AND OTHER TEXTILES

Bolton, Ethel Stanwood, and Coe, Eva Johnston. *American Samplers*. New York: Dover Publications, 1973.

Bowles, Ella Shannon. *Homespun Handicrafts*. Philadelphia: J.B. Lippincott, 1931.

Cummings, Abbott Lowell. *Bed Hangings: A Treatise on Fabrics and Styles in the Curtaining of Beds 1650–1850*. Boston: The Society for the Preservation of New England Antiquities, 1961.

Davison, Mildred, and Mayer-Thurman, Christa C. *Coverlets*. Exhibition catalogue. Chicago: The Art Institute of Chicago, 1973.

Earle, Alice Morse. *Two Centuries of Costume in America, 1620–1820*. New York: B. Blum, 1968.

Fratto, Toni Flores. "Samplers, One of the Lesser American Arts." *The Feminist Art Journal* (Winter 1976/77), pp. 11–15.

Garrett, Elizabeth Donaghy. "American Samplers and Needlework Pictures in the D.A.R. Museum." The Magazine *Antiques* (April 1975), pp. 688–701.

Gilfoy, Peggy S. *Indiana Coverlets.* Exhibition catalogue. Indianapolis, Ind.: Speedway Press for the Indianapolis Museum of Art, 1976.

Ginsburg, Cora. "Textiles in the Connecticut Historical Society." The Magazine *Antiques* (April 1975), pp. 712–725.

*Hand-Woven Coverlets in the Newark Museum.* Newark, N.J.: The Newark Museum, 1947.

Harbeson, Georgiana Brown. *American Needlework.* New York: Bonanza Books, 1938.

Harrison, Constance Cary. *Woman's Handiwork in Modern Homes.* New York: Charles Scribner's Sons, 1881.

Hartley, Florence. *The Ladies' Handbook of Fancy and Ornamental Work.* Philadelphia: G. G. Evans, 1859.

Hedlund, Catherine. *A Primer of New England Crewel Embroidery.* Sturbridge, Mass.: Old Sturbridge Village, 1973.

Huish, Marcus. *Samplers and Tapestry Embroideries.* New York: Dover Publications, 1970.

Kopp, Joel, and Kopp, Kate. *American Hooked and Sewn Rugs: Folk Art Underfoot.* New York: Dutton Paperbacks, 1975.

Little, Frances. *Early American Textiles.* New York: The Century Co., 1931.

Little, Nina Fletcher. *Floor Coverings in New England Before 1850.* Sturbridge, Mass.: Old Sturbridge Village, 1967.

Maines, Rachel. "Fancywork: The Archaeology of Lives." *The Feminist Art Journal* (Winter 1974/75), pp. i, 3.

Ring, Betty. "The Balch School in Providence, Rhode Island." The Magazine *Antiques* (April 1975), pp. 660–671.

——, ed. *Needlework: An Historical Survey.* New York: Main Street/Universe Books, 1975.

Schiffer, Margaret B. *Historical Needlework of Pennsylvania.* New York: Bonanza Books, 1968.

Swan, Susan Burrows. *Plain and Fancy: American Women and Their Needlework, 1700–1850.* New York: Holt, Rinehart & Winston, 1977.

——. *A Winterthur Guide to American Needlework.* New York: Crown Publishers, for the Henry Francis du Pont Winterthur Museum, 1976.

Swygert, Mrs. Luther M., ed. *Heirlooms from Old Looms.* rev. ed. Chicago: privately printed, 1955.

Warren, William Lamson, and Callister, Herbert. *Bed Ruggs: 1722–1833.* Exhibition catalogue. Hartford, Conn.: Wadsworth Atheneum, 1972.

FOLK ART, MOURNING ART

Muto, Laverne. "A Feminist Art—The American Memorial Picture." *Art Journal,* 35/4 (Summer 1976), pp. 352–358.

Schorsch, Anita. "The Art in Mourning." *American Antiques* (June 1976), pp. 20–24.

——. "Mourning Art: A Neoclassical Reflection in America." *The American Art Journal* (May 1976), pp. 5–15.

——. *Mourning Becomes America: Mourning Art in the New Nation.* Exhibition catalogue. New Jersey: Main Street Press, 1976.

FOLK ART, PAPER SCULPTURE

Carrick, Alice Van Leer. *A History of American Silhouettes.* Rutland, Vt.: Charles E. Tuttle, 1968.

Hopf, Claudia. *Scherenschnitte: Traditional Papercutting.* Lebanon, Pa.: Applied Arts Publishers, 1977.

FOLK ART, PAINTING, PORTRAITURE, AND WATERCOLORS

*American Primitive Paintings from the Collection of Edgar William and Bernice Chrysler Garbisch.* Exhibition catalogue. Washington, D.C.: National Gallery of Art, 1954 (part 1); 1957 (part 2).

Anderson, Marna Brill. *Selected Masterpieces of New York State Folk Painting.* Exhibition catalogue. New York: Museum of American Folk Art. 1977.

Andrews, Edward Deming, and Andrews, Faith. *Visions of the Heavenly Sphere: A Study in Shaker Religious Art.* Charlottesville, Va.: The University Press of Virginia, 1969.

Black, Mary C. "American Primitive Painting." *Art in America,* 51, no. 4 (August 1963), pp. 64–82.

——, and Lipman, Jean. *American Folk Painting.* New York: Clarkson N. Potter, 1966.

Borneman, Henry S. *Pennsylvania German Illuminated Manuscripts.* New York: Dover Publications, 1973.

Ebert, John, and Ebert, Katherine. *American Folk Painters,* New York: Charles Scribner's Sons, 1975.

*The Gift of Inspiration/Religious Art of the Shakers.* Exhibition catalogue. Hancock, Mass.: Hancock Shaker Village, 1970.

*A Group of Paintings from the American Heritage Collection of Edith Kemper Jetté and Ellerton Marcel Jetté.* Waterville, Me.: Colby College Press, 1956.

Jones, Agnes Halsey. *Rediscovered Painters of Upstate New York, 1700–1875,* Utica, N.Y.: Munson-Williams-Proctor Institute, 1958.

Lipman, Jean. *American Primitive Painting.* New York: Oxford University Press, 1942.

——. *Primitive Painters in America: an Anthology.* New York: Dodd, Mead, 1950.

——, and Black, Mary. *American Folk Painting.* New York: Clarkson N. Potter, 1966.

——, and Winchester, Alice, eds. *Primitive Painters in America 1790–1950.* Freeport, N.Y.: Books for Libraries Press, 1971.

Little, Nina Fletcher. *American Decorative Wall Painting 1700–1851.* Sturbridge, Mass.: Old Sturbridge Village, 1952.

——. *Land and Seascape as Observed by the Folk Artist.* Exhibition catalogue. Williamsburg, Va.: Colonial Williamsburg, 1969.

————. *New England Provincial Artists, 1775–1800.* Exhibition catalogue. Boston: Museum of Fine Arts, 1976.

*Louisiana Folk Paintings.* Exhibition catalogue. New York: Museum of American Folk Art, 1973.

*M. & M. Karolik Collection of American Watercolors and Drawings 1800–1875.* 2 vols. Boston: Museum of Fine Arts, 1962.

*M. & M. Karolik Collection of American Paintings 1815–1865 (catalogue) for Museum of Fine Arts, Boston.* Cambridge, Mass.: Harvard University Press, 1949.

*Nineteenth-Century Folk Painting: Our Spirited National Heritage* (selections from the collection of Mr. and Mrs. Peter H. Tillou; exhibition catalogue). Storrs, Conn.: University of Connecticut, William Benton Museum of Art, 1973.

*101 American Primitive Watercolors and Pastels from the Collection of Edgar William and Bernice Chrysler Garbisch.* Exhibition catalogue. Washington, D.C.: National Gallery of Art, n.d.

*101 Masterpieces of American Primitive Painting from the Collection of Edgar William and Bernice Chrysler Garbisch.* Exhibition catalogue. New York: American Federation of Arts, 1961.

*The Paper of the State.* Exhibition catalogue. New York: Museum of American Folk Art, 1976.

## FOLK ART, SCULPTURE

Cahill, Holger. *American Folk Sculpture.* Exhibition catalogue. Newark, N.J.: The Newark Museum, 1931.

Fried, Frederick. *Artists in Wood.* New York: Bramhall House, 1970.

Hemphill, Herbert W., Jr., ed. *Folk Sculpture, USA.* Exhibition catalogue. Brooklyn: The Brooklyn Museum, 1976.

Lipman, Jean. *American Folk Art in Wood, Metal and Stone.* New York: Dover Publications, 1972.

Mills, George, and Grove, Richard. *Lucifer and the Crucifer: The Enigma of the Penitent.* Colorado Springs: Taylor Museum, Colorado Springs Fine Arts Center, 1966.

## FOLK ART, FURNITURE

Bishop, Robert. *Centuries and Styles of the American Chair, 1640–1970.* New York: E.P. Dutton, 1972.

Fales, Dean A., and Bishop, Robert. *American Painted Furniture, 1660–1880.* New York: E.P. Dutton, 1972.

Trent, Robert F. *Hearts and Crowns: Folk Chairs of the Connecticut Coast, 1720–1840.* New Haven, Conn.: The New Haven Colony Historical Society, 1977.

## FOLK ART, POTTERY

Lasansky, Jeanette. *Made of Mud: Stoneware Potteries in Central Pennsylvania, 1834–1929.* Lewisburg, Pa.: Union County Bicentennial Commission, 1977.

Webster, Donald Blake. *Decorated Stoneware Pottery of North America.* Rutland, Vt.: Charles E. Tuttle, 1970.

## FOLK ART, TINWARE

Coffin, Margaret. *American Country Tinware, 1700–1900.* Camden, N.J.: Thomas Nelson, 1968.

Lipman, Jean. "From the Golden Age of Tinware." *Life,* 63, no. 7 (February 1970), p. 10.

## INDIVIDUALS

Andrews, Wayne. "Patience Was Her Reward: the Records of the Baroness Hyde de Neuville." *Journal of the Archives of American Art* (July 1964).

Bishop, Robert. *The Borden Limner and His Contemporaries.* Exhibition catalogue. Ann Arbor, Mich.: The University of Michigan Art Museum, 1976.

Clarke, Caroline Cowles Richards. *Diary of Caroline Cowles Richards, 1852–1872.* New York: privately printed, 1908.

Devoe, Shirley Spaulding. "The Upson Tin and Clock Shops." *The Connecticut Historical Society Bulletin,* 26, no. 3 (July 1961), pp. 83–87.

*Fannie Lou Spelce.* Exhibition catalogue. New York: Kennedy Galleries, 1972.

Finch, Helen. Unpublished album (c. 1897–1899). Collection of Marsha Mac-Dowell and C. Kurt Dewhurst.

Fry, Gladys-Marie. "Harriet Powers: Portrait of a Black Quilter." In Anna Wadsworth, ed., *Missing Pieces: Georgia Folk Art, 1776–1976.* Exhibition catalogue, pp. 17–19.

Giffen, Jane. "Susanna Rowson and Her Academy." The Magazine *Antiques* (September 1970), pp. 436–440.

Hamblett, Theora, in collaboration with Edwin E. Meek. *Dream and Visions,* 1975.

Harris, Estelle M. N. "A Pedigreed Antique: Molly Stark's Wedding Gift." The Magazine *Antiques,* 12, no. 5 (November 1927).

Heslip, Colleen Cowles. Unpublished master's thesis on Susan Waters. Cooperstown Graduate Program, Cooperstown, New York.

*Horace Pippin.* Exhibition catalogue. Washington, D.C.: The Phillips Collection, 1976.

Hosmer, Harriet Goodhue. *Letters and Memories* edited by Cornelia Carr. London: Lane, 1913.

Kallir. Otto. *Grandma Moses.* New York: Harry N. Abrams, 1973.

Karlins, N. F. "Mary Ann Willson." The Magazine *Antiques* (November 1976), pp. 1040–1045.

Kubler, George. *Santos.* Exhibition catalogue. Fort Worth, Tex.: Amon Carter Museum of Western Art, 1964.

Lane, Nona Alice Ginger. Unpublished quilting scrapbook album. Collection of Marsha MacDowell and C. Kurt Dewhurst.

Leonard, Patrick J., Jr. *Miss Susan Torrey Merritt of South Weymouth, Massachusetts: An Artist Rediscovered.* Quincy, Mass.: President Press, 1976.

Lesley, Parker. "Patience Lovell Wright." *Art in America,* 24 (October 1936), pp. 148–157.

Lipman, Jean. "Eunice Pinney, An Early Connecticut Watercolorist." *Art Quarterly,* 6 (Summer 1943), pp. 213–221.

———. "Deborah Goldsmith, Itinerant Portrait Painter." *Antiques* (November 1943), pp. 227–229.

Loggins, Carlene. "Artist May Bring Fame to Maysville" (Mattie Lou O'Kelley). *The Jackson Herald,* November 26, 1975.

Middleton, Margaret Simons. *Henrietta Johnston: America's First Pastellist.* Columbia, S. C.: University of South Carolina Press, 1966.

Miller, Herschel. "Clementine Hunter, American Primitive." *New Orleans,* December 1978.

O'Kelley, Mattie Lou. "Autobiography," unpublished poem, 1975.

———. Personal interview with artist. New York, June 1977.

Pinckney, Elise., ed., assisted by Marvin R. Zahniser. *The Letterbook of Eliza Lucas Pinckney.* Chapel Hill, N.C.: University of North Carolina Press, 1972.

Pirtle, Caleb III. "Fannie Lou Spelce: Keep on Painting Until the Memories Run Out." *Southern Living* (September 1976).

Rogers, Gertrude. Personal interview with artist, Sunfield, Michigan, May 1977.

*Queena Stovall: Artist of the Blue Ridge.* Exhibition catalogue. Utica, N.Y.: Brodock Press for the New York State Historical Association, 1974.

Shaffer, Sandra C. "Deborah Goldsmith, 1808–1836." Unpublished master's thesis, Cooperstown Graduate Program, Cooperstown, New York, 1968.

Shaw, Anna Howard. *The Story of a Pioneer.* New York: Harper and Brothers Publishers, 1915, 1929.

Starr, Nina Howell. *Minnie Evans.* Exhibition catalogue. New York: Whitney Museum of American Art, 1975.

Stowe, Charles Messer. "Ann Butler's Painted Tinware—First Signed Work Discovered." *The New York Sun,* March 11, 1933.

"Tella Kitchen, She Paints Her Memories." *The Columbus Dispatch Magazine,* October 19, 1975.

*Theora Hamblett.* Exhibition catalogue. New York: Morris Gallery, 1963.

"TV to Feature Banks (Co.) Painter: Mattie Lou O'Kelley." *The* [Atlanta, Georgia] *Times,* December 9, 1976.

Vogel, Donald, and Vogel, Margaret. *Aunt Clara: The Paintings of Clara McDonald Williamson.* Austin, Tex.: University of Texas Press for the Amon Carter Museum of Western Art, 1966.

Warren, William Lamson. "Connecticut Pastels, 1775–1820." *The Connecticut Historical Society Bulletin,* 24, no. 4 (October 1959), pp. 101–107, 116–120.

Weissman, Julia. "Malcah Zeldis: A Jewish Folk Artist in the American Tradition." *The Jewish National Monthly* (September 1975), pp. 2–5.

## 3. Other References

~ ~ ~

Boston. Massachusetts Historical Society Archives. Abigail Adams papers.

Hartford. Connecticut Historical Society. Miscellaneous Filley papers, 177?–1867. One box, correspondence and papers, principally of Oliver Filley.

Inventory of American Paintings, National Collection of Fine Arts, Washington, D.C.

Kunitz, Stanley. "Words for the Unknown Makers." *Craft Horizons* (February 1974), pp. 32–39.

*Ladies' Home Journal*, editorial, 16, no. 2 (January 1899); 47 (May 1930).

Lewis, Everett E. *Historical Sketch of the First Congregational Church of Haddam, Connecticut*. Haddam, Conn.: First Congregational Church, 1879.

The Magazine *Antiques*. vols. 1–111 (New York 1922–June 1977).

*Two Hundredth Anniversary of the First Congregational Church of Haddam, Connecticut*. Haddam, Conn.: First Congregational Church, 1902.

# Index of Artists

A list of artists whose work is illustrated in this book.

# Index

Page numbers in *italic* type indicate illustrations.